Bryce Glass

Bryce Glass

ART AND NOVELTY IN NINETEENTH-CENTURY PITTSBURGH

DEBRA M. COULSON

HARLEY N. TRICE

Edited by
GERALD W. R. WARD
Katharine Lane Weems Senior Curator of American Decorative Arts
and Sculpture Emeritus, Museum of Fine Arts, Boston

With a Foreword by
BROCK JOBE
Professor Emeritus of American Decorative Arts, Winterthur Museum, Garden & Library

Photography by
GAVIN ASHWORTH

BRYCE GLASS LLC, DEBRA M. COULSON, and HARLEY N. TRICE
in association with D GILES LIMITED

First published in 2023 by GILES
An imprint of D Giles Limited
66 High Street,
Lewes, BN7 1XG, UK
gilesltd.com

Bryce Glass LLC
422 Chapel Harbor Dr.
Pittsburgh PA 15238 USA
BryceGlassLLC@gmail.com

Library of Congress Control Number: 2022916198

ISBN (hardcover): 978-1-913875-33-6

Bryce Glass: Art and Novelty in Nineteenth-Century Pittsburgh was made possible
with generous support from the Richard C. von Hess Foundation, Jason
Hazelwood and Reed Smith LLP, Lea Simonds, Mark Coulson, Paul Singer, John
Unkovic, and Reed Smith attorneys Nicole Snyder Bagnell, Dan Booker, Chris
Brennan, Doug Cameron, Deb Dermody, Paul Didomenico, Ron Francis, Megan
Haines, Ron Hartman, Courtney Horrigan, Mike Lowenstein, Michelle Mantine,
Jim Martin, Perry Napolitano, Ryan Purpura, Andrew Roman, Allison Sizemore,
Jen Smokelin, Alexander Thomas, Ginevra Ventre, and Justin Werner.

Dimensions are in inches and centimeters and presented as height × width ×
depth, or height × diameter, as appropriate.

All objects photographed are in the collections of the authors, except as noted.
All photographs are by Gavin Ashworth, except as noted.
Factory B Catalogue images are courtesy of the Carnegie Library of Pittsburgh, PA,
and the Tiffin Glass Collectors Club, Museum, Shoppe and Archives, Tiffin, OH.
Wholesale catalogue images are courtesy of Sid Lethbridge, Tom Felt, and the
Glass Flakes of the Museum of American Glass in West Virginia, Weston, WV.

For Bryce Glass LLC: Debra M. Coulson and Harley N. Trice
Project Manager: Debra M. Coulson
Project Editor: Gerald W. R. Ward, Katharine Lane Weems Senior Curator of
American Decorative Arts and Sculpture Emeritus, Museum of Fine Arts, Boston

For D Giles Limited:
Copy-edited and proof-read by Jodi Simpson
Designed by Helen Swansbourne
Produced by GILES, an imprint of D Giles Limited
Printed and bound in China

Front cover: Openwork Dish with Dolphin Standard (aka), circa 1887
Back cover: Banner butter (omn), 1886
Frontispiece: Fly and Banner butters (omn), 1886
Right: Ambidextrous cream pitcher (aka), 1881
Page 31: Diamond footed bowl (omn), mid-1880s
Pages 76–77: Puritan Boats (omn), 1886

Contents

6 Foreword
BROCK JOBE

8 Acknowledgments

11 Introduction

17 James Bryce, from Sheep Farm
to Glass Entrepreneur

Company History

33 Bryce, McKee & Company,
1850 to 1854

37 Bryce, Richards & Company,
1854 to 1865

43 Bryce, Walker & Company,
1865 to 1882

53 Bryce Brothers,
1882 to 1891

65 Bryce Brothers Company,
Blown Glass from 1893 to 1965

71 Authenticating Bryce
Glassware

Catalogue

79 PART 1 • Patterns

171 PART 2 • Novelties

223 PART 3 • Lamps

Compendium

247 APPENDIX I
Bryce Family Glassmakers

248 APPENDIX II
Bryce Patents, 1850 to 1891

249 Bibliography

251 Index

Foreword

DURING MY TEACHING DAYS, I ENCOURAGED students to welcome serendipity. Accidental discoveries can lead you in rewarding directions, and certainly my presence here, writing these words, is a case in point. Through a mutual friend, I renewed an acquaintanceship with Harley Trice in the fall of 2020. I had begun to plan a conference on decorative inlay and marquetry for Winterthur, and Harley generously offered to share his knowledge of ornamented furniture from western Pennsylvania. We agreed to meet in Pittsburgh the following March for a whirlwind tour of antique shops and collectors' residences. Our journey ended at the home of Debra Coulson, where the conversation soon shifted from furniture to glass. I immediately sensed the passion and knowledge that Debra and Harley had for the local glass-making firm founded by James Bryce in 1850. Their efforts deserved to be published, and I wanted to lend a hand. I suggested a potential funding source, content editor, and photographer. Happily, each complied and helped push this work across the finish line. Throughout the process, it has been a privilege to play a small part in bringing Debra and Harley's exemplary scholarship into print.

Historians have long recognized Pittsburgh's place as a center of early glass production. Much of that acclaim has concentrated on Benjamin Bakewell, whose glassworks was the first in America to make flint glass successfully. Yet other individuals are central to that story, especially during the second half of the nineteenth century. This volume brings to the forefront, for the first time, the contributions of James Bryce, his sons, and his grandsons. James takes center stage, both because of his extraordinary achievements and the survival of a journal that he kept for forty-two years. In his account, we learn that in 1823 he joined the Bakewell firm as a laborer at the age of ten and soon was assigned to a glass-blower who continually berated him. "The harder I worked," wrote James, "the more was expected of me and because I bore hardships and abuse without complaint, I was subjected to it more than any other. He never beat me because he could find no reasonable excuse to do so but he made me miserable by a continual system of petty annoyance and vexation: scolding and swearing at me for things in which I was not to blame, especially what was worst of all before the masters."

Later passages recount the difficult conditions and inconsistent income of the trade. Like the young James, his father worked as a laborer for Bakewell, but his task

Puritan Boat on a silver-plated stand, 1886
(cat. 110).

involved processing the lead used in making flint glass. The consequences were dire, as James noted: "this I think was one great cause of the disease that ended his life." After his father's passing, James served an apprenticeship with Bakewell, became a skilled glassmaker, and continued at his trade until 1840, when declining demand prompted him to take up shopkeeping—a disastrous decision. "For in the two years I have kept store we have not made one dollar," he lamented. James eventually returned to his trade and in 1850 formed the first in a succession of pressed glass companies in which he maintained a leading role until his death in 1893.

Debra Coulson and Harley Trice present the definitive history of each Bryce enterprise, backed by impeccable documentation. Afterwards, they turn to an analysis of the many patterns of Bryce's glassware and here again apply the same intellectual rigor that distinguishes the initial

chapters of the book. Company catalogues (of which there are regrettably few), advertisements, and patents guide the identification of specific forms. Period trade journals and wholesale catalogues point to other patterns that can be attributed to Bryce. Together these sources yield a portfolio of colorful glass creations, ranging from utilitarian to novelty, from common bowls to glass slippers. Every step of the way, Gavin Ashworth's stunning photography captures the brilliance and beauty that appealed to nineteenth-century customers, and still hold our interest today. You are in for a fascinating journey. Enjoy the ride.

BROCK JOBE
Professor Emeritus of American Decorative Arts
Winterthur Museum, Garden & Library

Acknowledgments

WE TALKED ABOUT WRITING A BRYCE glass book for a decade, and the generous support of the Richard C. von Hess Foundation, our former law firm Reed Smith LLP, and our families and friends finally brought it to fruition. It also took the support and encouragement of a host of glass scholars and enthusiasts, all of whom deserve our sincere thanks.

The Pittsburgh Glass Center (PGC) and its Executive Director, Heather McElwee, embraced this project as a way to celebrate Pittsburgh's rich glass history. PGC is a nonprofit education center, art gallery, and state-of-the-art glass studio that encourages everyone, from the casually curious to the master artist, to learn, create, and be inspired by glass. The artisans at PGC pressed a piece of glass for us in a twenty-first-century reenactment of a nineteenth-century process. PGC's glassblowers jury-rigged a pressing device using a period iron mold to produce 3-inch-high cordials that are indistinguishable from their nineteenth-century counterparts.

You don't need to look beyond our book cover to see the enormous impact our photographer, Gavin Ashworth of New York City, had on this book. Gavin is a rock star in the world of fine and decorative arts photography, and his artistry and magic created truly exceptional photographs that transformed our glass book into an art book.

From the outset we envisioned this book as an authoritative, scholarly work based on primary and secondary sources with clear articulation of the bases for our identification of Bryce glassware. To do that, we needed period resources. We were fortunate to find enthusiastic support for our efforts.

Cary Reed and Jacalyn Mignogna of the Carnegie Library of Pittsburgh facilitated our review of an 1892 United States Glass Company catalogue in its collection that includes Bryce glass. Nancy A. and Paul D. Coffman of the Tiffin Glass Collectors Club provided scans of additional U.S. Glass catalogue pages in the collection of the Tiffin Glass Collectors Club, Museum, Shoppe and Archives, Tiffin, Ohio.

Regan Brumagen and Gail Bardhan of the Rakow Research Library at the Corning Museum of Glass, Corning, New York, assisted our review of material in its collection. One especially important find was an original page of Bryce, Richards & Company patterns of circa 1854 that enabled us to publish a high-resolution image of that page.

Our thanks to Anne Madarasz, Sierra Green, and Elizabeth Simpson Romano of the Senator John Heinz History Center,

Pittsburgh, and the Cooper-Siegel Community Library, Fox Chapel, Pennsylvania, for assistance with our research.

This book could not have been written without the community of pattern glass enthusiasts who have spent countless hours pursuing their passion. The collectors we contacted generously shared their expertise. Sid Lethbridge compiled a timeline of trade journal and wholesale catalogue excerpts relating to the Bryce companies based in part on previous work by Tom and Neila Bredehoft, Gail Bardhan, Tom Felt, and J. Stanley Brothers. Most importantly, Sid answered our questions and did a critical reading of our manuscript. Tom Felt and the Glass Flakes of the Museum of American Glass in West Virginia provided wholesale catalogues that helped us authenticate and date Bryce products. Tom and Neila Bredehoft and Paul Kirk, Jr., shared research material, including trade journal excerpts and catalogue pages.

The pattern identification index on the Early American Pattern Glass Society (EAPGS) website was particularly valuable in identifying forms and colors produced by early glassmakers. Our thanks to the EAPGS members who maintain this valuable resource.

We are grateful to several collectors, some of whom we had never met, who loaned noteworthy pieces for inclusion in the book. Brad Gougeon stands out among that group. The collection of Bryce glass in his Glass Shed is exceptional, and he kindly delivered four totes full of his treasures to Pittsburgh to entrust to virtual strangers for a photo shoot. Brad also shared his glass knowledge and did a critical reading of the manuscript.

Mary Lamica invited us to tour her enormous pattern glass collection and gave us our pick of glassware to photograph. Others who loaned glass include Jim Masterson, John and Alice Ahlfeld, Terri Frauzel, Kathy Grant, Carmen Keehn, Karin Kolsky, and Sid Lethbridge.

Bryce descendants Norah Molnar and Andrea Howells shared nineteenth-century painted portraits of Elizabeth and James Bryce.

Mark Johnson's image preparation skills turned photographs of 130-year-old catalogue pages into clear and crisp images for the Compendium. When a legible period image was not available, the talented Livja Koka created beautiful line drawings to complete the Compendium.

Brock Jobe, Professor Emeritus of American Decorative Arts, Winterthur Museum, Garden & Library, introduced us to exceptionally well-qualified people who participated in this project. Brock recognized the importance of preserving the story of Bryce glass and we are grateful for his support and the wonderful foreword he wrote for this book. Our editor Gerald W. R. Ward, Katharine Lane Weems Senior Curator of American Decorative Arts and Sculpture Emeritus, Museum of Fine Arts, Boston, reviewed our manuscript and guided us through the book production process.

Our publisher D Giles Limited, and in particular Dan Giles, managing editor Allison McCormick, production director Louise Ramsay, editor Jodi Simpson, and designer Helen Swansbourne, helped us produce an exceptional publication.

The Southern Alleghenies Museum of Art at Ligonier Valley, Pennsylvania, is collaborating with us to host a Bryce glass exhibition from August to November 2023. Our thanks to Jerry and Joan Hawk and Kristin Miller for making the exhibition possible.

Most of all, we are grateful to the Richard C. von Hess Foundation and Anne Genter, Jason Hazelwood and Reed Smith LLP, Lea Simonds, Mark Coulson, Paul Singer, John Unkovic, and our friends at Reed Smith, all of whose generous support made this book possible.

One final note—many times we thought this book was finished only to discover another treasure that needed to be included. No doubt that will continue. There are many knowledgeable scholars and collectors who could add to what we have presented here and we welcome their contributions.

DEBRA M. COULSON
HARLEY N. TRICE
Pittsburgh, Pennsylvania
August 2022

Introduction

THE ADVENT OF GLASS PRESSING in the mid-1800s transformed the lives of everyday people by making beautiful tableware widely available to those who could not afford the expensive blown and cut crystal enjoyed by their wealthy neighbors. Another important innovation in glassmaking occurred in 1864 with the development of a method for producing high-quality glass using soda lime instead of lead, which greatly reduced production costs.

Pressed glass production soared as manufacturers successfully imitated expensive cut glass at a fraction of the cost. The highest praise for pressed tableware was to compare it favorably to cut glass. Period advertisements promoted patterns that "so closely resemble cut glass that only experts can detect the difference. . . . So fine in design and finish as to be readily mistaken for the genuine expensive cut glass."[1]

Pittsburgh's first major industry was glassmaking, and Pittsburgh was known as America's Glass City long before it became known as the Steel City. Glassmaking in Pittsburgh had begun in 1797 and by 1869 Pittsburgh was producing nearly half of all glass made in America. Pittsburgh's strategic location on three rivers made it a gateway to frontier markets and its abundant natural resources, including silica from river sand and coal for firing glass furnaces, made it ideally suited to become a glassmaking hub.[2]

In 1850, James Bryce (1812–1893) founded a glassware company in Pittsburgh that provided a comfortable living for generations of his family; employed more than six hundred people in its heyday in Mount Pleasant, Westmoreland County, Pennsylvania; and operated in western Pennsylvania for more than 113 years, making it one of the longest-lasting glassware companies begun in Pittsburgh. James's brothers, sons, and grandsons participated in the ownership and management of the company until 1952. In 1965, Bryce

Fig. 1. Maltese Cross finial on a Bryce, Walker Orient butter, ca. 1877 (detail, cat. 37).

11

sold its business to Lenox, Inc., then the oldest and most famous manufacturer of fine china in the United States.

The story of Bryce glass begins with company founder James Bryce, who immigrated to America from Scotland with his family in 1818 when he was five years old. James became the family patriarch and his glassmaking career spanned nearly seventy years. He weathered economic upheavals and recessions, the Civil War, financial hardships, and family tragedies to become one of the most prominent and innovative glassmakers in nineteenth-century Pittsburgh.

James began a personal journal in 1834 that he continued writing until 1876, although at times life intervened and months or even years passed between journal entries (fig. 2). His journal consists of 391 handwritten pages in two volumes.[3] This unique first-person account chronicles James's personal life, his career as a glassmaker, and his front-row seat to many of the significant historical events in nineteenth-century Pittsburgh, such as the devastating fire in 1845 that burned approximately sixty acres of the downtown area, including the Bakewell factory where James began his glassmaking career. James's journal is quoted here extensively, edited for punctuation and readability.

James was a deeply religious man and much of his journal is devoted to his musings on life and death and God Almighty. His Christian morality and religious devotion permeated all aspects of his life, such that his factory was nicknamed "the Church."[4] He wrote: "Religion has been the source of the highest and purest enjoyment I have experienced and therefore it is often in my thoughts."[5]

James began his glassmaking career in June 1823 at the age of ten, working for $1.25 a week at the glass factory of the highly respected Pittsburgh firm of Bakewell, Page & Bakewell where his father, James Bryce, Sr., and older brother William worked as laborers. In 1826, his father lay dying from lead poisoning contracted while processing the lead used in making flint glass. James recognized that lead was to blame: "When my Father began to work at the glasshouse it was at common laboring work but for a year or two before his death he made lead and this I think was one great cause of the disease that ended his life."[6]

On his deathbed, James's father asked Mr. Bakewell to apprentice James as a glassblower so he could help support his family after his father's death. Mr. Bakewell agreed to teach James "the art, trade, and mystery" of a glassblower, and James formally became an apprentice glassblower in 1827.[7] James spent seventeen years at Bakewell learning glassmaking from the best American artisans of the time.

By 1850, James was ready to embark on his own glassmaking enterprise. James, his brothers Robert and John, and twelve others founded the glassware firm of Bryce, McKee & Company. The Bryce, McKee factory was located in East Birmingham, a borough on the south bank of the Monongahela River opposite the city of Pittsburgh, now part of Pittsburgh's South Side. The Bryce, McKee glassworks primarily

Fig. 2. Initial entry in James Bryce's journal, dated August 1, 1834.

Fig. 3. Interior of a Thistle high-footed bowl, a naturalistic design patented by John Bryce in 1872 (cat. 22).

Fig. 4. Interior of a Maltese high-footed bowl, a geometric design patented by John Bryce in 1876 (cat. 30).

produced pressed tableware, and it also made pearl and crystal lamps, perfume bottles, apothecary ware, and other flint-glass pieces.

The firm name changed to Bryce, Richards & Company in 1854 to reflect a change in ownership interests. James and his brothers remained partners in the new company. Three of James's sons were later employed at the firm—John P. as a mold maker, Andrew H. as a clerk, and David K. as a bookkeeper. A family tree identifying the Bryce family glassmakers and their relationships is in Appendix I.

A single page depicting Bryce, Richards patterns of circa 1854 has been found, but its original source is unknown (see fig. 24). "Bryce, Richards & Co., Manufacturers, Pittsburgh, PA" is printed at the top of the page. Seven pressed glass patterns are illustrated: Tulip with Sawtooth, Tulip, Harp, Sawtooth, Excelsior, Ashburton, and Huber.

After another partial change in ownership in 1865, the firm became Bryce, Walker & Company. It was the second largest of the twenty-four glass tableware factories operating in Pittsburgh at that time.[8] Bryce, Walker has been recognized as one of the first glassware companies to produce naturalistic patterns on a large scale.[9] Patterns of fruits, flowers, birds, insects, and animals were popular in the Midwest, while the New England glass companies primarily used geometric patterns for their tableware.

James's brother John patented four naturalistic designs: Grape Band (1869), Curled Leaf (1869), Strawberry (1870), and Thistle (1872) (fig. 3). Each of these patterns and other naturalistic designs appeared on many forms of Bryce tableware, including table sets, goblets, mugs, covered bowls, pitchers, and lamps. Finials of three-dimensional strawberries and thistle blossoms adorned the lids of covered bowls in those two patterns. John Bryce also patented designs for two of the most popular Bryce geometric patterns—Diamond Sunburst (1874) and Maltese (1876), the latter also known as Jacob's Ladder or Imperial (fig. 4). Diamond Sunburst finials were shaped like a crown and Maltese finials like a Maltese Cross.

Fig. 5. Bucket Jellies
and Toy Buckets,
1885 (cat. 99).

Bryce, Walker became one of the largest producers of pressed glass in the United States and by 1878 shipped its products all over the world, including to London, Glasgow, South America, the West Indies, and Japan.

Walker withdrew from the company in 1882 and James's sons Andrew, David, James McDonald (known as Donald), Samuel Allan (known as Allan), and Frank G.; grandson Marion G.; and nephew Edwin W. Bryce became partners. The firm name was changed to Bryce Brothers.

Colored glassware surged in popularity in the mid-1880s, and Bryce Brothers began making glassware in amber, blue, and canary (the color some collectors today call "vaseline"). Bryce produced two additional colors not typically made by other manufacturers—amethyst and a rare tint of deep rose known as Jacqueminot Rose. Bryce also made a few articles in green that are hard to find today.

Novelties became the rage in the 1880s, and Bryce Brothers became a major producer of whimsical knick-knacks in crystal and colored glass in forms that were new and unusual, including shoes, boats, buckets, flies, and fish (fig. 5). Bryce Brothers' novelties often reflected current events such as the 1886 dedication of the Statue of Liberty, or popular trends such as toothpick chewing.

By the late 1880s, the glassware industry in Pittsburgh was highly competitive and companies were under tremendous economic pressure to reduce costs and increase profits. That led to the consolidation of glass companies into large conglomerates. In 1891, eighteen glass companies from western Pennsylvania, Ohio, and West Virginia formed a conglomerate in Pittsburgh named United States Glass Company, which for many years was the largest glass company in the world. Bryce Brothers joined that company at its

inception, and U.S. Glass operated the former Bryce Brothers factory under the designation U.S. Glass Company, Factory B.

In early 1892, U.S. Glass released a composite catalogue of the wares it was offering for sale. It was a compilation of existing catalogues produced by member companies prior to the consolidation as well as several new tableware patterns designed by U.S. Glass. Part of an 1891 Bryce Brothers catalogue was included in that compilation; it is referred to here as the Factory B Catalogue. Many patterns can be documented as Bryce production based on their illustration in the Factory B Catalogue.

In 1893, the year James Bryce died, his sons Andrew and Donald withdrew from U.S. Glass and reorganized Bryce Brothers with Andrew as president and Donald as secretary-treasurer. The company purchased and moved to an existing glass factory in Hammondville, Fayette County, Pennsylvania. It changed its production from pressed glass to blown glass, including tumblers, stemware, and tableware, some hand-decorated by the process known as needle etching. This class of work had previously been imported from Europe and this was the first concerted effort to supplant foreign glass for fine tableware.[10]

The new venture in Hammondville was so successful it soon outgrew its factory. In 1896, the company incorporated as Bryce Brothers Company and moved its operations to a new facility in nearby Mount Pleasant, Westmoreland County, Pennsylvania, that it built with the help of financial incentives from the town. Bryce Brothers produced blown lead crystal ware, both plain and decorated by cutting, engraving, needle etching, and color, in competition with European glassware. By 1906 the glassworks covered four acres and employed more than six hundred people.[11] Its products were used in the White House and U.S. embassies, and shipped all over the world.

The following chapters provide a description of James Bryce's early years, a brief history of each successive company and its production, and a catalogue of significant patterns, novelties, and lamps, generally presented in chronological order. The Compendium includes an alphabetical list of these and additional patterns and novelties along with catalogue images and descriptions of the bases for the Bryce attributions.

NOTES
1. Butler Brothers, "Our Drummer" (86th Trip 1886): 32, 35.
2. Lowell Innes, Pittsburgh Glass 1797–1891 (Boston: Houghton Mifflin, 1976), 7–8, 10; David Lowry, James Mills, and E. A. Myers, Pittsburgh: Its Industry and Commerce, Embracing Statistics of the Coal, Iron, Glass, Steel, Copper, Petroleum, and Other Manufacturing Interests of Pittsburgh (Pittsburgh,

PA: Barr & Myers Publishers, 1870), 6, 60.
3. James Bryce, journal, vol. 1, Aug. 1, 1834–June 3, 1840; vol. 2, Sept. 7, 1840–May 30, 1876. The original journal is owned by a Bryce descendant and a copy is in the Detre Library & Archives of the Senator John Heinz History Center, Pittsburgh, PA.
4. Neila Bredehoft, "Nicknames of

Glass Companies," NewsJournal (Early American Pattern Glass Society) 21, no. 3 (Fall 2014): 10.
5. Bryce, journal, 2:133.
6. Bryce, journal, 1:28–29.
7. Glassblower Apprenticeship Indenture, Dec. 1, 1827 (fig. 13).
8. George H. Thurston, Pittsburgh and Allegheny in the Centennial Year (Pittsburgh, PA: A. A. Anderson & Son, 1876), 133.

9. John Welker and Elizabeth Welker, Pressed Glass in America: Encyclopedia of the First Hundred Years, 1825 to 1925 (Ivyland, PA: Antique Acres Press, 1985), 32.
10. John Newton Boucher, History of Westmoreland County, Pennsylvania, vol. 2 (New York: Lewis Publishing Company, 1906), 125.
11. Boucher, Westmoreland County, 125.

James Bryce
from Sheep Farm to Glass Entrepreneur

J AMES BRYCE WAS BORN NOVEMBER 5, 1812, on a sheep farm known as Barstibley in the Stewartry of Kirkcudbright (ker-KOO-bree), Scotland (fig. 7), where he lived with his father James Sr. (1773–1826), his mother Agnes Ferguson Bryce (1783–1866), and his older brother William (1807–1827?).[1]

Kirkcudbright is an ancient seaport in southwestern Scotland, located at the mouth of the River Dee, which broadens into Kirkcudbright Bay, just four miles from the Irish Sea. The town may be as old as the early eighth-century church of St. Cuthbert, from which the town takes its name. In 1821 its population was about two thousand.[2]

James lived with his family at the Barstibley farm for five years. James's younger siblings Mary and Dunbar were also born there, but Dunbar survived only three months and three days. Some sixty years later, James still remembered Dunbar fondly as a "pretty yellow-haired boy."[3]

The Bryce family decided to seek new opportunities in America and set sail on March 12, 1818, with heavy hearts from parting with all their friends and neighbors. At the time of their journey, James was five years old, his brother William was ten years old, and his sister Mary was three years old.

They booked passage on the vessel *Jessie of Dumfries*, which was cleared to travel from Dumfries, Scotland, to Halifax, Nova Scotia, but not to America; Scottish laws restricted the emigration of mechanics to America. James described their ship: "Our vessel was a brig of the smallest class. Only about four feet between decks and crowded with passengers. There were nearly two hundred and to accommodate all these they had four double tiers of berths up each side of the vessel and a double row up the middle with only room enough to pass up the two alleys that were left between."[4]

The weather was fair the first ten days of the voyage to Halifax, but after that "nearly every day was foul." The overcrowded passengers bickered and quarreled about cooking and every other thing. Many passengers, including James, became sick.

One thing I [remember that] caused many disputes [was that] there [were] only two skylights in the deck and except just under these it was almost dark as midnight on a stormy day when [we were] not able to go on deck. The right of sitting near these was a never failing subject of contest.

The passengers that were not sick were kept below by the weather and nearly one half of them had to lie in bed at a time to give the rest room. The berths were all double, one over another, and just room enough left to crawl in. Whoever lay at the side was obliged to keep a fast hold to avoid being tossed out as the brig rolled and pitched on the waves.

Our family occupied two of these berths, my Father the upper one with Mary and me and my Mother and William the under one. Mother was confined to bed most of the passage and I was nearly at death's door with the bloody flux [dysentery] so that I can [remember] very little of what occurred on board from the day we sailed until we made the banks of Newfoundland.

I remember one fine day my Father carried me on deck—it was the first time I had seen the boundless ocean and I will never forget it.[5]

At Halifax, the ship was nearly condemned for having too many passengers. The captain waited until the port guard and pilot left the ship, then gave orders to set sail for America immediately under cover of darkness. From Halifax it was a stormy passage of more than two weeks before reaching the capes of Delaware, then another three days working up the

Fig. 7. Barstibley Farm in Kirkcudbright, Scotland, where James Bryce was born in 1812. In 1876, when he was sixty-four, James returned to Scotland and visited his birthplace. He said his only regret during his trip abroad was not spending more time at Barstibley. *Photograph by Bryce descendant Margaret Hobbs, 2017.*

Fig. 8. Conestoga wagon illustrated in *Pittsburgh in 1816* (Pittsburgh, PA: Carnegie Library, 1916).

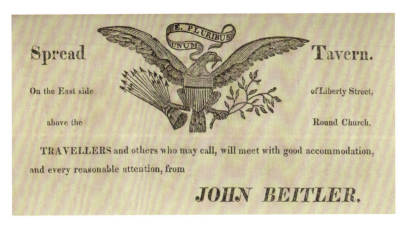

Fig. 9. Advertisement for John Beitler's Spread Eagle Tavern in J. M. Riddle and M. M. Murray, *The Pittsburgh Directory for 1819* (Pittsburgh, PA: Butler & Lambdin, 1819), 170. James and his family stayed at the Spread Eagle Tavern when they first arrived in Pittsburgh in 1820. *Courtesy of the Detre Library & Archives of the Senator John Heinz History Center, Pittsburgh, PA.*

river to Philadelphia, where they arrived on May 3, 1818, almost two months after they set sail.

In Philadelphia, James's father quickly found work with a marble cutter named John Guillen. However, over the next two years economic conditions worsened, so James's parents decided to move to Pittsburgh where family friends lived.

In 1820, the family traveled west over the Allegheny Mountains by Conestoga wagon rather than the more expensive stagecoach (fig. 8). They stopped at wayside inns to rest for the night. For seven-year-old James, the journey over the mountains was an adventure "long to be remembered in all its details." It made such an impression on James that forty years later he spent a vacation traveling portions of the same route and "it all came back to him as in a dream, marking the wonderful changes that less than half a century had accomplished."[6]

After a sixteen-day journey, they arrived in Pittsburgh at dusk on Halloween night. They stayed at John Beitler's Spread Eagle Tavern on the "east side of Liberty Street above the Round Church," between Seventh and Strawberry (fig. 9). The family eventually rented a log house on the property of Mr. Benjamin Bakewell at the corner of Fourth and Grant Streets in downtown Pittsburgh for three dollars a month.[7]

In 1820, the Borough of Pittsburgh had a population of about 9,000,[8] more than four times the size of the birthplace James had left behind. Pittsburgh was gritty and bustling and industrial—vastly different from the bucolic sheep farm in Scotland where he had begun his life's journey:

Fig. 10. *View of the Country round Pittsburg* (detail) in John Melish, *Travels in the United States of America in the years 1806 & 1807, and 1809, 1810 & 1811*, vol. 2, facing p. 54 (Philadelphia: printed for the author, 1812). 8 × 4¾ inches (20.3 × 12.1 cm). Two glass factories are identified on this map. The Glass Works across the Monongahela River from the "Pittsburg" point and below Coal Hill (now called Mt. Washington) is the O'Hara & Craig Glass Works founded in 1797, Pittsburgh's first glass factory. The Glass Works on the opposite side of the Monongahela River below Grant's Hill is Benjamin Bakewell & Company, founded in 1808.

The traveller who has glanced his eye over a map in search of this city, or who has formed an idea of its beauty from the accounts he has heard of its wealth and importance, is not a little disappointed when he enters it. The streets are narrow and the houses crowded together without uniformity. No splendid edifice rears its head to designate the dwelling of opulence, or to prove the existence of taste, and no public monument catches the eye of curiosity. Every object wears a black and sombre appearance. The concourse of waggons and drays that throng the streets, the clattering of hammers, the sounds of industry on every side, the cloud of smoke that pervades the air, and the busy faces of the inhabitants give it the appearance of a vast workshop.[9]

Business was even worse in Pittsburgh than in Philadelphia. It was not until August 1821, nearly a year after their arrival in Pittsburgh, that James's father and older brother William obtained steady work as laborers at Bakewell, Page & Bakewell, then the most successful flint glass factory in America (fig. 10).

Benjamin Bakewell was an Englishman who came to New York City in 1793 and established an import–export business that went bankrupt in 1808 after President Thomas

Fig. 11. William Coventry Wall (1810–1886) after a sketch by Mrs. E. C. Gibson. *View of the City of Pittsburgh in 1817. Taken from a sketch drawn by Mrs. E. C. Gibson, Wife of Jas. Gibson, Esq. of the Philad'a Bar, while on her Wedding Tour in 1817*, 1877. Chromolithograph. 12⅝ × 18¼ inches (32.1 × 46.4 cm). Printed by Pittsburgh Lithographing Co., published by Charles O. Lappe. The smokestack on the right along the Monongahela River is at the Bakewell factory.

Jefferson imposed an embargo prohibiting American ships from sailing to foreign ports. In the summer of 1808, Bakewell moved to Pittsburgh, purchased a glass works, and began producing blown glass under the name Bakewell & Ensell (fig. 11). Bakewell was the first glassware company in the United States to make clear flint glass successfully and it flourished under successive names for the next seventy-four years (fig. 12).[10]

In June 1823, when James was ten years old, he began training for his life's work as a glassmaker. He joined his father and brother as laborers at Bakewell and would spend the next seventeen years learning the glass trade from the best artisans in America at that time. When James began working at Bakewell, he was the "youngest boy about the place for about two years." He was paid $1.25 a week to do odd jobs about the factory. James recalled how proud he had been to bring his hard-earned dollar and a quarter home to his mother to help with the family expenses.

ENTERED ACCORDING TO ACT OF CONGRESS IN THE LIBRARIANS OFFICE AT WASHINGTON BY CHARLES O. LAPPE IN THE YEAR 1877. Lithographed by Pittsburgh Lith. Co.

VIEW OF THE CITY OF PITTSBURGH IN 1817.

Market conditions were sometimes uncertain and demand for Bakewell's products fluctuated, resulting in shutdowns and layoffs.

> Messrs. Bakewell, Page & Bakewell were not always in operation, as the trade was not always one of certainty in those days, and sometimes it would be difficult to find a market for their wares. A flatboat would be loaded with goods and run down the river, where its cargo would be traded at the various settlements for such articles as the people had for sale, which would be brought back to Pittsburgh and disposed of. Sometimes the wagons that had brought merchandise from Baltimore would be loaded with glassware on their return trips; but little was sent this way, as the freight charges were such that there was little or no money in it.[11]

Turnover in the glass factories was high. James was one of about fifty men and boys employed at Bakewell in 1823. Eleven years later, he was the only one of the fifty still working at the factory. By 1837, only four of the eight glassblowers he had known in 1823 were still alive.[12]

After two years, James began to gather glass and he described the trials and lessons learned from his experiences with the glassblowers:

I was there nearly two years before I began to gather [glass] and during that time I don't think ever [a] boy worked harder or tried more assiduously to please my blower, not from any mean or dishonest motive, I am sure, but because I knew it was my duty and I made it my pleasure also. I was but poorly rewarded for it. The harder I worked the more was expected of me and because I bore hardships and abuse without complaint, I was subjected to it more than any other. He never beat me because he could find no reasonable excuse to do so but he made me miserable by a continual system of petty annoyance and vexation: scolding and swearing at me for things in which I was not to blame, especially what was worst of all before the masters. All the rest I could bear patiently because the other men and boys in the factory knew his disposition and could see that he vented his ill nature on me because I was the only one on whom he dared. But to be misrepresented to my masters, abused for speaking the truth and ridiculed for being honest and trying to do to others as I wished to be done by was very hard to be borne.

After I left him he wished me to go back to work for him again. I refused, and from that time he became my bitter enemy using every means in his power to injure me and even, with forecasting malice trying to hinder me from learning my trade by falsehoods to the masters as well as by endeavouring to destroy what little confidence I had in myself, but let it pass. I had the satisfaction of knowing him thoroughly and despising him heartily.[13]

Tragedy struck the Bryce family in 1826. James's father became seriously ill as a result of processing lead at the Bakewell factory, and lead poisoning ultimately claimed his life on September 7, 1826. On the eve of his death, James's father asked Mr. Bakewell to apprentice James as a glassblower to help support his family. Mr. Bakewell agreed, and James began his training as an apprentice.[14]

With the death of James Sr., sons nineteen-year-old William and fourteen-year-old James were left to support the family, which included their mother Agnes and younger siblings Mary, Robert, and John. Calamity struck the family again in July 1827 when James's older brother William "went down the river" and was never seen or heard from again. That left James as the primary provider for his family, with help from his twelve-year-old sister Mary who made seventy-five cents a week as a domestic servant working "night and day . . . toiling on at the caprice of a mistress and no one near to speak a kind word to her."[15]

James was formally bound as an apprentice glassblower by a written indenture dated December 1, 1827 (fig. 13), which was to terminate almost six years later on November 5, 1833—the day James would turn twenty-one. James agreed "not [to] absent himself, day nor night, from his said masters service, without their leave; nor haunt ale-houses, taverns, or play-houses; but in all things behave himself as a faithful apprentice ought to do." In

return, the Bakewells agreed to "use the utmost of their endeavours to teach or cause to be taught or instructed, the said apprentice, in the art, trade, or mystery of a Glass Blower." The Bakewells also agreed to provide "sufficient meat, drink, clothing, lodging and washing, fit for an apprentice." If James conducted himself with propriety during the term of the apprenticeship, they agreed to give him a "new Suit of Clothing."

James's first responsibility was small work, which included "wines, goblets, creams, sugar bowls and etc." He was paid two dollars per week for boarding, forty dollars a year for clothing, and twelve dollars a year for shoes. By doing errands and working in the gardens he was able to earn extra to contribute to the three-dollar monthly rent on the log house where his family lived.

Between his work obligations as an apprentice at Bakewell and his family responsibilities as head of his household, James had little opportunity for formal education. At the age of sixteen or seventeen, James "became painfully aware of my ignorance and gladly joined with a club of my comrades in taking lessons from Mr. Thos. Will. We worked hard for all our school time was taken off our sleep or rest and we progressed rapidly until we unfortunately in order to acquire a more correct knowledge of English began the study of French Grammar and that put a period to our acquisition of book knowledge—but I always remember with a feeling of gratification this time of my life"[16]

While James was an apprentice, Bakewell was engaged to make the table crystal for President Andrew Jackson's White House in 1829. This was the second time Bakewell was honored with a presidential commission. In 1818 Bakewell had made the first American crystal table service for the White House during President Monroe's term.[17] It is not known whether any of James's pieces were among those delivered to President Jackson's White House, but James must have known of the prestigious commission.

Upon completing his apprenticeship as a glassblower in November 1833 at the age of twenty-one, James signed a Memorandum of Agreement to serve as a Castor Pot Servitor for Bakewell (fig. 14).[18] At that time, the company was doing business as Bakewells & Anderson. The term of the Castor Pot Agreement was three years and it provided that James

Fig. 13. Glassblower Apprenticeship Indenture between James Bryce and Bakewell, Page & Bakewells, dated December 1, 1827. The original has been lost, but a copy is in the Senator John Heinz History Center, Pittsburgh, PA.

Visit from the Marquis de Lafayette

The American Revolutionary War hero, French aristocrat and military officer Gilbert du Motier, Marquis de Lafayette, visited Pittsburgh in 1825 and toured the Bakewell factory, where he was presented with two blown vases of cut glass, one engraved with a view of Lafayette's Château de la Grange-Bléneau in France and the other with an American eagle. James was working at the Bakewell factory at that time and surely would have been aware of the visit from the famous guest.

THIS INDENTURE Witnesseth,

THAT *James Bryce* by and with the consent of his *Guardians* as testified by *his* signing as a witness hereunto, hath put himself, and by these presents doth voluntarily, and of his own free will and accord, put himself as an apprentice to *Bakewell Page & Bakewells* to learn *the* art, trade and mystery, and after the manner of an apprentice, to serve *them* from the day of the date hereof, ~~for and during the full end and term of~~ *until the fifth November Eighteen hundred & thirty three* next ensuing. During all which term, the apprentice, his said master*s* faithfully shall serve, *their* secrets keep, ~~his~~ lawful *their* commands every where gladly obey. He shall do no damage to his said master*s* nor see it done by others, without letting, or giving notice thereof to his said master*s* He shall not waste his said master*s* goods, nor lend them unlawfully to any. With his own goods, nor the goods of others, without license from his said master he shall neither buy nor sell. He shall not absent himself, day nor night, from his said master*s* service, without *their* ~~his~~ leave; nor haunt ale-houses, taverns, or play-houses; but in all things behave himself as a faithful apprentice ought to do, during the said term. And the said master*s* shall use the utmost of *their* endeavours to teach, or cause to be taught or instructed, the said apprentice, in the art, trade, or mystery of a *Glass Blower* and procure for him sufficient meat, drink, *Clothing* lodging and washing, fit for an apprentice, during the said term of *years & at the Expiration thereof if he conduct himself with propriety, during the said term they shall give him a new Suit of Clothes* —

And for the performance of all and singular, the covenants and agreements aforesaid, the said parties bind themselves each unto the other, firmly by these presents. **In Witness** whereof, the said parties have hereunto set their hands and seals.—Dated the *first* day of *December* in the year of our Lord One Thousand Eight Hundred and *twenty seven*

Sealed and Delivered } *Benj. Bakewell for himself & B. Page*
in presence of *Thos Bakewell & P B Bakewell*
M B Lowrie *Edmund Steelman*
yand
James Bryce

ALLEGHENY COUNTY, ss.

THE above done and acknowledged before me, a justice of the peace in and for said county, the day and year above written.

M B Lowrie

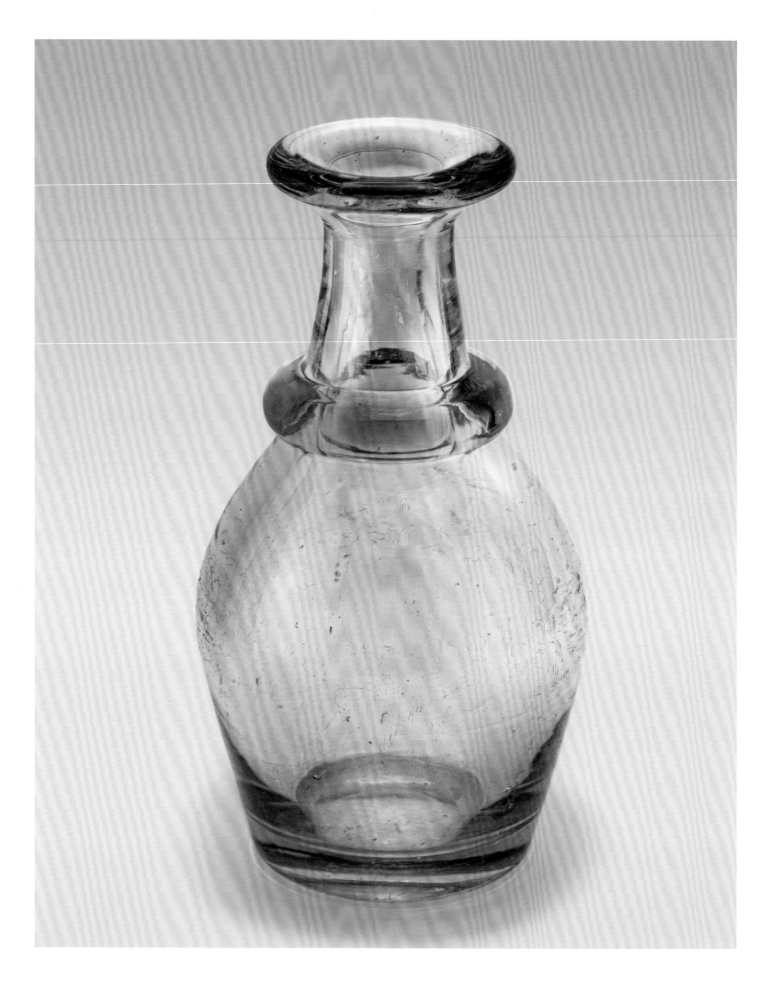

Fig. 14. Decanter, ca. 1830. 9¼ × 5⅛ inches (23.5 × 13 cm). Family history attributes this heavy, blown, flint-glass decanter to James during his apprenticeship as a glassblower at Bakewell. It may have been his Masterpiece, a work produced by an apprentice to demonstrate competence to become a master craftsman.

would be paid for every move of merchantable work at the rate of thirty cents the first year, thirty-five cents the second year, and forty cents the third year. A "move" was generally the number of articles made in a six-hour period, but in this case the agreement specified the number of each article that would constitute a move.

The castor-hole pot was dedicated to the production of large goods and was manned by a team consisting of a workman, servitor, footmaker, and boy. "Tall or muscular men are employed in this department; as occasionally, goods of thirty or forty pounds weight of Glass will require great power to work into form, the leverage of the blowing iron giving additional weight to the article under manufacture."[19] Before this three-year agreement ended, James was promoted to finisher with a considerable advance in wages.[20]

The late 1830s were a time of economic and political upheaval. The Panic of 1837 was a financial crisis in the United States that triggered a major depression that lasted until the mid-1840s. Banks closed, businesses failed, and unemployment was high. Bakewell glassworks suspended operations for two months in 1837 and James's wages were reduced 12 percent. The following year Bakewell closed for four months.

James had a growing family to support. In 1835, the day after his twenty-third birthday, he married Elizabeth Haugh, who had emigrated from Scotland with her family and settled in Pittsburgh (figs. 16–17). Their first child, John Phillips, was born in 1836, followed by

First Pressed Glass Made in Pittsburgh

In later life, James recalled that while at Bakewell he made the first article of pressed glass tableware in Pittsburgh. The story was reported in the *Crockery & Glass Journal* (July 8, 1880, 19):

The *Commercial Gazette* published an account during the week of the first pressed ware made in this country, giving the honor of making the press to a farmer of Sandwich, Mass., in the year 1827. Your correspondent had a conversation with Mr. James Bryce, of the firm of Bryce, Walker & Co., upon the subject of the history of pressed ware, and from him ascertained the very interesting fact that he had pressed the first piece of ware produced in

Pittsburgh. He thinks the article turned out was a plate, and holds that the mode of pressing was not a credit to the ingenuity of those in the trade. The lever of the press was made of wood, and when it was brought down, two boys standing nearby on a box jumped upon it to complete the job. Things have changed considerably since then, and Mr. Bryce could not see that there was anything in the incident worth publishing. The pressing was done in Bakewell's old glass-house, where Mr. Bryce was employed as a boy.

Bakewell was issued the first American patent for pressed glass in 1825.

daughter Mary in 1838. In 1839 James had built two houses near Fifth Avenue in downtown Pittsburgh, one for his mother and one for his family. He owed money on both houses, which contributed to his financial difficulties. With Bakewell's frequent shutdowns, James needed to find a more dependable source of income.

By January 1840, James said that "times could not be worse." A few months later he decided "to leave off Glassblowing and try merchandizing, an error of judgment dearly atoned for by the experiences of the next four years."[21] During his first years of shopkeeping, James lamented that he did not make one dollar:

> For in the two years I have kept store we have not made one dollar but rather sunk money—however circumstances as they are we must continue another year at the business and then I hope to change, if not to a more profitable at least a more congenial way of earning a living, that is to farming if I do not succeed in procuring work at Glass blowing which I hardly expect.[22]

In February 1845, James finally found the opportunity he wanted. He was delighted to give up shopkeeping and return to "what I was trained for and gloried in, a working mechanic."[23] James and his brother Robert began working as glassblowers for Mulvany & Ledlie at its Birmingham Flint Glass Works across the Monongahela River from Pittsburgh. James moved his family to East Birmingham to be closer to the factory.

Shortly after starting work at Mulvany & Ledlie, James witnessed a "terrible . . . overwhelming calamity which befell our city on Thursday, April 10, 1845."[24] The Great Fire of 1845 was one of the worst disasters ever to hit the city of Pittsburgh. It destroyed about

Fig. 15. William Coventry Wall (1810–1886). *Pittsburgh after the Fire from Birmingham*, 1845. Oil on canvas mounted on pulpboard. 8⅝ × 27½ inches (21.9 × 69.9 cm). The burned-out glassworks of Bakewell with its furnace exposed and chimney standing is to the right of the steamboat. The pilings were all that remained of a wooden bridge over the Monongahela River. *Carnegie Museum of Art, Pittsburgh: Bequest of Mary O'Hara Darlington (25.15.3).*

one-third of the city but miraculously there was little loss of life, likely because the fire started around noon and people had an opportunity to escape the flames.

The conflagration began when a residential outdoor fire for heating wash water was left unattended and a spark ignited the roof of a nearby ice shed on the corner of Second and Ferry Streets. The weather was extremely dry with high winds that rapidly spread the flames, so that "the very air seemed to be on fire."[25]

James was an eyewitness to the devastation: "I have seen many accounts of the fire since, but all alike fail to convey any adequate idea of the horrible tempest which has laid nearly 60 acres of our city in smoking ruins. . . . At 4 o'clock, from the Monongahela to 4th St. was an ocean of flame and still pressing on with a roar like that of a tornado in the

Figs. 16–17. Martin B. Leisser (1845–1940). Portraits of James Bryce (1812–1893) and his wife Elizabeth Haugh Bryce (1815–1888), ca. 1899. Oil on canvas. Each 23½ × 19½ inches (59.7 × 49.5 cm). James and Elizabeth had seven sons and four daughters born between 1836 and 1858. James outlived his wife and all his children except four sons who followed him into the family glass business. *Courtesy of Bryce descendants Norah Molnar (fig. 16) and Andrea Howells (fig. 17); fig. 17 photograph by Mike Jensen.*

woods."[26] James watched as the Bakewell glassworks where he had spent seventeen years learning his trade was consumed by flames (fig. 15).

> The burning of Mr. Bakewell's glass works was a splendid and to me affecting scene in the drama of the great conflagration, this oldest and most extensive establishment in the west or perhaps in the union with the accumulation of 36 years of successful enterprise was swept by the desolating flame to the lowest foundation of all the buildings connected with the manufactory and covering the square bounded by Water, Grant and Ross Streets and the river where 17 of the best and happiest years of my life were spent, familiar to me as my own home. The furnaces only with one cellar room under the old blowing house remain.[27]

Many people tried to save personal possessions by placing them onto the wooden bridges over the rivers, but that only fueled the flames. James watched as fire consumed the wooden bridge over the Monongahela River and sent it crashing into the water below in just twelve minutes from start to finish.[28]

Five years later, with more than twenty-two years of glassmaking experience, thirty-eight-year-old James was ready to embark on the next step in his glassmaking career:

> I was considerably in debt as a result of my unfitness for Storekeeping but after removing over the river we were favored with health and temporal prosperity so that in 1850 with my brothers and twelve other individuals under the firm name of Bryce, McKee & Co. we began manufacturing glass ware.[29]

NOTES

1. Historical and biographical information in this chapter is taken from James Bryce's journals unless otherwise noted. James Bryce, journal, vol. 1, Aug. 1, 1834–June 3, 1840; vol. 2, Sept. 7, 1840–May 30, 1876, original in private collection, copy in the Detre Library & Archives of the Senator John Heinz History Center, Pittsburgh, PA.
2. Robert Chambers and William Chambers, *The Gazetteer of Scotland Vol. II* (Glasgow: Blackie & Son, 1838), 664–68. American Revolutionary war hero and naval commander John Paul Jones was born in Kirkcudbright in 1747.
3. Bryce, journal, 2:193.
4. Bryce, journal, 1:23.
5. Bryce, journal, 1:23–25.
6. William W. Williams, ed., *Magazine of Western History, vol. 3, November,* 1885–April, 1886 (Cleveland, OH: Magazine of Western History Co. Publishers, 1886), 381.
7. Bryce, journal, 2:194; Obituary of Robert D. Bryce, *China, Glass, and Lamps,* Feb. 10, 1906.
8. J. M. Riddle and M. M. Murray, *The Pittsburgh Directory for 1819* (Pittsburgh, PA: Butler & Lambdin, 1819), 17.
9. Riddle and Murray, *Pittsburgh Directory for 1819,* 13.
10. Lowell Innes, *Pittsburgh Glass 1797–1891* (Boston: Houghton Mifflin, 1976), 28.
11. Williams, *Western History,* 381.
12. Bryce, journal, 1:26, 161.
13. Bryce, journal, 1:27.
14. Bryce, journal, 1:30. In his journal, James gives the date of his formal indenture as Nov. 9, 1827, but the indenture is dated Dec. 1, 1827.
15. Bryce, journal, 1:29–30, 2:194.

Mary died in 1834 at the age of nineteen after a brief illness, leaving a lonely and despondent James to care for his family. Bryce, journal, 1:11.
16. Bryce, journal, 2:195.
17. Jane Shadel Spillman, *White House Glassware, Two Centuries of Presidential Entertaining* (Washington, DC: White House Historical Association, 1989), 26–27.
18. A copy of the agreement is in the Detre Library & Archives of the Senator John Heinz History Center, Pittsburgh, PA.
19. Apsley Pellatt, *Curiosities of Glass Making: With Details of the Processes and Productions of Ancient and Modern Ornamental Glass Manufacture* (London: David Bogue, 1849), 88.
20. The Welkers describe a finisher as "The man who controls the finishing touches on a piece of glass as it is taken from the mold. This function includes crimping an edge, straightening a foot or stem, forming a lip on a jug, etc." John Welker and Elizabeth Welker, *Pressed Glass in America: Encyclopedia of the First Hundred Years, 1825 to 1925* (Ivyland, PA: Antique Acres Press, 1985), 476.
21. Bryce, journal, 2:81, 196.
22. Bryce, journal, 2:42.
23. Bryce, journal, 2:81.
24. Bryce, journal, 2:82–83.
25. Bryce, journal, 2:84.
26. Bryce, journal, 2:84.
27. Bryce, journal, 2:85–87.
28. Bryce, journal, 2:85–87.
29. Bryce, journal, 2:196–97.

Company
History

Bryce, McKee & Company
1850 to 1854

IN ARTICLES OF ASSOCIATION DATED May 11, 1850, James, his brothers Robert and John, and twelve others formed a co-operative partnership for the manufacture of glass doing business as Bryce, McKee & Company.[1] Most were experienced glassworkers. City directories[2] identified six as glass blowers: James Bryce, John Bryce, James Reddick, Joseph Doyle, John A. H. Carson, and Samuel Charters. Frederick McKee and W. T. Hartley were listed as glass manufacturers and Robert D. Bryce was listed as a glass presser and manufacturer. Peter W. Reid was a glass mold maker and Thomas Adams a glass cutter. Three grocers rounded out the list: Edward Hazelton, John Floyd, and Richard Floyd, who was also a director of Farmers Deposit Bank. Matthew Siebler's occupation is unknown.

The firm was capitalized initially with $8,400. James Bryce and Frederick McKee each contributed $1,000 for twenty shares apiece with the remaining thirteen partners contributing $250 to $800 each. The fledgling firm quickly required additional capital, and on September 20, 1850, the Articles of Association were amended to increase the total capital contribution by $1,850. Frederick McKee became the majority shareholder with forty-two shares, followed by James Bryce and Thomas Adams with twenty shares each, and the remaining partners with ten or eleven shares each.

Bryce, McKee built a factory at the corner of Wharton and Twenty-First (also known as Railroad) Streets in the Borough of East Birmingham, which in 1872 became Pittsburgh's South Side. The partners had purchased the land on May 1, 1850, from Oliver Ormsby and his wife for $4,320. When the factory was built it was surrounded by "the original forest."[3] The offices and showroom were located in a four-story brick warehouse at 41 Wood Street

Fig. 18. Strawberry finial with a pierced, curled stem on an opaque white Strawberry sugar bowl, a naturalistic design patented by John Bryce in 1870 (detail, cat. 19.2).

across the river in downtown Pittsburgh.[4] The firm "employed a single drayman and one horse and this was the only method of transportation between the factory [in East Birmingham] and the warehouse in Pittsburg, the route via the Twelfth Street ferryboat to the Monongahela wharf, between Grant and Smithfield Streets. But this one dray was sufficient for freighting both ways for a long while" (fig. 19).[5]

James managed the factory while the business department was under the care of Frederick McKee.[6] The Bryce, McKee glassworks primarily produced tableware, and it also made pearl and crystal lamps, perfume bottles, apothecary ware, and other flint-glass pieces.

The new partnership struggled:

The first year was one of intense anxiety and toil but resulted in giving us a foothold in the trade. The first year July 1851 two of our partners sold out and in the following years one after another followed the example until in 1865 there were left of the original fifteen partners only three, the Bryce Bros. In 1854 the McKee Bros. sold out to Joseph Richards and the firm name was changed to Bryce, Richards & Co.[7]

Fig. 19. Stationery letterhead hand-dated October 28, 1852, with an unsigned engraved view of Pittsburgh. Sheet 11 × 8¾ inches (27.9 × 22.2 cm). The steamboats *Packet Brilliant* on the right and *Packet Messenger No. 2* on the left were both part of the Pittsburgh & Cincinnati Packet line. Showman P. T. Barnum and Swedish opera star Jenny Lind, known as the "Swedish Nightingale," rode the *Messenger 2* in a steamboat race down the Ohio River in an 1851 publicity stunt.

Pittsburgh October 28 1852

Fig. 20. Iron glass-pressing mold with cordial. 3 × 1½ inches (7.6 × 3.8 cm). Bryce production in Pittsburgh consisted primarily of pressing glass into molds such as the one pictured here. This mold is labeled "#4947 Cordial," which was the designation assigned by U.S. Glass for 3-inch, half-ounce cordials in this pattern, which is sometimes called "Zig Zag." The cordial is illustrated in the "Factory B" (Bryce Brothers) section of the United States Glass Company composite catalogue (Jan. 1892), as "126. Cordial Wine & Goblet." The cordial pictured here was pressed at the Pittsburgh Glass Center in 2017 using this mold. It is indistinguishable from its nineteenth-century counterpart. *Mold courtesy of Jane Langol.*

Brothers Frederick and James McKee[8] then formed the glassware company F. & J. McKee, which later became the successful McKee & Brothers glass company. Other partners who learned the glass business from James started successful glassware companies of their own, including such well-known firms as Richards & Hartley; Bryce, Higbee & Co.; and Doyle & Co.

There are no known primary or secondary sources that document Bryce, McKee production during its four years of operation. It is likely its successor, Bryce, Richards & Company, used the same molds and produced the same patterns as Bryce, McKee, at least for some period of time. Molds were expensive and each full line pattern would have required thirty or more (fig. 20). If the patterns remained popular there would be no reason for a struggling new venture to discontinue a pattern and incur the expense of new molds solely because of a change in ownership interests.

Bryce, Richards
& Company
1854 to 1865

WHEN THE MCKEES SOLD THEIR interest in Bryce, McKee in 1854, Joseph Richards became an investor and partner, replacing Frederick McKee as manager of the business department.[9] The firm began doing business as Bryce, Richards & Company. James Bryce and his brothers Robert and John remained with the firm.[10] At least three other partners from Bryce, McKee continued with the new company, presumably retaining their status as partners in the business. The 1858–59 Pittsburgh city directory lists William T. Hartley as a glass manufacturer, John A. H. Carson as a glassblower, and Thomas Adams as a glass cutter, all associated with Bryce, Richards.[11]

James's oldest son, John P. Bryce, was the first son to follow him into the glass business. He is listed in Pittsburgh city directories as a "mould maker" at Bryce, Richards from 1859 to 1863. He died in 1864 after a brief illness. A second son, Andrew H. Bryce, joined the company as a clerk in 1862. He remained with the Bryce companies and went on to become president of Bryce Brothers Company in Mount Pleasant, Pennsylvania, until his death in 1909, a glassmaking career of more than forty-five years. Another son, David K. Bryce, joined the company as a bookkeeper about 1864 and remained with the company until his death in 1885 from typhoid fever.

Bryce, Richards maintained its downtown warehouse and sales office at 41 Wood Street, and it continued to operate the factory at Wharton and Twenty-First Streets in East Birmingham. In 1861, it operated eighteen pots and employed seventy-five hands.[12] Bryce, Richards was recognized for the brilliance and quality of its glassware. The Pennsylvania State Agricultural Society awarded the company a diploma and monetary prize for the best

Fig. 21. Finial on a Bryce, Walker No. 80 butter, 1880 (detail, cat. 46.2).

display of flint glassware at its 1858 exhibition in Pittsburgh.[13] Bryce, Richards also exhibited at the 1858 Franklin Institute of Philadelphia's Exhibition of American Manufactures and won a First Class Premium award for its pressed and cut glassware, described as follows:

This collection is large and highly meritorious. The pressed glass is equal in brilliancy and finish to any heretofore on exhibition; and is finished at ten to twenty per cent. less price than from other sources. The cutting is good and the engraving equal to the French and German ordinarily found on sale. The deposit, large as it is, is a fair sample of what is furnished on regular orders.[14]

In April 1862, James and his family moved to a house at the corner of Sidney and Twenty-First Streets, next to the factory in East Birmingham.[15] James would reside there for the rest of his life.

An important innovation in glassmaking occurred in 1864 that enabled the glass industry to flourish. William Leighton, Sr., of Wheeling, West Virginia, developed a formula for producing high-quality glass using soda lime instead of lead, which greatly reduced production costs. The ingredients used were less expensive than those used to produce lead glass, and the glass cooled faster so workers could press it quicker. The *Crockery & Glass Journal* noted how by 1880 lime glass had surpassed flint in popularity:

Samples of the flint glass made by Bakewell, Pears & Co., nearly 30 years ago, can still be seen. There is enough glass in the ware to make two or three articles of similar size in lime glass now. Flint glass is not made now because of the remarkable difference in the cost of producing, the manufacturers having discovered several years ago that consumers are quite satisfied with lime glass because of its cheapness as well as beauty of design and finish.[16]

Examples of Bryce's earliest glassware made with lead can still be found. Flint glass produced using lead can be distinguished from soda lime glass by its distinctive bell-like ring when the glass is tapped.

Bryce, Richards dissolved in 1865 when Joseph Richards, John A. H. Carson, and William T. Hartley sold their interests to the partnership of W. & H. Walker and started their own glassware company under the name Richards & Hartley. That company operated from 1865 until 1891, when it became part of U.S. Glass Company. In a notice of dissolution published in the *Daily Pittsburgh Gazette* on August 31, 1865, the former partners endorsed the new company: "we take pleasure in recommending to our former patrons and the public in general our successors, Bryce, Walker & Co."[17]

A Bryce, Richards catalogue has not been located, although there is an extant page illustrating seven Bryce, Richards patterns that appears to be an authentic period document (fig. 24). It was found in the J. Stanley Brothers research files at the Corning Museum

Fig. 22. Tulip butter base, interior, ca. 1854 (cat. 4.2).

Fig. 23. Tulip with Sawtooth butter base, interior, ca. 1854 (cat. 4.1).

of Glass, Corning, New York, in a file marked "Bryce Brothers Company, Mt. Pleasant" without any identifying information other than the penciled date "ca 1854" written at the bottom by an unknown annotator. In *American Pressed Glass and Figural Bottles*, Albert Christian Revi published a cropped version of this page and identified it as one page from a Bryce, Richards catalogue of circa 1854.

The patterns illustrated on the page, from left to right, are: (top row) Tulip with Sawtooth and Ashburton; (middle row) Tulip and Harp; (bottom row) Excelsior, Tulip, Sawtooth, Sawtooth, and Huber. The original manufacturer's names for these patterns are not recorded on the page.

This document may be a catalogue page or it may be an in-progress layout of a catalogue page. The images of the Tulip butter in the second row and the Sawtooth footed covered bowl in the bottom row were cut from a different page and pasted onto this page. There is a horizontal line to the right of the Harp butter, suggesting that another image was to be pasted there. A similar line can be seen under the pasted Tulip butter.

Tulip, Tulip with Sawtooth, and Sawtooth were among the earliest and most popular patterns produced by Bryce, Richards and were probably made as early as 1850 by Bryce, McKee (figs. 22–23, 25). They were still being sold by Bryce Brothers forty years later and are illustrated in the U.S. Glass Factory B Catalogue, where Sawtooth is labeled the Diamond pattern.

Revi identified one of the butter dishes illustrated on the page as the Harp pattern, but the stringed instrument depicted is not a harp—it is a lyre. The so-called Harp pattern

Fig. 24. Page with Bryce, Richards & Co. patterns, ca. 1854. 5½ × 4 inches (14 × 10.2 cm). Images of the Tulip butter in the second row and the Sawtooth footed covered bowl in the bottom row were cut out of a different page and pasted onto this one. The handwritten pencil notation "ca 1854" was added by an unknown annotator. *Courtesy of the Rakow Research Library, Corning Museum of Glass, Corning, NY, www.cmog.org.*

does not appear on any of the known pages of the Factory B Catalogue. McKee & Brother, whose principals Frederick and James worked at Bryce, McKee from 1850 to 1854, also made a pattern called Harp that depicts a lyre, illustrated in the McKee & Brother catalogue of 1859–60. Both the Bryce and McKee Harp patterns depict lyres and arches in alternating panels, but the Bryce lyre has a slightly different shape and three strings instead of four. McKee Harp spoon holders, lamps, and salts have been found, but Harp pieces that can be attributed conclusively to Bryce, Richards based on this page have not yet been identified.

Ashburton, Excelsior, and Huber are not illustrated in the Factory B Catalogue, although that catalogue is not complete and it is possible they were illustrated on pages that have not yet been found. All three patterns, along with Sawtooth, were made by multiple manufacturers.

Fig. 25. Tulip butters, one with Sawtooth, ca. 1854 (cat. 4). Both are illustrated on the Bryce, Richards page (see fig. 24).

Bryce, Walker & Company

1865 to 1882

THE PARTNERSHIP OF BRYCE, WALKER & COMPANY succeeded Bryce, Richards in 1865 and consisted of James and his brothers Robert and John; two Floyd brothers, John (who had also been a partner in Bryce, McKee) and William; and the partnership of W. & H. Walker. The Articles of Agreement dated August 15, 1865, provided for $119,000 in capital in the following proportions: W. & H. Walker, partnership (30 shares); James Bryce (26 shares); John Floyd (16.5 shares); William Floyd (16.5 shares); John Bryce (16 shares); and Robert D. Bryce (14 shares).[18]

W. & H. Walker was a partnership organized in 1837 by William Walker and his brother Hay Walker who were chandlers manufacturing soap and candles.[19] In November 1865, William Walker left the W. & H. partnership and Hay Walker released his ownership interest in Bryce, Walker so that William remained the only Walker with an interest in the glass company. Walker was known as a man of substantial wealth and great financial ability who may have provided needed capital and valuable business experience that enabled the company to grow during the 1870s.[20]

James's son Robert joined the firm as a clerk in 1868, followed by sons Donald, Allan, and Frank in 1877. Andrew and Frank were in charge of the general offices while Donald, David, and Allan managed the works. By that time, James and his brother Robert had turned day-to-day operations of the business over to the next generation and acted in an advisory capacity.[21]

Bryce, Walker was highly regarded in the glass business: "No more affable gentlemen can be found in the business, and their quiet way of doing things reminds one of the firm

Fig. 26. Crown finial on a Diamond Sunburst high-footed covered bowl, a geometric design patented by John Bryce in 1874 (detail, cat. 25).

of whom it is said that they had made half their fortune by 'minding their own business, and the other half by letting other people's alone.'"[22]

By 1870, glass was the most important industry in Pittsburgh. It employed more than 4,000 hands with an annual payroll of almost $2.5 million. Its twenty-one bottle factories produced 70 million bottles a year, its twenty-three window glass factories produced 600,000 boxes of glass, and its twenty-five flint and lime glass factories produced 12,000 tons of merchantable ware and 2,500 tons of the finest glassware in the country, worth a total of almost $7 million, nearly half the value of all glass being made in America at that time.[23]

Bryce, Walker operated its sales office and showroom at 41 Wood Street until 1870 (figs. 28, 30), when it moved to a three-story warehouse at 95 Water Street, extending through to 122 First Avenue in downtown Pittsburgh.[24] Nine years later, the company moved its offices and its sample and sales rooms across the Monongahela River to Twenty-First Street on Pittsburgh's South Side, next to the company's factory. The factory and offices were connected by a bridge over Wharton Street. The works were connected with the city jobbing houses by the new innovation of the telephone, which was generating much excitement: "Bryce, Walker & Co. expect to be connected with the city by telephone next week. The wonderful boom in the telephone business has almost overwhelmed the company, and

they, too, are behind in their work."[25] At that time, nearly all the glass manufacturers were moving their offices and sample rooms to the South Side near their factories.[26]

Bryce, Walker's extensive new warehouse sheds resembled a "mammoth wharf boat."[27] The buildings were fitted out in superb style and pronounced the finest in western Pennsylvania:

> Bryce, Walker & Co. have taken possession of their new office, sample and warerooms on 21st Street, half a square from their factory and but two squares from the new upper freight depot of the Pittsburgh & Lake Erie Railroad. Their new quarters are as handsome and comfortable as need be, everything being arranged with an eye to convenience. The office is very tastefully fitted up and furnished, and the floor covered with a bright Brussels carpet, that of the outer office and the sample room with linoleum. The former is in size 30 by 30 feet, the latter 30 by 33 feet. All are well lighted and airy. There are coat and washrooms, closets, etc. A telephone connects the office and Factory. The new storage and shipping sheds in the rear of this building have also been occupied. They are 150 feet long, 120 feet deep and 31 feet wide, extending continuously around the large lot except at the gateway for wagons. The storage capacity is 13,000 packages. The sheds are well built and covered with felt.[28]

Bryce, Walker continued to operate its factory at Wharton and Twenty-First Streets on Pittsburgh's South Side, where it manufactured table, lamp, perfumery, flint, pearl, and crystal glassware (fig. 33).[29]

A portion of the 1882 G. M. Hopkins map of the South Side (fig. 29) shows Twenty-First Street (where the railroad tracks were) between Sidney and Water Streets. James Bryce is identified as the owner of a large parcel at the intersection of Twenty-First and Sidney, where he built his personal residence. North of James's property, closer to the river, are three blocks stretching from Fox Alley to Clifton Street identified as "Glass Works Bryce, Walker & Co."

Fig. 28. Bryce, Walker & Co. letterhead detail, hand-dated June 17, 1869. Sheet 9 × 5⅝ inches (22.9 x14.3 cm). The letterhead has the same office address as the Bryce, Walker & Co. trade card (see fig. 30).

The earlier 1872 G. M. Hopkins map shows a second Bryce, Walker glassworks several blocks away along the Monongahela River north of Neville Street, between Perry and Harmony Streets. Bryce, Walker probably leased that location, which was the site of the former Birmingham Flint Glass Works operated by Mulvany & Ledlie, where James and Robert had worked from 1845 to 1850. Patrick Mulvany founded the Birmingham Flint Glass Works around 1832, and after his death in 1854 it was advertised as available to rent.[30] By 1882, Bryce, Walker was no longer operating at that location and the 1882 Hopkins map identifies the factory as "Mulvaney Hrs. [Heirs] Glass Works." A trade card pictures the Birmingham Flint Glass Works below the name Bryce, Walker & Co. with an office address of 41 Wood Street (fig. 30). This trade card was made between 1865, when Bryce, Walker was formed, and 1870, when it changed office locations. It is not known why Bryce, Walker pictured the Birmingham Flint Glass Works on its trade card rather than its primary Wharton Street glassworks.

Fig. 29. G. M. Hopkins & Co., *Pittsburgh Map*, 1882, Plate 24, Wards 25 and 26 (detail), showing the corner of Wharton and Twenty-First Streets. Brick or stone buildings are in pink and wooden frame buildings are in yellow. *Courtesy of the Detre Library & Archives of the Senator John Heinz History Center, Pittsburgh, PA.*

In 1876, George Thurston described the Bryce, Walker facility as encompassing three furnaces with thirty-one pots.[31] That made Bryce, Walker the second largest of the twenty-four table glassware factories in Pittsburgh recorded by Thurston, with the next largest running twenty-one pots. The largest was McKee Brothers, Bryce, McKee's former partners, with forty pots. The same year, Bryce, Walker exhibited glassware at the 1876 Centennial Exposition in Philadelphia.[32]

By 1877, Bryce, Walker employed 104 men and sixty-four boys, including two foremen, twenty-four blowers, eighteen gatherers, fourteen packers, fourteen laborers, ten packing room boys, six mold makers, six mold cleaners, five batch mixers, four glass cutters, three assistant teasers, and two drivers.[33]

The company was known in all the commercial marts of the world and by 1878 its products were shipped around the globe: "Bryce, Walker & Co., manufacturers of tableware, lamps and perfumery, have a regular trade with London and Glasgow, and received a large order recently from Japan. They are constantly putting up packages for the South American and West Indian trade."[34]

Fig. 30. Bryce, Walker & Co. trade card issued between 1865 and 1870. 1¹⁵⁄₁₆ × 3⅛ inches (4.9 × 7.9 cm). Bryce Brothers Company and Lenox, Inc., Records, MSS 800. *Detre Library & Archives of the Senator John Heinz History Center, Pittsburgh, PA; photograph restored by Mark Johnson.*

Fig. 31. John Bryce (1824–1888). *Courtesy of Paul Kirk, Jr.*

James Bryce's brother John was an extraordinarily talented designer responsible for Bryce, Walker's designs of the 1870s (fig. 31). One of his earliest innovations was to introduce naturalistic glassware patterns, and Bryce, Walker became known as one of the first companies to manufacture naturalistic patterns on a large scale.[35] John Bryce patented four naturalistic designs between 1869 and 1872: Grape Band, Curled Leaf, Strawberry, and Thistle. All were used on a variety of tableware including table sets, goblets, bowls, lamps, berry sets, and pickle dishes. Three-dimensional strawberries and thistle blossoms were used as finials on covered pieces in those patterns. A few years later, John Bryce patented two geometric designs, Diamond Sunburst and Maltese (aka Jacob's Ladder, Imperial). Diamond Sunburst finials were shaped like a crown and Maltese finials like a Maltese Cross (fig. 27). In 1879, John Bryce and his son Charles withdrew from Bryce, Walker to start their own successful glassware company, Bryce, Higbee & Company, which rose to prominence in the late nineteenth century.

Bryce, Walker advertised that it produced pearl or opal (pronounced oh-PAL) ware. Both terms were used by nineteenth-century glassmakers to refer to opaque white glass, which some collectors today call milk glass. Opaque white glass was made in Europe as early as the sixteenth century. It became popular in Pittsburgh in the 1870s and was made by several Pittsburgh glass companies including Bryce, Walker; Atterbury & Company;

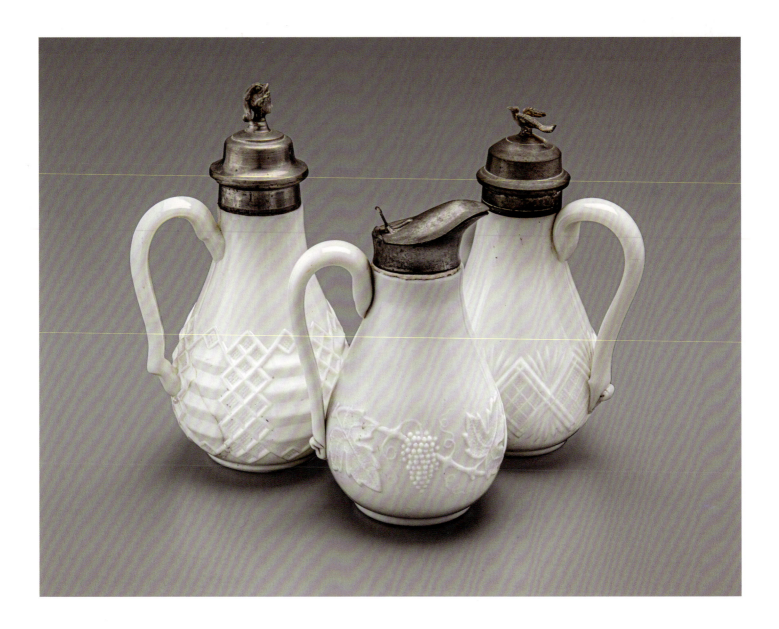

Bakewell, Pears & Co.; and McKee & Brothers. Bryce, Walker made some of its earliest patterns in opaque white glass, including Tulip, Grape Band, Strawberry, Palmette, Filley, Birch Leaf, Sunken Icicle, Diamond Sunburst, Maltese, and Swiss (fig. 32).

Alongside tableware, lamps were an important part of Bryce, Walker's business, and by late 1880 it was shipping the largest consignments of lamps in the history of the company.[36] It sometimes stepped outside its usual product lines, however. One of the commissions it received in 1880 was to fabricate telescope disks for John Alfred Brashear (1840–1920), a former Pittsburgh millworker turned astronomer who became the most skillful and famous maker of fine telescopic lenses in the world. He was considered one of the greatest scientists of his time, also known for constructing precision instruments, lenses, reflectors, and plates for spectroscopes. The disks he designed and Bryce, Walker produced were 10 inches in diameter and weighed more than 10 pounds each.[37] There is also an intriguing reference in one trade journal to Bryce, Walker producing glass tobacco fly traps for southern tobacco growers:

Fig. 32. Maltese (1876), Grape Band (1869), and Diamond Sunburst (1874) opaque white syrups, all designs patented by John Bryce (cat. 34).

Among the novel uses to which glass has been put the following may be cited as an example: Bryce, Walker & Co. are now making for a Southern tobacco grower large numbers of a white glass imitation of a flower which is to be used as a trap to catch the tobacco fly. It looks very much like a miniature smoke bell, and the bottom having been covered with a poisonous mixture it is suspended among the tobacco plants. The unsuspecting fly, supposing it to be the real flower, crawls in and imbibes some of the artificial honey, which is the means of its final destruction. The firm expects to make this blossom in large quantities.[38]

William Walker became incapacitated and eventually withdrew from the partnership on June 13, 1882.[39] James, Robert, Andrew, and David Bryce purchased Walker's interest and associated in partnership with James's sons Donald, Allan, and Frank, grandson Marion, and nephew Edwin Bryce under the name Bryce Brothers. Operations continued at the same locations.[40]

There are no known catalogues published by Bryce, Walker, but there are several patents that document Bryce, Walker patterns, including John Bryce's Grape Band (1869), Curled Leaf (1869), Strawberry (1870), Thistle (1872), Diamond Sunburst (1874), and Maltese (1876). Henry J. Smith patented an Ambidextrous cream pitcher (1881) and assigned the patent to Bryce, Walker (fig. 62).

Period trade journals that reported on the glass companies, their products, and the latest trends provide valuable information for identifying and dating Bryce, Walker patterns. Period trade journals reference the following Bryce, Walker patterns by name: No. 79 aka Chain with Star (1879), No. 80 aka Star in Honeycomb or Leverne (1880), No. 85 aka Double Vine (1880), No. 90 aka Hand and Bar (1880), No. 95 aka Inominata (1880), Ruby aka Beaded Band (1881), Albion (1881), and Derby (1882). These patterns are illustrated in the Factory B Catalogue, indicating that Bryce Brothers continued selling them until 1891 when it became part of U.S. Glass. Trade journals name two additional Bryce, Walker patterns—Crown (1875) and Russia (1881)—but there are no known illustrations of them.[41]

Period wholesale catalogues contain illustrations that can be used to attribute and date additional patterns to Bryce, Walker, including Filley, Swiss, and Orient. Another way to attribute and date patterns is by identifying common elements. If there is a distinctive element on an authenticated Bryce, Walker pattern that also appears on another pattern, it can be assumed that both patterns were made by Bryce. This method can be used to attribute additional patterns to Bryce, Walker, including: Beaded Oval and Scroll, Birch Leaf, Colossus, Geddes, Jasper, Loop and Dart, New York, Palmette, and Sunken Icicle.[42]

OVERLEAF: Fig. 33. Reprint of a description of Bryce, Walker & Co. published between 1875 and 1879. Sheet 17 × 12 inches (43.2 × 30.5 cm). This page was found in the Albert Christian Revi research files at the Rakow Research Library, Corning Museum of Glass. The source of the page is unknown. The top and side borders depict a variety of forms in Bryce, Walker's Diamond Sunburst pattern, patented in 1874. The sign on the company factory pictured at the bottom of the page says "Bryce Walker & Co. Glass Works."
Courtesy of the The Rakow Research Library, The Corning Museum of Glass, Corning, NY, www.cmog.org.

BRYCE, WALKER & CO.,

Manufacturers of

CRYSTAL TABLE GLASSWARE,

95 Water Street & 122 First Avenue,

PITTSBURGH, PA.

—:o:—

The manufacture of Glass is of such great antiquity that all record of the discovery of the art is lost. In the tombs of the ancient Egyptians glass beads and other ornaments of glass of crystal purity, and colored to imitate precious stones, have been found, thus proving that the art was known more than three thousand years ago. One of the first manufactories established in America was a glass works. With the establishment of the first colony at Jamestown, Va., in 1607, some of the colonists brought over were glass makers, and the first cargo sent back to England contained samples of glass. From Stith's History of Virginia we learn that the glass house was built in the woods about a mile from Jamestown. He also informs us that in 1621 a fund was subscribed to establish a factory for the manufacture of glass beads to be used as currency in trading with the Indians for furs, and a Captain Norton with a number of skilled Italian workmen were sent over to conduct this profitable business.

In Massachusetts glass was manufactured at a very early date; the first factory, it is said, having been located at the village of Germantown, in Braintree, though the date of its establishment is not given. In 1639 a glass house was established at Salem, and the Court granted " to the glass men severall acres of ground adjoyning to their howses." Bottles and coarse glass articles only were made at these works. In New York there were two glass houses previous to 1732, which are located on a map issued in that year. A glass house was in operation in Philadelphia in 1683, but the business did not assume any importance until after the Revolution. In 1787 glass works were established in Boston, which in 1800 were producing goods at the rate of $100,000 per year, and the business is still successfully carried on in Massachusetts. In 1788 the Legislature of New York voted a loan of £3,000 for eight years to the proprietors of a glass factory near Albany, and in 1797 these works, having in the meantime become the property of an association, were exempted from taxation by the State for five years. In 1815 the business was discontinued.

The value of the annual production of glass and glassware in the United States now reaches fully $20,000,000, nearly one half of which is manufactured at Pittsburgh, Pennsylvania. The first factory at this point was established in 1795. It would be interesting to trace the progress of the business from this

BRYCE, WALKER

beginning, and to note the improvements that have been made, but space forbids, and we must confine ourselves to a brief notice of a single representative establishment, Bryce, Walker & Co., a small view of whose very complete and extensive works, and numerous engravings of whose productions adorn this page.

This house was organized in April, 1850, under the firm name of Bryce, McKee & Co., and began manufacturing in a small Nine Pot Furnace, with the necessary outbuildings, erected on a block of ground in what was then known as the Borough of East Birmingham, now the Twenty-sixth Ward of Pittsburgh, South Side, on Wharton, between 20th and 21st Streets. The capacity of the pots was between fifteen and sixteen cwt. each of melted Flint Glass, which they made up chiefly into Table and Apothecaries', including Perfumery Ware, giving employment to about fifty men and boys.

Early in the year 1854, the style of the firm was changed to Bryce, Richards & Co. During the first four years the firm had attained a high reputation among business men, and dealers in glassware of such descriptions as they manufactured classed their goods as fully equal to any made. Then came their harvest time, and during the year 1865, the increase of business was so great that in order to meet the demand it was necessary to enlarge their manufacturing facilities. This was accomplished by the erection of a second furnace, somewhat larger than the first, thereby doubling their production of glass, which, by this time, was mostly made up into Pressed and Moulded Ware for table use. In the year 1858, the Silver Medal of the Pennsylvania State Agricultural Society was awarded to Bryce, Richards & Co., for excellence in this line of manufacture, and they also received the Silver Medal of the Franklin Institute for the superior display exhibited at the Exposition in Philadelphia in the following year, 1859.

In August, 1865, the firm name was again changed—this time to Bryce, Walker & Co., the present style. During the years 1866, '67, '68 and '69, the business largely increased owing to the change from Flint to Crystal Glass, and a further enlargement of the works was necessary to enable them to keep pace with the demand, and, in 1870, a large furnace of Eleven Pots was erected, each Pot containing from 26 to 30. cwt. of melted glass. This increase of furnace room afforded such facilities for manufacture that, at the time of its erection, the firm fully believed it would be all they should ever require, but with the increased production came a still greater increased demand, and within two years another large furnace of Eleven Pots was built on the site of the original small furnace, in which they had begun operations in 1850, making at the present time three Glass Furnaces, aggregating thirty-one pots, and, when in full operation, giving employment to one hundred and ninety hands.

'S MANUFACTORY.

These furnaces with the other necessary buildings, occupy two blocks of ground, each block measuring 120 by 312 feet. The main office of the firm is at 95 Water Street and 122 First Avenue, Pittsburg, Pa., but they are represented in Philadelphia, by Mr. A. S. Tomkinson, at 407 Arch Street, and in New York, by Mr. William J. Snyder, No. 54 Barclay Street.

Bryce Brothers
1882 to 1891

BRYCE BROTHERS CONTINUED TO OPERATE and modernize its South Side facility so that by the end of 1882 it had a capacity second only to the largest glassware firm in the United States, Rochester Tumbler Co. in nearby Beaver County, Pennsylvania.[43] Bryce Brothers was viewed as one of the most solid, respectable enterprises in the glass business, and in 1886 it was the oldest existing glass house in Pittsburgh, employing more than three hundred people (fig. 35).[44] "Bryce Bros. . . . are modest gentlemen and do not court newspaper notoriety. Notwithstanding this it is only just to say that they have about the largest and best equipped tableware factory here, and in none is a greater diversity of patterns made."[45]

In 1888, Bryce Brothers renovated its offices in splendid style. Its showroom was the largest in the city:

> The ceilings and walls have been painted and repapered in an elegant manner and in brilliant designs; the chandeliers have been burnished up, the show tables newly arrayed in dark velvet and the floor coverings entirely renewed. The outside of the building has also been painted and the entire place is transformed. The display room is especially deserving of notice as it is the largest in town and the best lighted, having windows on three sides, and it shows the new improvements to perfection. Visitors can move around here without fear of knocking over the samples with their coat sleeves, though large as the place is it is fully stocked with specimens of the firm's many productions.[46]

Bryce Brothers produced a large assortment of tableware, lamps, and novelties that were sold in every city in the United States and Canada.[47] It produced a full line in thirty tableware patterns, with each line having as many as sixty-five different pieces.[48] Many

Fig. 34. Lion-head handle on a Bryce Brothers opaque white Amazon deep dish, 1890 (detail, cat. 90).

Fig. 35. Men and boys employed at Bryce Brothers gather for a group photograph in front of the factory at Wharton and Twenty-First Streets in 1887. Children were an essential part of the glass pressing process. Company records show that circa 1891 Bryce Brothers employed thirty-three girls and twenty boys in the shipping and packing rooms alone. Additional boys worked on the factory floor in positions such as mold boy, which required sitting at the feet of a glassmaker ten hours a day, opening and closing molds. *Courtesy of the Carnegie Library of Pittsburgh.*

patterns were advertised as plain or engraved. Perfumery continued to be an important segment of Bryce's business, but examples today are rare. Bryce Brothers did an immense business in glass oil lamps, which were considered "a specialty of this house" and came in an extensive variety of patterns and colors.[49] The company produced goods in every price range and would sometimes introduce a higher-priced line, such as Atlas, along with a moderately priced line, such as Coral or Magic, so there would be something new at different price points.

Glassmakers often released new lines in January to coincide with an annual month-long glass exhibition headquartered at the Monongahela House, a popular hotel in downtown Pittsburgh that had hosted nineteenth-century notables such as Abraham Lincoln, Ulysses S. Grant, and Charles Dickens (fig. 36). This glass exhibition attracted buyers from all over the United States and Canada. Glass manufacturers displayed their new wares at the exhibition or in nearby showrooms and took advance orders. It was an opportunity to see which lines were the most popular and modify production accordingly.[50] Trade journals often reported on the new lines by name, which provides a reliable basis for identifying the year a pattern was introduced.

Glass novelties surged in popularity in the mid-1880s, resulting in charming knick-knacks in colorful and whimsical forms. Glasshouses manufactured historical and political pieces, often commemorating newsworthy current events. Toothpick and match holders were popular, as well as individual pieces in unique forms, such as canoes and shoes. The *Crockery & Glass Journal* described Bryce Brothers' novelties as too numerous to list: "They have an immense number of knick-knacks and miscellaneous articles for which they have a constant demand. To call them off one by one would take several pages of this paper."[51]

The explosion of novelties coincided with the increased popularity of colored glass during the period from 1884 to 1887, which collectors call the ABC era—Amber, Blue, and Canary. Glass was colored by adding mixtures of chemical compounds and elements to the batch. Other variables such as heat, time, and the amount of oxygen in the melting chamber impacted color variations. Each manufacturer's recipes for producing its colors were closely guarded secrets.[52]

Bryce Brothers fully embraced the new trend with colorful tableware and novelties that transformed its showroom into a "veritable flower garden." In June 1885, the *Crockery & Glass Journal* first reported that Bryce Brothers was making "some very handsome lines of colored glassware . . . in all the popular colors."[53] Bryce produced "a great many miscellaneous wares in every diversity of color: bowls, salvers, water sets, pitchers, celeries, butters in square and round shapes, oil and vinegar cruets with long necks and handles, etc."[54]

No more elegant and varied assortment of colored and fancy glassware has ever been produced in this city than that now on exhibition at the sample room of Bryce Bros. . . . The chief attraction is a line of miscellaneous articles, among which we may enumerate celery boats (pointed at both ends), toothpick holders, custard cups, tumblers, goblets, nappies and pitchers arranged, on one table, and they look like a veritable flower garden. Some are crystal with hexagon shaped spots in Jacqueminot rose color, others crystal body with rims of same color and others again colored altogether with that beautiful tint.[55]

Fig. 36. Advertisement for the Monongahela House in *The Official 28th National Encampment of the Grand Army of the Republic* (Pittsburgh, PA, 1894). 12 × 9 inches (30.5 × 22.9 cm).

Like many glass companies, Bryce Brothers produced tableware and novelties in shades of amber, blue, and canary (fig. 37). It also made a handful of items in green, including in the Orion pattern that came in "canary, amber, amethyst, blue, green and combinations of these colors."[56] Wholesale catalogues described the No. 2 Genesta Boat and Puritan Boat novelties as available in amber, blue, canary, amethyst, and green.[57] A Bryce Brothers apple green boot is pictured in *Shoes of Glass, 2,*[58] and the boat-shaped Earl Ind. Boat has also been found in apple green. Spelman Brothers advertised Diamond, Princess, and Orion nappies available in "blue, green, old gold [amber] and canary."[59] Occasionally Bryce Brothers glassware is found in less common colors, such as periwinkle blue, light amber, and light amethyst.

Bryce Brothers sought to distinguish itself with some colors that were not typically produced elsewhere.[60] It made tableware and novelties in amethyst and a rare tint of deep

Fig. 37. Earl Pickles in rose, crystal, amber, canary, blue, and amethyst; blue Fashion Nappy, 1886 (cat. 109).

Fig. 38. Glassware
with ruby or rose
stain (cat. 64).

rose described as Jacqueminot Rose, a reference to a hybrid rose introduced in America in 1853 and named for General Jean-François Jacqueminot, a French general of the Napoleonic Wars:

> In colored ware they have made it a point to keep out of the common track, and get out a line of colors many of which have no duplicates in the market. Among these is a rare tint of rose color, in which they have pitchers, butters, custards, toothpick holders, goblets, and many other articles; and amethyst, in which they have a variety of different ware.[61]

> The array of colored glassware at Bryce Bros. is very inviting to visitors, and large orders for them are being received. They have a line of miscellaneous goods in a very beautiful tint of rose color which is attracting much attention, and the buyers are after them. They have also sets in amethyst which for delicacy of shade are hard to beat. But there is hardly anything in color that is not represented here, and all are selling well, especially as the number of shapes and patterns is not exceeded elsewhere.[62]

Bryce Brothers made five extended lines in amethyst: Orion aka Cathedral, No. 1000 aka Diamond Quilted, Argyle, Fashion aka Daisy and Button, and Old Oaken Buckets. It also made amethyst pieces in Regal, Maltese aka Jacob's Ladder, Orient, Derby, Monarch, and No. 159 aka Greenfield Swirl; as well as the Fly, Avon, Leaf, Lorne, Shamrock, and Banner butters.[63] It made many other novelties in amethyst, including fish, boats, shoes, toothpick holders, plates, and mugs. Bryce Brothers amethyst pieces are highly sought by collectors. Because Bryce's amethyst "had no duplicate in the market," collectors assume that an amethyst piece made in the 1880s is probably a Bryce Brothers product (fig. 39).

Bryce Brothers used the popular Jacqueminot Rose for all-over color and for decorating the hexagonal dots and scalloped edges on a variety of pieces (fig. 38).[64] "The new lines of rose-colored ware, comprising custards, tumblers, pitchers, celery boats, goblets, nappies, toothpick holders, and a lot of other fancies, got out by them this spring, is as beautiful a line and as fine a tint as any it produced. They have lots of orders for them."[65] Bryce Brothers' use of rose staining may be unique. It has not been found on other makers' production, and Bryce may have done the staining in-house.

The *Pottery & Glassware Reporter* describes Bryce Brothers producing both crystal and pale canary pieces flashed with ruby and rose, but the context indicates Bryce would have been using a staining process.[66] The Welkers explained the staining process in *Pressed Glass in America*: "A process of coating a piece of glass with a chemical whose true color is developed by heat. This is the least expensive way of coloring glass. The staining material is painted on the annealed [cooled] article with a brush wherever the decorative effect is

Fig. 39. Amethyst tableware, mid-1880s (cat. 76).

desired. It is then fired on for permanency at which time the glass assumes the desired color."[67] On blown glass, coloring is done using a process called flashing, in which a glass item is "dipped into hot glass of another color in such a manner to cause only a thin layer of it to adhere. . . . This is a *blown* glass method and is not to be confused with staining used on pressed glass."[68]

The era of colored glass quickly faded. By January 1887, trade journals were no longer reporting on Bryce Brothers' production of colored tableware. While the popularity of colored glass waned, it did not disappear entirely. Bryce Brothers' World's Fair lamps, introduced in 1890, were available in crystal, amber, blue, and opal, indicating that some items continued to be made in color.

On May 26, 1887, the *Crockery & Glass Journal* provided some insight into why factories stopped producing canary glass. Manufacturers of oxide of uranium, the substance that glows green under a black light and is used to color canary glass, had more than doubled their prices (fig. 40). As a result, glass manufacturers greatly reduced production of canary glassware:

> Canary yellow, one of the richest colors in glass, has quietly slid out of the list of colors in fancy goods. The secret of the matter is found in an attempt on the part of the manufacturers of the oxide of uranium—not the dealers, mind—to force the price to double figures. As soon as this was accomplished the manufacturers of fancy glass quietly dropped canary yellow, and the sale of uranium was materially lessened. When it gets back somewhere near its normal price the glass manufacturers will doubtless begin using it again, as the canary yellow with its combinations is still the most popular color in foreign fancy glass.[69]

Fig. 40. Canary Fashion Nappy in the shape of a fish, mid-1880s, illuminated with a black light. 2⅜ × 6 × 4 inches (6 × 15.2 × 10.2 cm). The uranium oxide used in coloring canary glass causes it to glow green under a black light.

This huge increase in manufacturing costs and the resulting decrease in production of canary glass may explain why some novelties from the late 1880s were made in crystal, amber, and blue, but not in canary.

By the late 1880s, the glass business was highly competitive and companies were under tremendous economic pressure: "[In] 1891, the glass industry had been experiencing hard times for the previous eight years. Starting in 1882, glass producers were failing and facing bankruptcy with increasingly large numbers going out of business. At the beginning of 1885 it was noted that there were seven nearly new glass factories available for purchase, with no takers."[70]

Demand fluctuated and manufacturers accumulated large unsold inventories. They began to look for ways to reduce production costs and increase profits. Bryce Brothers was not immune to the economic pressure. For several years it frequently had been running only two of its furnaces with the third one idle (figs. 42, 43).[71]

On July 1, 1891, Bryce Brothers and seventeen other glass companies from western Pennsylvania, Ohio, and West Virginia formed a conglomerate known as United States Glass Company, which for a time was the largest glass manufacturer in the world. U.S. Glass was based in Pittsburgh until it moved its headquarters to Tiffin, Ohio, in 1938. U.S. Glass continued to operate the former Bryce Brothers factory on the South Side under the designation U.S. Glass Factory B.

With the consolidation, U.S. Glass acquired enormous inventories that member companies had stored in huge warehouses but been unable to sell. U.S. Glass began liquidating the accumulated inventory. It also began manufacturing its own newly designed lines.[72]

Instead of producing an entirely new catalogue, Augustus H. Heisey, the U.S. Glass commercial manager, collected existing catalogues from member companies and bound them together, along with a handful of the new U.S. Glass patterns. U.S. Glass released that composite catalogue in January 1892 to show the products the new company was offering.

Portions of a Bryce Brothers catalogue were included in the "Factory B" section of the composite catalogue. The known pages of the Bryce Brothers catalogue are undated and do not include a title page, but the catalogue likely was produced in 1891 because it includes the Pittsburgh pattern, introduced in that year.

There are at least three versions of the composite catalogue, but they are not identical and none is complete. The Carnegie Library of Pittsburgh owns a copy labeled "U.S. Glass Co., Pittsburgh, Illustrated Catalogues." It was divided into four volumes and bound with a library buckram covering. Pages were trimmed and margins were cropped during the binding process, which obscured some of the illustrations and marginal notes. Volume two contains 101 pages from the Factory B Catalogue. The Tiffin Glass Collectors Club, Museum, Shoppe and Archives, Tiffin, Ohio, has ninety-five loose pages from the Factory B Catalogue. It includes fifteen pages of the new U.S. Glass Patterns 15003 and 15010, five

Nº 2 Fashion Butter.

Troy Butter.

Shamrock Flanged Butter

Leaf Flanged Butter.

Banner Butter.

Cameo Butter.

Albany Butter.

Fashion Butter.

½ SCALE.

Basket Butter.

THE ARMOUR LITHO CO. LIMITED PITTSBURGH

Fig. 41. Page from the "Factory B" (Bryce Brothers) section of the United States Glass Company composite catalogue (Jan. 1892). 8⅞ × 11⅝ inches (22.5 × 29.5 cm). *Courtesy of the Tiffin Glass Collectors Club, Museum, Shoppe and Archives, Tiffin, OH.*

of which are duplicates.[73] The Corning Museum of Glass, Corning, New York, has posted online thirty-six pages identified as from a Factory B Catalogue.[74]

The three versions are collectively referred to here as the "Factory B Catalogue." Some Factory B Catalogue pages have different printed headings in the margins that identify the maker as "Bryce Bros" or "U.S. Glass Factory B." Many pages have no printing at all in the margin. The Corning version may be more recent than the Carnegie and Tiffin versions because some of the marginal headings changed from Bryce Bros. to Factory B. For example, there are two identical pages of butter dishes in both the Carnegie and Tiffin versions with "Manufactured by Bryce Bro's Pittsburgh, Pa." in the margin of the Tiffin copy (fig. 41). The Corning version contains two different pages with fewer butter dishes on each page and "United States Glass Co. Pittsburgh, Pa." with a *B* in a circle in the margins.

Many illustrations in the Carnegie Factory B Catalogue have an *X* hand-drawn through them in blue pencil (see fig. 66). Most likely that was the annotator's method for identifying items that were not available, perhaps because none was left in inventory and new pieces

Fig. 42. Illustration of the interior of a South Side glassworks in Alex Y. Lee and Ward Brothers, *Souvenir of Pittsburgh and Allegheny City* (Columbus, OH: Ward Brothers, 1887). *Courtesy of the Detre Library & Archives of the Senator John Heinz History Center, Pittsburgh, PA.*

were not being produced. The Corning version has some handwritten notes, with only a few images crossed out. The Tiffin version is generally unmarked.

The Factory B Catalogue illustrates tableware lines and novelties Bryce Brothers had been selling at the time of the consolidation, as well as tumblers, stemware, syrups, salts, casters, plates, bowls, butters, and other miscellaneous pieces, many designated only by a pattern number. Many of these patterns are discussed in the following Catalogue and Compendium.

In January 1892, U.S. Glass introduced twelve of its newly designed lines designated by pattern numbers from 15001 to 15012. Two of the new U.S. Glass patterns, No. 15003 aka Flat Panel or Pleating, and No. 15010 aka Ribbon Candy or Double Loop, are included in the Tiffin Factory B Catalogue. Both patterns are sometimes mistakenly attributed to Bryce Brothers, possibly because they were published in the Factory B Catalogue with other Bryce Brothers products with the marginal heading "United States Glass Company, Factory B." U.S. Glass Pattern No. 15030 aka Roman Rosette is also sometimes mistakenly attributed to Bryce Brothers.

The Factory B Catalogue includes several items in lines that have been documented or attributed to Campbell, Jones & Co. or its successor Jones, Cavitt & Co. That company's factory was devasted by fire in January 1891, and the firm went out of business a few months later. Bryce Brothers may have acquired some molds or possibly existing Jones, Cavitt stock.[75] Three pages of the Factory B Catalogue illustrate primarily Jones, Cavitt patterns. That has resulted in confusion among some collectors who have then attributed the Jones, Cavitt patterns to Bryce Brothers. Patterns falling into this category include No. 125 Rose in Snow, Leaf Berry Set, No. 126 Mitered Diamonds aka Zig Zag, No. 128 Victor, No. 140 Waverly, No. 150 Atlanta, No. 160, No. 260 Fine Cut with Panels, and No. 720 Fine Cut.[76] These patterns are not discussed or included in the Compendium because they were not originally designed or produced by Bryce.

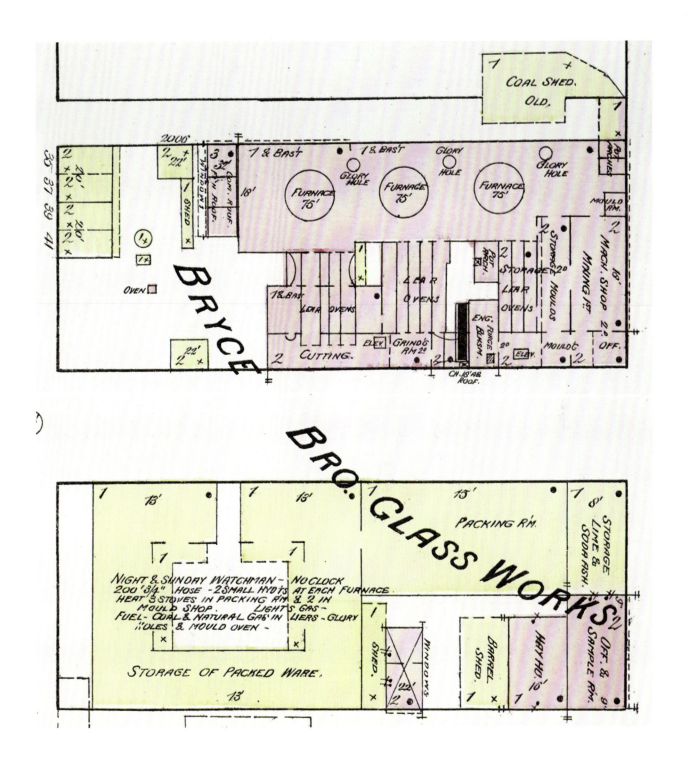

Fig. 43. Fire Insurance Map from *Pittsburgh, Pennsylvania, vol. 2, South Side and Allegheny* (New York: Sanborn Map Company, 1884). This image of the intersection of Wharton and Twenty-First Streets from an 1884 Sanborn Fire Insurance Map of Pittsburgh shows the layout of the Bryce Brothers glass works on Pittsburgh's South Side.

The building at the top of the page housed three furnaces, three glory holes, and lear (lehr) ovens that were used to slowly cool the temperature of a newly pressed glass article. There were cutting and grinding rooms, a machine shop, blacksmith forge, and a mold room along with storage areas associated with those functions. The second

building across Wharton Street in the lower part of the map had a packing room, storage for lime and soda ash, office and sample rooms, a barrel shed, and a storage area for packed ware.

Yellow indicates wooden frame structures and pink indicates brick structures. The number in the upper left corner of each structure represents the number of stories. The notation "1 & BAS'T" in the main factory building means one story plus a basement. The notes indicate coal and natural gas were being used in the lears, glory holes, and mold ovens. *Geography and Map Division, Library of Congress, Washington, DC, https:// www.loc.gov/item/sanborn07911_002/.*

Bryce Brothers Company
Blown Glass from 1893 to 1965

WHEN U.S. GLASS WAS FORMED IN 1891, each member company maintained its existing officers. As a result, the new conglomerate was top heavy, which was financially unsustainable. In 1893 U.S. Glass brought in Ralph Baggaley, a financier experienced in working with financially troubled companies.[77] One of his first cost-cutting actions as president was to terminate twenty-two officers. Donald Bryce was among those who received a letter dated Saturday, September 30, 1893, addressed to "Dear Sir," advising him that "As a means of reducing the company's present heavy operating expense, it is the intention to save the amount now paid you as salary. For this reason your services will not be required by the company, after this evening September 30th, 1893."[78] Donald's brother Andrew H. Bryce was listed as the secretary of U.S. Glass on the printed letterhead of Donald's termination letter.

Donald Bryce's termination resulted in the best career move of his life. Donald and Andrew reorganized Bryce Brothers with Andrew as president and Donald as secretary-treasurer. James's sons Frank and Allan remained with U.S. Glass while also taking positions with the new Bryce Brothers (fig. 45).

In October 1893, the company purchased the bankrupt Smith-Brudewold Co. glass factory in Hammondville, Fayette County, Pennsylvania, about forty miles southeast of Pittsburgh. It converted production to blown ware, including tumblers, stemware, and tableware, some decorated by the process known as needle etching, a class of work that had previously been imported from Europe; this was the first concerted effort to supplant foreign glass for fine tableware.[79]

Fig. 44. Space Needle champagne glass made by Bryce Brothers Company for the iconic Space Needle Restaurant at the Seattle World's Fair, 1962. 5⅝ × 3⅜ inches (14.3 × 8.6 cm).

Fig. 45. Seated: James McDonald Bryce and Andrew Haugh Bryce; standing: Marion Graham Bryce, Samuel Allan Bryce, and Frank Gordon Bryce, ca. 1900.

Fig. 46. Bryce Brothers Company factory in Mount Pleasant, Westmoreland County, PA, ca. 1920. Canton Engraving and Electrotype Co., Canton, OH. 15 × 43 inches (38.1 × 109.2 cm).

Production couldn't keep up with demand, and Bryce Brothers soon outgrew the Hammondville plant. In 1896 the company incorporated as Bryce Brothers Company and built a new brick factory on Depot Street in nearby Mount Pleasant, Westmoreland County, Pennsylvania (figs. 46, 48). The borough of Mount Pleasant had provided significant financial incentives to entice Bryce Brothers Company to make the move.

The new factory opened on October 12, 1896, with nationwide sales to top-quality restaurants, hotels, and private clubs. An important element in its initial success was the wide range of decorating techniques it offered: cutting, needle etching, sand blasting, engraving, and gilding in bands. By 1906, the Mount Pleasant works had three furnaces, the buildings covered four acres of ground, and it employed more than six hundred people.[80] Over the years, the company became accepted as one of the outstanding producers of high-quality hand-blown lead crystal.

Fig. 47. Silhouette series, designed by Eva Zeisel, 1952. Hungarian-born Eva Zeisel was an internationally renowned modernist designer who died in 2011 at the age of 105. She was the first female designer ever featured in a solo exhibition at New York's Museum of Modern Art. She designed this Silhouette series for Bryce Brothers Company in 1952. Crystal Silhouette pieces are the most difficult to find today. The amethyst glass is a sherbet or old fashioned with a 7.5-ounce capacity (3⅛ × 3½ inches, 7.9 × 8.9 cm); the crystal and blue glasses on the left are goblets with an 11-ounce capacity (5⅜ × 3 inches, 13.7 × 7.6 cm); and the gold and green glasses on the right are juice glasses with a 6-ounce capacity (4⅜ × 2½ inches, 11.1 × 6.4 cm). Bryce Brothers also made a 12-ounce iced tea glass in this pattern.

The company produces all styles of light tumblers and stemware, suitable for the table and buffet, in plain as well as cut, engraved sand blast, needle etched and color decorations. They find a market all over the United States and have a reputation for quality of goods equal to the best French factories, and while succeeding in creating a trade in this country for the class of goods they manufacture have been able to curtail to some extent the importations.[81]

Bryce Brothers glass manufactured in Mount Pleasant was used in the White House, the United Nations headquarters, and U.S. embassies around the world. Among its notable commissions, Bryce Brothers made glassware for the Space Needle Restaurant at the 1962 Seattle World's Fair (fig. 44) and for the N.S. *Savannah*, the first nuclear cargo and passenger ship built in the late 1950s at a cost of $47 million. In the 1950s, Bryce Brothers hired internationally known designers Eva Zeisel and Garth Huxtable to create unique modern glassware, examples of which are in the Carnegie Museum of Art in Pittsburgh and the Museum of Modern Art in New York, respectively (fig. 47). Bryce Brothers used Huxtable's design to produce glassware for the iconic Four Seasons Restaurant in New York City.

Bryce Brothers was run by James's sons and grandsons until 1952. It continued as the oldest company in America still hand-blowing and hand-decorating fine lead crystal until it sold its Mount Pleasant operations to Lenox, Inc., in 1965.

James Bryce died in Pittsburgh on March 8, 1893, the same year the new Bryce Brothers company was reorganized. He had been a pioneer in the glassmaking industry and had watched Pittsburgh grow from a small settlement to one of the major industrial centers in the world. James left an indelible mark on the production of nineteenth-century pattern glass in Pittsburgh and across America, and his sons and grandsons carried the family glassmaking legacy well into the next century.

Fig. 48. James McDonald Bryce's bookplate, ca. 1905, signed "JRW & Co / JHF. SC." The plate features a view of the Bryce Brothers Company, Mount Pleasant, PA, glass factory from the front study window on the second floor of Bryce's residence.

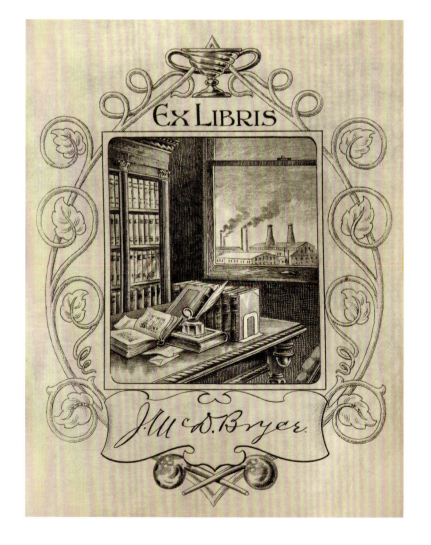

NOTES

1. A copy of the Articles of Association is in the Detre Library & Archives of the Senator John Heinz History Center, Pittsburgh, PA.
2. Samuel Fahnestock, *Fahnestock's Pittsburgh Directory for 1850* (Pittsburgh, PA: Geo. Parkin & Co., 1850); George H. Thurston, *Directory of Pittsburgh 1856–57* (Pittsburgh, PA: George H. Thurston, 1856); George H. Thurston, *Directory of Pittsburgh and Vicinity for 1857–58* (Pittsburgh, PA: George H. Thurston, 1857). Pittsburgh city directories are available online at Historic Pittsburgh, https://www.historicpittsburgh.org/collection/historic-pittsburgh-city-directories.
3. Obituary of James Bryce, *China, Glass and Lamps*, Mar. 15, 1893, 23.
4. Woodward & Rowlands, *Pittsburgh Directory for 1852* (Pittsburgh, PA: W. S. Haven, 1852), 11.
5. Obituary of Robert D. Bryce, *China, Glass and Lamps*, Feb. 10, 1906.
6. James Bryce, journal, vol. 2, Sept. 7, 1840–May 30, 1876, 197, original in private collection, copy in the Detre Library & Archives of the Senator John Heinz History Center, Pittsburgh, PA.
7. Bryce, journal, 2:196–97. It is unclear why James said the only partners left in 1865 were the three Bryce Brothers. John Floyd was an original Bryce, McKee partner and he was also a partner in Bryce, Walker.
8. James McKee did not sign the Articles of Association, but he worked at the firm and his withdrawal was noted in the announcement of the name change to Bryce, Richards & Co. published in the *Pittsburgh Gazette*, Apr. 3, 1854, 3.
9. Bryce, journal, 2:197.
10. A copy of the partnership agreement has not been found and the terms of the partnership are not known.
11. George H. Thurston, *Directory of Pittsburgh and Vicinity for 1858–59* (Pittsburgh, PA: George H. Thurston, 1858).
12. Jay W. Hawkins, *Glasshouses & Glass Manufacturers of the Pittsburgh Region, 1795–1910* (New York: iUniverse, 2009), 99.
13. Pennsylvania State Agricultural Society, *Annual Report of the Transactions of the Pennsylvania State Agricultural Society, for the Years 1857–1858* (Harrisburg, PA: A. Boyd Hamilton, State Printer, 1859), 266.
14. Franklin Institute, *Report of the Twenty-Sixth Exhibition of American Manufactures, Held in the City of Philadelphia* (Philadelphia, PA: William S. Young, 1858), 69.
15. Bryce, journal, 2:197.
16. *Crockery & Glass Journal*, July 8, 1880, 19.

17. *Daily Pittsburgh Gazette* 78, no. 221 (Aug. 31, 1865): 2.
18. A copy of the Articles of Agreement is in the Detre Library & Archives of the Senator John Heinz History Center, Pittsburgh, PA.
19. Frank C. Harper, *Pittsburgh of Today, Its Resources and People*, vol. 4 (New York: American Historical Society, 1931), 529.
20. Stephen Neal Dennis, *Keep Tryst: The Walkers of Pittsburgh & the Sewickley Valley* (Rensselaer, NY: Hamilton Printing Co., 2004), 71, 137. William Walker was elected president of the Farmers Deposit National Bank in 1869 and the announcement described him as a gentleman of "substantial wealth and great financial ability." *Pittsburgh Weekly Gazette*, Sept. 20, 1869, 8.
21. *Crockery & Glass Journal*, Dec. 11, 1879, 14; Sept. 9, 1880, 19; Nov. 11, 1880, 6.
22. *Crockery Journal*, Feb. 27, 1875.
23. David Lowry, James Mills, and E. A. Myers, *Pittsburgh: Its Industry and Commerce, Embracing Statistics of the Coal, Iron, Glass, Steel, Copper, Petroleum, and Other Manufacturing Interests of Pittsburgh* (Pittsburgh, PA: Barr & Myers Publishers, 1870), 6, 60.
24. *Pittsburgh Commercial Gazette*, Feb. 14, 1880, 1.
25. *Crockery & Glass Journal*, Feb. 19, 1880, 24.
26. *American Pottery & Glassware Reporter*, Sept. 25, 1879.
27. *Crockery & Glass Journal*, Apr. 8, 1880, 8; Nov. 27, 1879, 30.
28. *American Pottery & Glassware Reporter*, Nov. 20, 1879.
29. Advertisement in *Crockery & Glass Journal*, Mar. 7, 1878, 31. The *American Pottery & Glassware Reporter* noted on Nov. 18, 1880, that Bryce "make some specially nice holiday goods in the shape of perfumery ware, such as scent and toilet bottles, in great variety of styles. The demand for this class of articles is always brisk in November and December."
30. Hawkins, *Glasshouses & Glass Manufacturers*, 376; *Pittsburgh Daily Post*, Aug. 5, 1859, 3.
31. George H. Thurston, *Pittsburgh and Allegheny in the Centennial Year* (Pittsburgh, PA: A. A. Anderson & Son, 1876), 133.
32. Lowell Innes, *Pittsburgh Glass 1797–1891* (Boston: Houghton Mifflin, 1976), 57; John Welker and Elizabeth Welker, *Pressed Glass in America: Encyclopedia of the First Hundred Years, 1825–1925* (Ivyland, PA: Antique Acres Press, 1985), 32.
33. Pennsylvania Bureau of Industrial Statistics, *Annual Report of the Secretary of Internal Affairs of the Commonwealth of Pennsylvania: Industrial Statistics.*

1875–76, pt. III, vol. 4 (Jan. 1877), 711.
34. *Daily Post*, Pittsburgh (Jan. 10, 1878), 4; *Crockery & Glass Journal*, Feb. 19, 1880, 24; Mar. 3, 1881, 19.
35. Welker and Welker, *Pressed Glass*, 32.
36. *Crockery & Glass Journal*, Oct. 28, 1880, 2.
37. *American Pottery & Glassware Reporter*, Nov. 11, 1880.
38. *Crockery & Glass Journal*, June 23, 1881, 6.
39. Correspondence from Eliza Walker, Margaret H. Walker, and Lillie Walker, William Walker's wife and daughters, dated June 13, 1882. A copy is in the Detre Library & Archives of the Senator John Heinz History Center, Pittsburgh, PA.
40. *Crockery & Glass Journal*, June 22, 1882, 14.
41. It is possible Crown is the original manufacturer's name for the Diamond Sunburst pattern, which was patented in Dec. 1874. Finials in that pattern are in the shape of a crown.
42. Sid Lethbridge recently attributed a Sunken Icicle high-footed bowl to Bryce, Walker based on the standard.
43. *Crockery & Glass Journal*, Dec. 7, 1882, 10.
44. William W. Williams, ed., *Magazine of Western History: Vol. 3, November, 1885–April, 1886* (Cleveland, OH: Magazine of Western History Co. Publishers, 1886), 382.
45. *Crockery & Glass Journal*, May 21, 1885, 14.
46. *Pottery & Glassware Reporter*, Dec. 20, 1888, 12.
47. *Crockery & Glass Journal*, Oct. 4, 1882, 28.
48. *Crockery & Glass Journal*, Feb. 14, 1884, 14.
49. *Crockery & Glass Journal*, Nov. 8, 1883, 20; Dec. 1, 1887, 107; *Pottery & Glassware Reporter*, Jan. 21, 1886, 13.
50. Paul Kirk, Jr., *Homestead Glass Works, Bryce, Higbee & Company, 1879–1907* (Atglen, PA: Schiffer Publishing, 2016), 20–23.
51. *Crockery & Glass Journal*, Dec. 11, 1890.
52. Welker and Welker, *Pressed Glass*, 120–21.
53. *Crockery & Glass Journal*, June 18, 1885; July 2, 1885, 14.
54. *Pottery & Glassware Reporter*, Jan. 21, 1886, 13.
55. *Pottery & Glassware Reporter*, Jan. 21, 1886, 13. *Nappy* (pl. *nappies*) is a nineteenth-century term for bowls measuring from about 4 inches and up; Kirk, *Homestead Glass Works*, 56.
56. *Pottery & Glassware Reporter*, Jan. 21, 1886, 13.
57. Butler Brothers, *"Our Drummer"* (85th Trip 1886): 25; G. Sommers & Co., *Our Leader* (Early Fall Edition 1887): 20.

58. Libby Yalom, *Shoes of Glass, 2* (Marietta, OH: Glass Press dba Antique Publications, 1998), 51.
59. Spelman Brothers, *Special Bargain Catalogue* (Spring 1886): 2.
60. *Pottery & Glassware Reporter*, June 10, 1886.
61. *Crockery & Glass Journal*, Nov. 18, 1886, 10.
62. *Crockery & Glass Journal*, Feb. 25, 1886.
63. Brad Gougeon, "Bryce's Amethyst. The Third 'A' in the ABC Era," *NewsJournal* (Early American Pattern Glass Society) 27, no. 3 (Fall 2020): 3–8. The Leaf, Avon, and Lorne butters were advertised as available in amber, blue, and amethyst in *American Potter & Illuminator* 5, no. 4 (Apr. 1886).
64. *Pottery & Glassware Reporter*, Apr. 29, 1886.
65. *Crockery & Glass Journal*, May 6, 1886.
66. *Pottery & Glassware Reporter*, Jan. 21, 1886, 13.
67. Welker and Welker, *Pressed Glass*, 478.
68. Welker and Welker, *Pressed Glass*, 476.
69. *Crockery & Glass Journal*, May 26, 1887.
70. Neila Bredehoft, Tom Bredehoft, and Sid Lethbridge, *United States Glass Company, Vol. 1—Tableware Lines 1891–1895* (Weston, WV: Glass Flakes Press, 2020), 195.
71. *American Pottery & Glassware Reporter*, Oct. 29, 1891.
72. Bredehoft, Bredehoft, and Lethbridge, *United States Glass Company, Vol. 1*, 195–98.
73. The Factory B Catalogue pages were donated to the Tiffin Glass Collectors Club by a former factory superintendent at U.S. Glass Co., Tiffin, OH.
74. https://www.cmog.org/library/collected-sales-catalogues-and-catalogue-pages-united-states-glass-co-and-companies-merged-0.
75. Sid Lethbridge, *Campbell, Jones & Co.: The Tableware Products of a 19th Century Pittsburgh Glass Maker* (Brights Grove, ON: Sid Lethbridge, 2015), 8.
76. See Lethbridge, *Campbell, Jones*, for a complete discussion of the basis for the Campbell, Jones or Jones, Cavitt attributions of these patterns.
77. Bredehoft, Bredehoft, and Lethbridge, *United States Glass Company, Vol. 1*, 17.
78. Letter from Ralph Baggaley to J. McD. Bryce, dated Sept. 30, 1893. A copy is in the Detre Library & Archives, Senator John Heinz History Center, Pittsburgh, PA.
79. John Newton Boucher, *History of Westmoreland County, Pennsylvania*, vol. 2 (New York: Lewis Publishing Company, 1906), 125.
80. Boucher, *Westmoreland County*, 125.
81. Boucher, *Westmoreland County*, 125.

Authenticating Bryce Glassware

THE BEST WAY TO AUTHENTICATE Bryce glassware is through primary sources. Patterns authenticated by primary sources are described as *documented patterns*. Company-issued catalogues are the most authoritative primary source for documenting patterns, but unfortunately comprehensive catalogues of Bryce production have not been found.

There is a single page of Bryce, Richards & Co. products of circa 1854 that appears to be an authentic period document illustrating seven patterns (see fig. 24).[1] The composite catalogue released by the United States Glass Company in early 1892 includes portions of an 1891 Bryce Brothers catalogue labeled "Factory B," the U.S. Glass designation for the Bryce Brothers factory (fig. 50). Only partial copies of that catalogue have been located.[2] Previous authors and some trade journal reports have mentioned additional catalogues, but no other Bryce catalogues from the 1850 to 1891 period have been located.

Illustrated company advertisements are also primary sources that can be used to authenticate patterns (fig. 51). There are illustrated advertisements for a handful of Bryce products, but most Bryce advertisements included only the company name and contact information, not product illustrations or original manufacturer's names.

Patents provide another primary source for identifying and dating patterns, keeping in mind that patents can be assigned or production licensed to other makers. Patents include a description and illustration of the pattern, identification of the designer, and the date of issuance. A list of Bryce patents from 1850 to 1891 is in Appendix II.

Secondary sources can also be used to identify and date Bryce production. Patterns authenticated by secondary sources are described as *attributed patterns*. Contemporaneous trade journals such as *American Pottery & Glassware Reporter* (published in Chicago from

Fig. 49. Hand and Bar finial on a Bryce, Walker No. 90 sugar bowl, 1880 (detail, cat. 49).

Fig. 50. Novelties page from the "Factory B" (Bryce Brothers) section of the United States Glass Company composite catalogue (Jan. 1892). 8¾ × 11½ inches (22.2 × 29.2 cm). *Courtesy of the Carnegie Library of Pittsburgh, PA.*

1879 to 1893) and *Crockery & Glass Journal* (published in New York from 1875 to 1961) reported on new patterns and trends in the glass industry. They can provide a basis for attributing a pattern and dating its introduction. For example, the Albion butter was illustrated in the Factory B Catalogue, but it can be dated 1881 and attributed to Bryce, Walker based on a trade journal report that Bryce, Walker had a "new and beautiful specialty," the Albion butter.[3]

The trade journals do not include illustrations, so when a pattern is mentioned by name it usually is not possible to know what it looked like unless it is illustrated by that name in another document. For example, the journals reported that Bryce, Walker was producing the Russia table set in 1881, but there are no known illustrations of that pattern.[4]

Similarly, the *Crockery & Glass Journal* reported in 1875 that Bryce, Walker's "Crown pattern still sustains its high reputation, and almost sells itself,"[5] but there are no known illustrations of a pattern with that name. It is possible Crown is the original manufacturer's name for the Diamond Sunburst pattern, patented in December 1874, because Diamond Sunburst has a distinctive crown finial. However, no primary or secondary source has yet been found for ascribing the Crown name to the Diamond Sunburst pattern.

Although trade journals sometimes published the names of new patterns, they usually did not describe the patterns in detail. Monarch and No. 85 aka Double Vine are two exceptions where the pattern can be identified based on detailed descriptions in the trade journals.

It is also possible to identify and date Bryce patterns based on catalogues published by wholesalers, also called jobbers, who sold the products of multiple manufacturers. Wholesalers often sold assortments of items by the barrel or package, which would include a specified number of each item illustrated in the assortment. The barrels were packed and shipped by the glassware manufacturer and opened by the customer. Butler Brothers, one of the largest wholesalers at that time, explained:

Fig. 51. Advertisement for Bryce Brothers' Amazon pattern in *Pottery & Glassware Reporter*, Feb. 6, 1890, 3. *Courtesy of Tom Felt.*

Our wonderful success is due chiefly to our introduction (and origination) of the "Assorted Package" Plan, which gives our customers the advantage of a large variety without buying full packages of any one kind, giving our friends these beautiful quick selling goods at prices previously unheard of Our assortments are all made up and packed by professional packers at the factory before being shipped to us, and are not opened until they reach the customer's store.[6]

Since the barrels were sealed at the glassware factory and not opened until they reached the customer's store, it can be assumed that every item illustrated in an assortment and packed together in a barrel was made by the same maker and packed at its factory. Therefore, if one of the items in an assortment can be authenticated as Bryce, then the other items can be attributed to Bryce.

Each year Butler Brothers published several editions of its *"Our Drummer"* catalogue and many have survived, at least in part (fig. 52). Other wholesalers advertising Bryce wares include Spelman Brothers, *American Potter & Illuminator*, F. H. Lovell & Co., G. Sommers & Co., R. P. Wallace & Co., and Falker & Stern, among others.

The F. H. Lovell *Catalogue of 1877 & 8* and *Export Catalogue* of 1888 are particularly valuable to researchers because both contain handwritten annotations that identify the maker, original manufacturer's name, and cost code for many of the illustrated pieces.[7] The 1877–78 catalogue has "O. D. Lovell" embossed on the cover, and the 1888 catalogue is signed "O. D. Lovell July 28th 1888"; the name may refer to Orville Dewey Lovell, brother

Fig. 52. Masthead of Butler Brothers, *"Our Drummer"* (Cold Weather Edition 1885), a wholesale catalogue that included Bryce Brothers products. *Courtesy of The Museum of American Glass in West Virginia, Weston, WV.*

of the company founder. The annotator likely was affiliated with the company and made the annotations at the time the catalogue was in use. Subsequent research has confirmed the accuracy of many annotations, leading to the conclusion that the other annotations are accurate as well. As such, these catalogues provide a valuable resource for authenticating early patterns.[8]

Sometimes wholesale catalogues illustrated a pattern or novelty as an individual item and not as part of an assortment. In that case, the catalogue can be used to assign a date, but additional information is needed to identify the maker.

Bryce often used the same design elements on multiple patterns, which provides another way to attribute and date patterns. One element that can be used to attribute a pattern is the standard (stem and foot) (fig. 53). Some manufacturers pressed the standards and bowls separately and later joined them. It was common practice to use the same form of standard with bowls in different patterns, which enables patterns to be attributed and dated.

For example, there were at least four different standards that Bryce, Walker used on multiple patterns in the 1870s. The first form was used on the early patterns of Tulip with Sawtooth, Filley, Birch Leaf, and Sunken Icicle (cat. 6). A second form of standard with egg-and-dart decoration around the foot was used with Grape Band, Thistle, Strawberry, and Palmette bowls (cats. 16, 23).

A shorter, less distinctive standard was used with smaller bowls in the Thistle, Diamond, New York, and Palmette patterns (cats. 7, 27). This observation is especially helpful with patterns such as Diamond and New York that were made by multiple manufacturers, which makes it difficult to attribute a particular piece to Bryce. But a Diamond or New York piece with the identical standard found on Thistle or Palmette can be attributed to Bryce.

Finally, a fourth type of standard was used on Orient, No. 79, Jasper, Colossus, and Beaded Oval and Scroll. Three of those patterns—Jasper, Colossus, and Beaded Oval and Scroll—also have identical finials, another element that can be used to attribute a pattern.

Fig. 53. Amethyst Openwork Dish with Dolphin Standard (aka), ca. 1887 (cat. 127.1). This piece is attributed to Bryce Brothers because the dish (which was also sold separately) was illustrated with documented Bryce Brothers patterns in Butler Brothers assortments from the 1887 Mid-Winter and Santa Claus Editions. Additionally, Bryce Brothers produced a Maltese bowl with an identical dolphin stem and oval foot, but with different decoration around the oval foot (cat. 33). Finally, Bryce Brothers may have been unique in producing amethyst glassware at that time. *Courtesy of the Bennington Museum, Bennington, VT.*

Similarly, Geddes and No. 80 pickle dishes have the same elaborate center medallion (cat. 45). Another less distinctive center medallion was used on pickle dishes and other forms in Thistle, Maltese, Diamond Sunburst, Orient, Jasper, Colossus, and Beaded Oval and Scroll (cat. 51).

Bryce Brothers continued the practice of using the same design elements on multiple patterns during the 1880s, but because the Factory B Catalogue provides a primary source for documenting patterns, reliance on identical elements to attribute a pattern is less important.

NOTES
1. Page with Bryce, Richards & Co. patterns, ca. 1854, Rakow Research Library, Corning Museum of Glass, Corning, NY. See fig. 24.
2. United States Glass Company, "Factory B" (Bryce Brothers) section, composite catalogue (Jan. 1892). There are at least three extant versions of this catalogue, but they are not identical and none is complete. See "Company History" (pp. 60–62 in this volume).
3. *American Pottery & Glassware Reporter*, Feb. 3, 1881.
4. *American Pottery & Glassware Reporter*, Feb. 3, 1881.
5. *Crockery & Glass Journal*, Oct. 28, 1875, 5.
6. Butler Brothers, *"Our Drummer"* (83rd Trip 1885): 26.
7. The annotated Lovell catalogues are at the Sandwich Glass Museum, Sandwich, MA.
8. Sid Lethbridge, *Campbell, Jones & Co.: The Tableware Products of a 19th Century Pittsburgh Glass Maker* (Brights Grove, ON: Sid Lethbridge, 2015), 12.

Catalogue

THE FOLLOWING PAGES IDENTIFY PATTERNS, novelties, and lamps produced by the Bryce companies between 1850 and 1891, generally presented in chronological order and authenticated by primary or secondary sources. Descriptions of colors produced are based on wholesale catalogues, trade journal reports, photographs, and personal observations.

When a pattern is authenticated as Bryce production based on a primary source—such as the Factory B Catalogue;[1] the Bryce, Richards page;[2] an illustrated Bryce advertisement; or a patent—it is described as a *documented pattern*. When authentication is based on secondary sources, such as trade journals, wholesale catalogues, or identical attributes, it is described as an *attributed pattern*.[3]

Patterns are generally referred to by the original manufacturer's name (omn) identified in a primary source. When the original manufacturer's name is not known or a pattern is also commonly known by another name, that is noted as *aka* (also known as).

Many Bryce products were reproduced in the twentieth century, and other authors have discussed reproductions in detail.[4] Reproductions may lack the detail or quality of the originals or have a slightly different shape; sometimes they were made in colors not originally made by Bryce. Reproductions are occasionally noted in the following pages but are not discussed in detail.

Patterns

THE IDENTITIES OF MOST OF THE ARTISTS WHO created Bryce glassware designs have been lost to time. John Bryce is a notable exception. He patented six early designs: Grape Band (1869), Curled Leaf (1869), Strawberry (1870), Thistle (1872), Diamond Sunburst (1874), and Maltese (1876). It is likely he designed other Bryce, Walker patterns of that era, some of which share design elements. The patterns Bryce produced after John Bryce left the company in 1879 are not as intricate as the patterns he designed. This could be due to changing tastes, or perhaps his artistic skills were difficult to replicate.

In 1869, the artist and teacher Annie W. Henderson patented the Loop and Dart design that Bryce, Walker produced, but there is no evidence she was responsible for any other Bryce patterns. Bryce Brothers' large and small boots were based on an 1886 patent issued to the perfume maker Herman Tappan for a glass boot designed to hold a perfume bottle.

The only other designer who can be identified with certainty is Henry J. Smith, whose patents were issued after John Bryce left the company. Smith patented the Ambidextrous cream pitcher (1881), glass slippers (1886), and the Atlas tableware pattern (1889), and assigned all three patents to Bryce. He also patented a two-bottle caster (1883) that Bryce Brothers produced as part of its Princess line. Henry Smith was listed in Pittsburgh city directories as a mold maker with no place of employment recorded.[5]

Mold makers were the skilled craftsmen who brought the designers' creations to life, painstakingly carving precise details into hundreds of molds for pressing the designs onto glassware. Their identities have been lost as well. Bryce had a mold shop in its factory, but it may also have ordered some molds from independent mold makers.

Although their names may not be known, the artistry and craftsmanship of these nineteenth-century designers and mold makers are preserved in the following examples of their work.

Tulip (omn), circa 1854

Aka Tulip with Sawtooth

Tulip is one of Bryce's earliest and most popular documented patterns. It was often decorated with Sawtooth, a variation commonly known as Tulip with Sawtooth. The Bryce, Richards page of circa 1854 illustrates two Tulip butters, one with Sawtooth and one without Sawtooth, but the original manufacturer's names are not recorded on the page (see fig. 24). Both variations probably were made as early as 1850 by Bryce, McKee. Bryce continued to sell this popular pattern for forty years until the consolidation with United States Glass Company in 1891. Both variations are illustrated in the Factory B Catalogue with an original manufacturer's name of "Tulip."

The Carnegie Factory B Catalogue illustrates two Tulip celeries, a larger one with Sawtooth decoration and a smaller one without Sawtooth decoration (fig. 55). Both illustrations have an *X* hand-drawn through them. When U.S. Glass was formed, it acquired large inventories accumulated by its member companies. It sold old inventory along with new patterns it designed and produced. Most likely the annotator crossed out these two celeries because they were no longer available in inventory.

Tulip butters and apothecary jars have been found in opaque white and it is possible other Tulip forms were made in opaque white (cat. 3).[6] Tulip with Sawtooth was also used on early lamps (see fig. 80).

1 Tulip with Sawtooth decanters

- 1.1. 11⅜ × 3½ inches (28.9 × 8.9 cm).
- 1.2. 14¾ × 4⅜ inches (37.5 × 11.1 cm).
- 1.3. Applied handle. 10¼ × 4¾ × 3¾ inches (26 × 12.1 × 9.5 cm).

Fig. 55. Illustration of Tulip Celery Large and Tulip Celery Small from the "Factory B" (Bryce Brothers) section of the United States Glass Company composite catalogue (Jan. 1892).

2 Tulip with Sawtooth jars

2.1. Apothecary jar. 5¾ × 3 inches (14.6 × 7.6 cm).
2.2. Pomade jar, footed. 5 × 2½ inches (12.7 × 6.4 cm).
2.3. Apothecary jar. 5¼ × 3 inches (13.3 × 7.6 cm).

3 Tulip apothecary jar

Opaque white. 4 × 2⅝ inches (10.2 × 6.7 cm).
Collection of Karin Kolsky.

4 Tulip butters

4.1. Tulip with Sawtooth. 5 × 6 inches (12.7 × 15.2 cm).
4.2. Tulip without Sawtooth. 4¼ × 6 inches (10.8 × 15.2 cm).

5 Tulip with Sawtooth plate

⅝ × 6½ inches (1.6 × 16.5 cm).

6 Tulip with Sawtooth high-footed covered bowl

12½ × 7⅜ inches (31.8 × 18.7 cm).

Diamond (omn), circa 1854

Aka Sawtooth

Diamond aka Sawtooth is an early documented pattern illustrated on the Bryce, Richards page of circa 1854 (see fig. 24). Bryce, McKee may have made it as early as 1850. Bryce Brothers continued to produce this popular pattern and it is illustrated in the Factory B Catalogue. Bryce also used the Sawtooth design as a decorative element with other patterns such as Tulip (circa 1854) and Amazon (1890).

Bryce Brothers produced Diamond in colors in the mid-1880s and this footed bowl was made in amber and blue, as well as amethyst and canary as pictured here. The wholesaler Spelman Brothers advertised Diamond, Orion, and Princess nappies available in "blue, green, old gold [amber] and canary."[7] *Nappy* is a nineteenth-century term for small bowls measuring from about 4 inches and up.[8]

Other companies also produced a Sawtooth pattern, which sometimes makes it difficult to attribute a particular piece to Bryce.

7 Diamond footed bowl

Amethyst, mid-1880s. 6⅛ × 7⅞ inches (15.6 × 20 cm).
The Factory B Catalogue labels this form a "saucer."

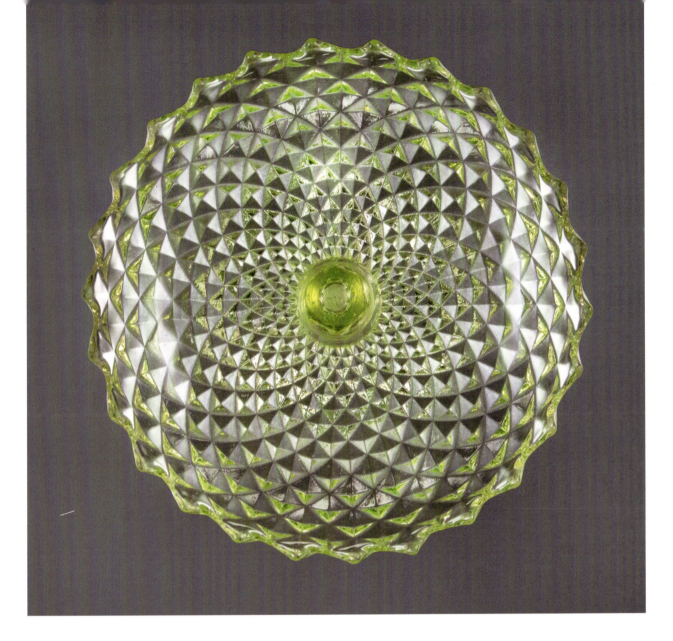

8 Diamond footed bowl, interior

Canary, mid-1880s. 6 × 8 inches (15.2 × 20.3 cm).

9 Diamond footed bowl

Canary, mid-1880s. 6 × 8 inches (15.2 × 20.3 cm).

Grape Band (aka), 1869

John Bryce patented his first naturalistic design, known as Grape Band, on October 19, 1869 (Design Patent No. 3,716; fig. 56). He described his design in the patent:

> My improved design consists in the raised representation, on the face of glass-ware, of a grape-vine, leaves, and fruit, the vine being striated, and the face of the leaves roughened. The design is made on the article of glass-ware in relievo, by the use of properly-shaped cavities in the moulds. The vine is striated on its upper face, in imitation of the small lines or striations of the natural vine, as shown. The fruit or berries are also raised, so as to present an increased amount of reflecting-surface, and so add to the brilliancy of the design.

Grape Band syrups, pickle dishes, and pitchers were also made in opaque white (cats. 10, 34; fig. 32).[9] The Grape Band design was also used on lamp fonts (see cat. 141.3).

Fig. 56. Illustration of the Grape Band design, 1869. Design Patent No. 3,716.

10 Grape Band pickle dish, bottom

Opaque white. 1¼ × 8½ × 4¾ inches (3.2 × 21.6 × 12.1 cm). *Collection of Brad Gougeon.*

11 Grape Band pitcher

Applied handle. 9 × 8 × 5 inches (22.9 × 20.3 × 12.7 cm).

Curled Leaf (aka), 1869

John Bryce patented his second naturalistic design, known as Curled Leaf, on November 23, 1869 (Design Patent No. 3,759). This design appears to represent the leaf and flower of the tulip tree. He described his design in the patent:

> My improved design for glass-ware is entirely of raised work, and consists of a main vine or stem, branch stems, leaf stems, and skeletons of leaves, all of prismatic shape, in cross-section; that is to say, the parts named have an outer face, which corresponds in shape to two sides of prism. The leaves between the sections are of raised roughened work. Such design may be arranged on or applied to any and all bowled or hollow articles of glass-ware.

As shown in the patent drawing (fig. 57), small leaves decorate the bottom of the bowl above the stem. The lid of the covered bowl (cat. 12) has small leaves around the base of the knob and a leaf on the top of the knob.

Fig. 57. Illustration of the Curled Leaf design on a form described in the patent as a fruit-dish, 1869. Design Patent No. 3,759.

12 Curled Leaf covered bowl lid

3½ × 7¾ inches (8.9 × 19.7 cm).

13 Curled Leaf low-footed covered bowl

8 × 8¼ inches (20.3 × 21 cm).

Loop and Dart (aka), 1869

Annie W. Henderson (1846–1909) of Pittsburgh patented the Loop and Dart design on June 1, 1869 (Design Patent No. 3,515). Henderson was an artist and superintendent of the Pittsburgh School of Design for Women founded in 1865 for the instruction of women in the arts.[10] She was a colleague of the well-known western Pennsylvania artist George Hetzel (1826–1899) and was associated with his Scalp Level school of artists, who were renowned for their landscapes painted onsite in western Pennsylvania.

Loop and Dart is attributed to Bryce, Walker because it shares several design elements with Palmette, an attributed Bryce, Walker pattern of the 1870s. Henderson's patent drawing illustrates a distinctive knob with six flat panels, a pointed top, and raised diamonds around the edge. The identical knob appears on Loop and Dart and Palmette sugar bowls (cat. 14). The Loop and Dart sugar bowl has a stem with six flat panels that end in points on the foot and on the bowl, forming a six-pointed star. The identical star appears on the foot and bowl of Palmette sugar bowls. Finally, the lid of the Loop and Dart sugar bowl has a border of raised diamonds around the rim. The Palmette sugar bowl lid has the identical border.

14 Palmette, Loop and Dart sugar bowls

14.1. Palmette. 7⅜ × 4¼ inches (18.7 × 10.8 cm).
14.2. Loop and Dart. 7¾ × 4¼ inches (19.7 × 10.8 cm).

Palmette (aka), early 1870s

A pattern can be attributed to Bryce, Walker if it has a distinctive element that is identical to that found on an authenticated Bryce, Walker pattern. Standards (stem and foot) are one common element that may be used to attribute a pattern.

Some Palmette high-footed bowls (cat. 16) have a distinctive standard with an egg-and-dart border around the foot. The identical standard with egg-and-dart border is found with the patented Bryce, Walker patterns Grape Band (1869), Strawberry (1870),[11] and Thistle (1872; cat. 23). On that basis, Palmette can be attributed to Bryce, Walker and dated to the early 1870s.

Palmette is also featured on lamps (cats. 141.1–2). Palmette syrups have been found in opaque white, and it is possible other Palmette pieces were made in opaque white.

15 Palmette butter lid

2½ × 5¾ inches (6.4 × 14.6 cm).

16 Palmette high-footed bowl

7¾ × 8¼ inches (19.7 × 21 cm). The foot has an egg-and-dart border that is also found on Thistle high-footed bowls (cat. 23).

17 Palmette five-bottle caster set

17.1, 17.6. Bottles, no stoppers. 6¾ × 2⅛ inches (17.1 × 5.4 cm).

17.2. Metal holder. 11⅜ × 5⅞ inches (28.9 × 14.9 cm).

17.3, 17.5. Bottles with metal lids. 7 × 2⅛ inches (17.8 × 5.4 cm).

17.4. Small Jar with metal lid. 5⅝ × 2⅛ inches (14.3 × 5.4 cm).

Strawberry (aka), 1870

Aka Fairfax Strawberry

John Bryce patented his third naturalistic design, known as Strawberry, on February 22, 1870 (Design Patent No. 3,855; fig. 58). He described it as a glassware design "consisting of strawberry stems, leaves, and fruit, formed in relievo," and arranged substantially as follows:

> My improved design consists of a strawberry stem of raised prismatic form, leaves of raised and roughened work between the edges and skeletons, which latter are plain faced, and fruit of raised and roughened form, in resemblance of the appearance of the natural berry.
>
> The stems, with a portion of the vine, are of raised work of prismatic form in cross-section.
>
> The leaves have edges corresponding in cross-section to one face of a stem, and with skeletons of like unroughened form.

> The berries are of raised work, and are a *fac simile* of the natural strawberry, as near as may be.
>
> This design is formed on the glass by cutting the same out the of inner face of the mold in which the article of glassware is to be pressed.

The finial on lids in the Strawberry pattern is a three-dimensional strawberry with a pierced, curled stem (see fig. 18). Strawberry goblets have six-paneled stems that terminate in points to form a star that can be seen inside the bowl of the goblet. Other early Bryce, Walker goblets share this characteristic.

Bryce, Walker made Strawberry table sets, covered bowls, syrups, pickle dishes, egg cups, and goblets in opaque white as well as crystal (cat. 19).

18 Strawberry pitcher

Applied handle. 9 × 8 × 5 inches (22.9 × 20.3 × 12.7 cm).

19 Strawberry table set

Opaque white.
19.1. Spoon holder. 5¼ × 3⅜ inches (13.3 × 8.6 cm).
19.2. Sugar bowl. 7⅛ × 4 inches (18.1 × 10.2 cm).
19.3. Cream pitcher, applied handle. 5¾ × 4½ × 2⅞ inches (14.6 × 11.4 × 7.3 cm).
19.4. Butter. 4 × 6 inches (10.2 × 15.2 cm). *Collection of Brad Gougeon.*

Fig. 58. Illustration of the Strawberry design, 1870. Design Patent No. 3,855.

Filley (omn), circa 1870

Aka Texas Bull's Eye

Filley is a documented Bryce, Walker pattern illustrated in the Factory B Catalogue. It was made as early as 1870, based on its illustration in a Chauncey I. Filley wholesale catalogue of circa 1870. It is also found on early lamp fonts. Filley was made in crystal and opaque white.

20 Filley egg cup

Opaque white. 4¼ × 2⅝ inches (10.8 × 6.7 cm).
Collection of Terri Frauzel.

Birch Leaf (aka), circa 1870

A Chauncey I. Filley catalogue of circa 1870 illustrates high-footed covered bowls in both the Filley and Birch Leaf patterns. The standards on both bowls are identical, and the same standard is found on Tulip with Sawtooth high-footed bowls (cat. 6). Birch Leaf can be attributed to Bryce, Walker based on the identical standard and dated circa 1870 based on the Chauncey I. Filley catalogue illustration. Birch Leaf was made in crystal and opaque white.

21 Birch Leaf table set

Opaque white.
21.1. Spoon holder. 5½ × 3½ inches (14 × 8.9 cm).
21.2. Sugar bowl. 7½ × 4⅛ inches (19.1 × 10.5 cm). *Collection of Brad Gougeon.*
21.3. Cream pitcher, applied handle. 6 × 5¼ × 3 inches (15.2 × 13.3 × 7.6 cm).
21.4. Butter. 4½ × 6 inches (11.4 × 15.2 cm).

Thistle (aka), 1872

Aka Scotch Thistle

John Bryce patented his fourth naturalistic design, known as Thistle, on April 2, 1872 (Design Patent No. 5,742). It may have been a nod to the Bryces' Scottish heritage, as thistle is the national flower of Scotland. Unlike his previous patent illustrations showing the design on a bowl (figs. 56–58), the Thistle patent includes a cross-section view of a glass pressing mold where the design appears in reverse (fig. 59). John Bryce described his design in the patent:

> My design, as represented on the sides of the mold cavity, shows a Scotch thistle, consisting of the stems, leaves, and flowers, so connected and repeated as to form a wreath. The leaves are striated, so as to represent the lines or striations of the natural leaf, and have a roughened surface.

Finials in the Thistle pattern are three-dimensional thistle blossoms with stems (see fig. 6). The Thistle goblet's six-paneled stem terminates in points on the base of the bowl so a six-pointed star is visible inside the bowl of the goblet, similar to other early Bryce, Walker goblets.

Thistle goblets have been reproduced, sometimes with cranberry or ruby stain and an *R* in a shield on the bottom of the foot.[12]

Fig. 59. Illustration of the Thistle design, 1872. Design Patent No. 5,742.

22 Thistle high-footed bowl, interior

11 × 8⅛ inches (27.9 × 20.6 cm).

23 Thistle high-footed covered bowl

11 × 8⅛ inches (27.9 × 20.6 cm). The foot has an egg-and-dart
border that is also found on Palmette high-footed bowls (cat. 16).

Diamond Sunburst (aka), 1874

John Bryce patented his first geometric design, known as Diamond Sunburst, on December 22, 1874 (Design Patent No. 7,948; fig. 60). He envisioned that the raised design could be used to ornament "glassware such as bowls, tureens, dishes, plates, saucers, and other similar articles designed for table and other purposes." He described his design in the patent:

> A series of arcs struck alternately in opposite directions from springing points arranged at uniform distances in a circle around the bottom or body of the dish or vessel, the converging arcs meeting each other at their terminations, the whole forming a series of double equilateral arches around the under surface or body of the dish. The arcs are formed of parallel raised beads, cast, stamped, or otherwise produced, the crowns of the arches being formed at the junctures of the arcs, and the crowns of the arches at the intersections of the arcs. These lines, in crossing each other at their intersections,

form polygonal or square figures. The spaces under the arches are ornamented by fan-shaped figures and the spaces between the upper parts of the arches by similar figures. These spaces are formed by round or angular raised beads, crossing each other at proper angles. Under the upper parts of the arches are formed a series of square or diamond-shaped ornaments, alternately plain or beaded. The whole design, as above described, is formed upon the glass in raised figures or ribs by casting, cutting, blowing, or pressing in the ordinary manner, well known to workers in glass.

Lids in this pattern have a distinctive finial shaped like a crown, which was also used on lids in the Geddes pattern (see fig. 26). Diamond Sunburst fonts were featured on lamps (cat. 140). Opaque white Diamond Sunburst syrups also have been found (cat. 34, fig. 32).

24 Diamond Sunburst berry plate

1 × 4⅛ inches (2.5 × 10.5 cm).

Fig. 60. Illustration of the Diamond Sunburst design, 1874. Design Patent No. 7,948.

25 Diamond Sunburst high-footed covered bowl

10½ × 7⅛ inches (26.7 × 18.1 cm).

26 Thistle, Maltese, Diamond Sunburst covered bowls

26.1. Thistle high-footed covered bowl, 1872. 11¼ × 8⅛ inches (28.6 × 20.6 cm).
26.2. Maltese low-footed covered bowl, 1876. 8¼ × 6¾ inches (21 × 17.1 cm).
26.3. Diamond Sunburst high-footed covered bowl, 1874. 10½ × 7⅛ inches (26.7 × 18.1 cm).

New York (omn), 1870s

New York is a documented Bryce, Walker pattern illustrated in the Factory B Catalogue. It was made by multiple manufacturers, which sometimes makes it difficult to attribute a particular piece to Bryce. This high-footed bowl can be attributed to Bryce, Walker because the identical standard was used on similarly sized bowls in Palmette, an attributed Bryce, Walker pattern of the 1870s.

27 New York high-footed bowl

$6\frac{5}{8} \times 7\frac{1}{8}$ inches (16.8×18.1 cm).

Maltese (omn), 1876

Aka Jacob's Ladder, Imperial

John Bryce patented a second geometric design he called "Imperial Pattern" on June 13, 1876 (Design Patent No. 9,335; fig. 61). This is the only design John Bryce named in a patent, but the name he selected was not used by the manufacturer. The original manufacturer's name for this pattern was Maltese, and it is more commonly known among collectors as Jacob's Ladder. Maltese, one of Bryce's most popular designs, is illustrated in the Factory B Catalogue.

Covered bowls in this pattern have a Maltese Cross finial on the lid, which was also used on lids in the Orient pattern made during the same period (cat. 37; see also fig. 1). In addition, Bryce made Maltese Cross stoppers that were used with cruets in several patterns, sometimes in colors (cat. 50).

Maltese is occasionally also found in amber, blue, canary, and amethyst. The syrup pictured here (cat. 34) is a rare example of Maltese in opaque white.

28 Maltese Cruet with Hand and Bar stopper

7¾ × 2½ × 3¼ inches (19.7 × 6.4 × 8.3 cm). In 1885, Spelman Brothers advertised this cruet with a Maltese Cross stopper as a "Large Pitcher Cologne." It is not the same shape as the amethyst Maltese cruet (cat. 50.4), the most noticeable differences being the shape of the lower part of the bottle and the foot.

Fig. 61. Illustration of the Maltese design, 1876. Design Patent No. 9,335.

29 Maltese high-footed covered bowl

11¼ × 7¾ inches (28.6 × 19.7 cm).

30 Maltese high-footed bowl, interior

9⅛ × 9½ inches diameter (23.2 × 24.1 cm).
Collection of Carolyn Coulson.

31 Maltese celeries

Amber, canary, blue, mid-1880s. 9½ × 4¼ inches (24.1 × 10.8 cm).
31.1 *Collection of John and Alice Ahlfeld; 31.2–31.3 Collection of Jim Masterson.*

32 Maltese pickle caster with metal frame, lid, and tongs

Jar. 4⅜ × 3¼ inches (11.1 × 8.3 cm).
Frame. 9⅝ × 4½ inches (24.4 × 11.4 cm).
As explained in *Homestead Glass Works, Bryce, Higbee & Company*, Victorians didn't limit pickling to little cucumbers. Other vegetables and fruits such as green tomatoes, cantaloupes, watermelon rind, and walnuts were pickled to make condiments and as a means to preserve food. Metal companies purchased glass pickle jars such as this one and fitted them with metal frames, lids, and tongs, then sold them as their own product.

33 Maltese bowl with dolphin standard

9 × 10¾ × 7½ inches (22.9 × 27.3 × 19.1 cm). The dolphin stem is on an oval foot. The oval bowl also came in a smaller size (8⅞ × 9⅞ × 6⅞ inches, 22.5 × 25.1 × 17.5 cm). Both sizes are in the collection of the Metropolitan Museum of Art, New York (46.140.853, 46.140.854). The same dolphin stem with different decoration around the oval foot was also used with an openwork dish (cats. 126–27).

34 Maltese, Grape Band, Diamond Sunburst syrups

Opaque white.
34.1. Maltese, 1876. 8½ × 5 × 4 inches (21.6 × 12.7 × 10.2 cm).
34.2. Grape Band, applied handle, 1869. 6¾ × 4¾ × 4 inches (17.1 × 12.1 × 10.2 cm). *Collection of Brad Gougeon.*
34.3. Diamond Sunburst, applied handle, 1874. 7¾ × 5 × 4⅛ inches (19.7 × 12.7 × 10.5 cm).

35 Maltese syrup lid
(detail, cat. 34.1)

Orient (omn), circa 1877

Aka Buckle and Star

Orient is a documented Bryce, Walker pattern illustrated in the Factory B Catalogue. It was made as early as 1877, based on its illustration in the F. H. Lovell & Co. *Catalogue of 1877 & 8* (plate 102). That catalogue illustrates more than thirty-five pieces in the Orient pattern and includes the handwritten note "BW & Co.," indicating that Bryce, Walker was the maker. Orient was made primarily in crystal, but Orient syrups have also been found in light amber, blue, and amethyst.

Lids in the Orient pattern have a Maltese Cross finial that is identical to the finial used on lids in the Maltese pattern (cats. 29, 37; fig. 1).

36 Orient syrups

Light amber, amethyst, mid-1880s. 7¾ × 5½ × 4½ inches (19.7 × 14 × 11.4 cm).
Collection of Brad Gougeon.

37 Orient butter

5 × 6¼ inches (12.7 × 15.9 cm).

38 Orient butter base, interior

1⅝ × 6¼ inches (4.1 × 15.9 cm).

Geddes (aka), circa 1877

Aka Star Band

Geddes is a simple but elegant geometric pattern consisting of a row of diamonds over a band. Each diamond features a six-pointed star in the hexagonal space in the center. Geddes is attributed to Bryce, Walker because the distinctive crown-shaped finial used on Diamond Sunburst lids was also used on Geddes lids.

Geddes also shares some design elements with No. 80 aka Star in Honeycomb or Leverne, a documented Bryce, Walker pattern introduced in 1880. No. 80 has a similar band of diamonds with stars, but it is greatly embellished with elaborate designs in and around the star band. The

similarities between the two patterns are particularly noticeable in pickle dishes. The No. 80 pickle dish (cat. 45) has the identical shape, scalloped edge, and handles as the Geddes pickle dish. Most obviously, both have the identical center medallion. Plates in both patterns feature identical center medallions that are a more rounded version of the pickle dish medallion.

Geddes was made as early as 1877, based on the illustration of a Geddes lamp font in F. H. Lovell & Co.'s *Catalogue of 1877 & 8* (fig. 82). For Geddes lamps, see cats. 142–43.

39 Geddes pitcher

Applied handle. 7½ × 7⅜ × 4¾ inches (19.1 × 18.7 × 12.1 cm).

Swiss (omn), circa 1877

Aka Beads in Relief, Grape with Scroll Medallion

Swiss is attributed to Bryce, Walker and dated based on its illustration in F. H. Lovell & Co.'s *Catalogue of 1877 & 8* (plate 107), which contains period handwritten notes recording pattern names and makers. Lovell illustrated a Swiss table set that was annotated with the description "Swiss Set, BW & Co.," an abbreviation for Bryce, Walker & Co. Swiss does not appear in the known pages of the Factory B Catalogue.

Bryce made Swiss table sets in crystal and opaque white. Bryce also made a set of three graduated mugs in the Swiss pattern in crystal, blue, opaque white, and opaque blue, with two different styles of handles. The smallest mug (cat. 40) is 1⅞ inches high and the largest is 3¼ inches high. The medium mug is 2¼ inches high. The two larger mugs have an open space on the front between the scrolls.

40 Swiss mug, small

Opaque blue.
1⅞ × 2⅜ × 1¾ inches (4.8 × 6 × 4.4 cm).

41 Swiss butter lid

2⅝ × 5½ inches (6.7 × 14 cm).

42 Swiss sugar bowl

Opaque white. 6¼ × 4⅜ inches (15.9 × 11.1 cm).
Collection of Brad Gougeon.

No. 79 (omn), 1879

Aka Chain with Star

No. 79, also known as Chain with Star, is a documented pattern illustrated in the Factory B Catalogue. Bryce, Walker introduced it in 1879 according to trade journal reports. Both the *American Pottery & Glassware Reporter* and the *Crockery & Glass Journal* previewed it as a new pattern in September 1879. Both journals noted that the bowl and lid of each article were scalloped with handsome ornamentation.[13]

43 No. 79 butter

4¼ × 6⅜ inches (10.8 × 16.2 cm).

No. 80 (omn), 1880

Aka Star in Honeycomb, Leverne

No. 80, also known as Star in Honeycomb or Leverne, is a documented pattern illustrated in the Factory B Catalogue. Bryce, Walker introduced it in 1880, according to the *American Pottery & Glassware Reporter* (February 12, 1880): "They have added several new styles to their line of ware, most noteworthy of which is their No. 80, a very handsomely ornamented set in pressed ware. The handled pieces in this set especially notable for neatness and strength. The bowls have also octagonal feet, a praiseworthy innovation." Octagonal feet were used on high-footed covered bowls (cat. 47) and salvers (cake stands), and represented a departure from earlier designs with round feet.

No. 80 shares some design elements with the earlier Geddes pattern, including the star band motif and identical center medallions on pickle dishes and plates (cat. 45).

A No. 80 pitcher with a molded handle was advertised as available in assorted colors in Butler Brothers, *"Our Drummer"* (Dull Season 1887).

44 No. 80 wine

Amber, mid-1880s.
3¾ × 2 inches (9.5 × 5.1 cm).

45 No. 80 pickle dish

1¼ × 9½ × 5⅝ inches (3.2 × 24.1 × 14.3 cm).

46 No. 80 pitcher, butter, cruet

46.1. Pitcher, applied handle. 7⅞ × 7¼ × 5 inches (20 × 18.4 × 12.7 cm).
46.2. Butter. 4¼ × 6 inches (10.8 × 15.2 cm). The finial on the butter was also used for cruet stoppers.
46.3. Cruet with stopper, applied handle. 7⅜ × 3 × 2½ inches (18.7 × 7.6 × 6.4 cm).

47 No. 80 high-footed covered bowl

12⅝ × 8½ inches (32.1 × 21.6 cm). The trade journals noted that the octagonal foot on this piece was a "praiseworthy innovation."

No. 85 (omn), 1880

Aka Double Vine

A No. 85 aka Double Vine bread plate (cat. 48; fig. 54) is illustrated in the Factory B Catalogue. Bryce, Walker introduced it in 1880, as described in the *Crockery & Glass Journal* (July 8, 1880): "[Bryce, Walker's] latest novelties include a bread-plate of which the mold shop seem very proud. It is ornamented with a double wreath, frosted in imitation of acid, the leaves appearing in the clear, while the remainder of the dish is frosted."

Bryce, Walker also made an asymmetrical No. 85 pickle dish tapered at one end with a central medallion. The *American Pottery & Glassware Reporter* (February 3, 1881) noted the "very pretty" No. 85 pickle dish.

48 No. 85 bread plate

1⅛ × 10¾ inches (2.9 × 27.3 cm).

No. 90 (omn), 1880

Aka Hand and Bar

No. 90, more commonly known as Hand and Bar, is a documented pattern illustrated in the Factory B Catalogue. It was available plain or engraved. Bryce, Walker introduced it in 1880, as reported in the *American Pottery & Glassware Reporter* (June 24, 1880):

> Bryce, Walker & Co., this city, will have ready for the fall some very attractive new styles of ware including two sets of table ware, Nos. 90 [aka Hand and Bar] and 95 [aka Inominata] in their catalogue. Both of these are in plain crystal glass, of good proportions and fine shape, one large in size, the other medium; one with large [No. 90] and the other with small scallops [No. 95]. They will include everything usually made in glass for table service, from largest bowls down to four-inch nappies. These are made of the clearest glass, are very nice looking sets, and would set off any table.

This report fails to mention the most distinctive characteristic of this pattern—the finial of a hand with fingernails holding a bar (see fig. 49). O'Hara Glass Company of Pittsburgh also made a hand and bar finial, but the Bryce Hand and Bar can be distinguished because when used as a finial it sits on a scalloped base.

Bryce also used the Hand and Bar design for cruet stoppers. In the mid-1880s, Bryce Brothers made colored cruets in several patterns with Hand and Bar stoppers (cat. 50). A hand holding a ring also adorns the handle of the Princess salt and pepper caster (cat. 60).

49 No. 90 sugar bowl

8⅝ × 4¾ inches (21.9 × 12.1 cm).

50 Cruets with stoppers

Mid-1880s.
50.1. Crystal No. 103 aka Prism and Diamond Points cruet. 8¼ × 3 × 2½ inches (21 × 7.6 × 6.4 cm).
50.2. Blue Diamond cruet. 8¼ × 3 × 2½ inches (21 × 7.6 × 6.4 cm).
50.3. Light amber cruet. 7⅝ × 2 × 3 inches (19.4 × 5.1 × 7.6 cm). This cruet has not yet been authenticated but it has characteristics that point toward Bryce as the maker, including the shape and attachment of the handle as well as the Maltese Cross stopper.
50.4. Amethyst Maltese aka Jacob's Ladder or Imperial cruet. 7⅞ × 2¾ × 3½ inches (20 × 7 × 8.9 cm). An amethyst Maltese cruet with a Hand and Bar stopper is in the collection of the Metropolitan Museum of Art, New York (46.140.293a, b).
50.5. Amber No. 103 aka Prism and Diamond Points cruet. 7½ × 2½ × 3 inches (19.1 × 6.4 × 7.6 cm).
Colored cruets collections of Brad Gougeon and Mary Lamica.

Jasper (omn), circa 1880

Aka Belt Buckle, Late Buckle

Jasper is a documented pattern illustrated in the Factory B Catalogue. It has been found in crystal, amber, and blue.

Jasper, Colossus, and Beaded Oval and Scroll share three identical elements: a distinctive finial, the standard on high-footed bowls, and the center medallion on pickle dishes. Because Jasper is a documented pattern, Beaded Oval and Scroll and Colossus can be attributed to Bryce, Walker based on identical elements.

All three patterns were probably made in the late 1870s or early 1880s, based on identical elements with other Bryce, Walker patterns of the late 1870s. The standard these patterns share was also used on Orient and No. 79. The center medallion used on Jasper pickle dishes was also used with the Thistle, Diamond Sunburst, Maltese, Orient, and Palmette patterns.

51 Jasper pickle dish

Blue, mid-1880s. 1⅜ × 5½ × 9¾ inches (3.5 × 14 × 24.8 cm).

Colossus (aka), circa 1880

Aka Lacy Spiral

Colossus is attributed to Bryce, Walker and dated circa 1880 based on identical elements with Jasper, a documented Bryce, Walker pattern.

52 Colossus high-footed bowl, interior

7½ × 8¾ inches (19.1 × 22.2 cm).

Beaded Oval and Scroll (aka), circa 1881

Aka Dot

Beaded Oval and Scroll is attributed to Bryce, Walker based on identical elements with Jasper, a documented Bryce, Walker pattern. A Beaded Oval and Scroll table set is illustrated in Spelman Brothers' *Fancy Goods Graphic* wholesale catalogue (February 1881).

53 Beaded Oval and Scroll butter

5 × 6¼ inches (12.7 × 15.9 cm).

54 Beaded Oval and Scroll butter base, interior

1⅝ × 6¼ inches (4.1 × 15.9 cm).

Ruby (omn), 1881

Aka Beaded Band

Ruby is a documented Bryce, Walker pattern introduced in 1881. The *American Pottery & Glassware Reporter* (February 3, 1881) noted a table set in this pattern and described it as "good design, tasteful ornamentation and very bright and clear."

A Ruby syrup (cat. 56) with a different lid is illustrated in the Factory B Catalogue, labeled "Ruby Can." The shape of this syrup is nearly identical to the shape of the No. 95 aka Inominata syrup, also illustrated in the Factory B Catalogue. The same distinctive handle was used on both syrups. No. 95 was introduced in 1880, as reported in the *American Pottery & Glassware Reporter* (June 24, 1880).

55 Ruby pickle dish

1⅜ × 8⅝ × 5¼ inches (3.5 × 21.9 × 13.3 cm).

56 Ruby syrup

8¼ × 5⅜ × 4¼ inches (21 × 13.7 × 10.8 cm). The lid is marked "PEERLESS PAT. Oct. 31, 1871 & C."

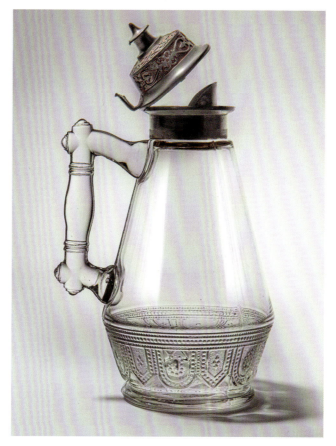

Ambidextrous (aka), 1881

Ambidextrous is one of the more unusual Bryce, Walker patterns. The cream pitcher (cat. 57) is symmetrical and could be picked up and poured from either side. Henry J. Smith patented the design and assigned the patent to Bryce, Walker on March 15, 1881 (Design Patent No. 12,189). Smith described his design:

> The leading feature of my design consists in the upward and outward curvature of the two pouring-lips in opposite directions from the top of the vase or main body of the pitcher, and the arrangement of the two handles on opposite sides of the pitcher and under the curves of the lips, thus giving the article a symmetrical and balanced effect to the eye.

The design also consists in the handles, each formed of two rings joined edgewise, one below the other, and projecting from the vase or main body of the pitcher directly under the curves of the lips.

The separate features, while being ornamental and of pleasing appearance in themselves, combine to form a unitary effect of symmetry and graceful poise.

The patent refers only to a cream pitcher (fig. 62), but Bryce, Walker made an Ambidextrous table set that also included a spoon holder, sugar bowl, and butter.

Henry J. Smith was listed as a mold maker in the 1890 Pittsburgh city directory, and city directories as early as 1862 listed a Henry Smith (no middle initial) as a "moulder" or "mouldmaker."[14] The directories do not record where he was employed.

Fig. 62. Illustration of the Ambidextrous cream pitcher, 1881. Design Patent No. 12,189.

57 Ambidextrous cream pitcher

6⅛ × 5½ × 3¼ inches (15.6 × 14 × 8.3 cm).
Collection of Gavin Ashworth.

Derby (omn), 1882

Aka Pleat and Panel

The *Crockery & Glass Journal* and *American Pottery & Glassware Reporter* both noted Bryce, Walker's introduction of the Derby line in early 1882.[15] Bryce Brothers continued to produce this popular pattern, and it is illustrated in the Factory B Catalogue. Derby was described as "one of the handsomest and picturesque" lines, containing at least thirty different forms.[16] It was made primarily in crystal with an occasional piece in amber, blue, canary, or amethyst.

Derby was popular and sales were good: "Bryce, Walker & Co. are having a good run on their 'Derby' pattern. They report that the design attracts general attention, and that a great deal of it is being disposed of."[17] Six years later, the *American Potter & Illuminator* advertised the Derby handled bread plate (cat. 58) as "a beauty and quick seller," retailing for ten cents.[18]

58 Derby bread plate with open handles

1¼ × 8½ × 13⅛ inches (3.2 × 21.6 × 33.3 cm).

Regal (omn), 1883

Aka Paneled Forget-Me-Not

Regal is a documented pattern illustrated in the Factory B Catalogue. Bryce Brothers introduced it with the Princess line in 1883, as reported in the *Crockery & Glass Journal* (January 18, 1883): "'Princess' and 'Regal' are both very handsome, and of great clearness and brilliancy. [Bryce Brothers] will make a full line of both. The former is perhaps as fine a piece of workmanship as has yet been brought out in pressed glassware, and the latter is also a pleasing design."

Bryce Brothers made Regal in crystal, amber, blue, canary, and amethyst.

59 Regal pitchers

59.1. Canary half-gallon pitcher. 9¼ × 8 × 5 inches (23.5 × 20.3 × 12.7 cm).
59.2–59.4. Blue, amber, amethyst quart pitchers. 8 × 6½ × 4¼ inches (20.3 × 16.5 × 10.8 cm).
Collection of Brad Gougeon.

Princess (omn), 1883

Aka Daisy and Button with Fine Cut Panels

The *Crockery & Glass Journal* (January 18, 1883) reported that Princess was a new full-line pattern that season. It has Daisy and Button panels on the sides and narrow Fine Cut panels on the ends. It was made in crystal, amber, blue, and canary. Spelman Brothers advertised a Princess nappy in green.[19]

The *American Pottery & Glassware Reporter* (January 11, 1883) compared it favorably to cut glass: "[Bryce's] new Princess pattern, just out, is a marvel of workmanship, and it requires a critical eye to distinguish between this and cut glass. It is an oval shape, and will assuredly be very popular."

Daisy and Button was a popular design in the 1880s that was made by multiple manufacturers. Bryce Brothers may have been the first to produce Daisy and Button, and Princess may be the first documented line to use that design.[20] Three pieces in the Princess pattern are illustrated in an assortment with documented Bryce Brothers products in *Our Leader Holiday Supplement*, published by B. Sommers & Co. of St. Paul, Minnesota, in 1883. These are the earliest known images of the Daisy and Button design.[21]

60 Princess salt & pepper caster handle

Threaded end. 5⅜ × 1⅞ × ¾ inches (13.7 × 4.8 × 1.9 cm).

The Factory B Catalogue illustrates two glass Princess casters: one is a two-bottle salt and pepper caster with a glass hand holding a ring as the handle (cat. 60; fig. 63); the other is a four-bottle caster with a Daisy and Button pattern on the base and Britannia trimmings. The introduction of both caster sets with a square shape was noted in the *American Pottery & Glassware Reporter* (January 10, 1884): "They have ready a very fine caster, containing four bottles, it is strong, handsome and of novel design. The shape is square, and the bottles are large and well fitted. They have also another caster with two holes, which is pretty and convenient."

Henry J. Smith patented the two-bottle caster on September 4, 1883 (Patent No. 284,499), and described his innovation in the patent:

> The object of my invention is to provide a glass cruet-caster capable of holding two or more bottles, and which will be cheap in construction, durable in use, and of highly ornamental appearance. My invention consists in a cruet-caster composed wholly of glass, having its frame pressed in a single piece and its handle in another piece, the two being united by a screw, and having the joint between them covered by a metal ferrule. . . . Cruet-stands constructed in this manner may be made of any desired form, and be ornamented in a great variety of styles. They are quickly and easily constructed, being pressed in molds or dies of the required form, and are not only cheap and durable, but are highly ornamental, even when made of plain glass, without decoration.

The patent does not mention the hand decorating the caster handle.

Fig. 63. Illustration of the Princess two-bottle caster, 1883. Patent No. 284,499.

61 Princess pitcher, goblet

Amber.

61.1. Half-gallon pitcher. 8⅞ × 8¾ × 4½ inches (22.5 × 22.2 × 11.4 cm). Butler Brothers described this pitcher in the 1888 Santa Claus Edition of its catalogue as "A 25¢ Wonder . . . To see it is to buy it."

61.2. Goblet. 6 × 3¼ inches (15.2 × 8.3 cm). This goblet has a flat stem with decoration on the front and back and plain, narrow sides. *Collection of Brad Gougeon.*

Fashion (omn), mid-1880s

Aka Daisy and Button

The Daisy and Button design was popular as early as 1883 when Bryce Brothers used it on its Princess line. It is illustrated in the Factory B Catalogue as the Fashion pattern. Bryce Brothers also used Daisy and Button on novelties such as toothpicks, slippers, canoes, and a fish-shaped nappy (cat. 109.2). Fashion was made in crystal, amber, blue, canary, amethyst, and crystal with ruby or rose stain.[22]

One of the reasons pressed glass surged in popularity in the mid-nineteenth century was that it was widely available and more affordable than blown and cut glass. The highest praise for pressed glass was to compare it favorably to cut glass, and that is what Butler Brothers stressed in its advertisements for the Daisy and Button pattern: "They are all of the elegant diamond star pattern, which so closely resembles cut glass that only experts can detect the difference. . . . So fine in design and finish as to be readily mistaken for the genuine expensive cut glass. They are beautiful beyond description."[23]

Two of the pieces pictured here (cat. 63) are illustrated in the Factory B Catalogue. The blue Fashion Cream No. 2 (cat. 63.3) is illustrated with a Fashion sugar bowl. Butler Brothers described the cream pitcher as "Cut Diamond Pitcher—Beautifully patterned and a cream favorite."[24]

The blue handled basket (cat. 63.6) is illustrated in the Factory B Catalogue as No. 1120 Basket. It is shown on a catalogue page with six variations of that form hand-tooled by the glassmaker from the same mold. In 1886, Butler Brothers advertised the basket as a twenty-five cent Glass Mantel Basket,[25] but just one year later it was listed as "The Best of all 10-Cent Leaders."[26] It was made in crystal, amber, blue, and canary.

The other items pictured here (cat. 63) appeared in wholesale catalogues in 1886–87. Butler Brothers described the amber cream pitcher (cat. 63.1) as "A Tiffany pattern, and an ornament to a Vanderbilt's table." It was made in crystal, amber, blue, and canary.[27] The canary jelly (cat. 63.2) was part of its "Tiffany" ten-cent assortment, described as useful "for table or a card basket."[28]

Butler Brothers illustrated the custard cup (cat. 63.7) in a five-cent assortment and described it as a "Handled Cup—A beauty for children or for custards, etc."[29] It was made in crystal, amber, blue, canary, and crystal with ruby stain. The small canary cream pitcher (cat. 63.8) is a companion to the custard cup, made in the same mold and shaped by hand. Spelman Brothers called it a Duke Cream and illustrated it in an assortment that included an egg cup (cat. 63.5), a Fashion toothpick, Small Slipper, Sandal, and Orion nappy (fig. 69). All were described as gems, "Artistic in style and brilliant in color," available in amber, blue, and canary.[30] The Duke Cream was also made in crystal with ruby stain.

The amethyst Fashion toothpick (cat. 63.4) is a modified form of the toothpick in the Spelman Brothers' assortment. Fashion toothpick holders were often hand-tooled into different forms (cat. 134).

Butler Brothers advertised the Fashion butter (cat. 62) as part of its "Sparkling Colored Assortment," available in amber, blue, and canary.[31] It was also made in opaque white and crystal with ruby or rose stain (cat. 65). In 1887 Missouri Glass Company described a crystal Fashion butter as "neat but not gaudy," wholesaling for $1.40 a dozen.[32]

62 Fashion butter

Blue. 5 × 7⅝ × 7⅝ inches
(12.7 × 19.4 × 19.4 cm).

63 Fashion assortment

63.1. Amber cream pitcher. 3⅝ × 4¾ × 3¾ inches (9.2 × 12.1 × 9.5 cm).

63.2. Canary jelly. 5 × 6 inches (12.7 × 15.2 cm).

63.3. Blue Fashion Cream No. 2. 3⅝ × 4¼ × 3½ inches (9.2 × 10.8 × 8.9 cm).

63.4. Amethyst toothpick holder. 2⅝ × 2⅞ inches (6.7 × 7.3 cm).

63.5. Amber egg cup. 2½ × 2⅛ inches (6.4 × 5.4 cm).

63.6. Blue No. 1120 Basket. 3⅞ × 6⅝ × 3⅜ inches (9.8 × 16.8 × 8.6 cm).

63.7. Crystal with ruby stain custard cup. 2⅛ × 3⅝ × 2⅝ inches (5.4 × 9.2 × 6.7 cm).

63.8. Canary Duke Cream. 2⅛ × 4 × 2⅝ inches (5.4 x10.2 × 6.7 cm).

63.1–63.5 *Collection of Brad Gougeon.*

64 Glassware with ruby or rose stain

64.1. Fashion cream pitcher with ruby-stained rim. 3½ × 3 × 3⅝ inches (8.9 × 7.6 × 9.2 cm). *Collection of Mary Lamica.*

64.2– 64.3. No. 5602 aka Peas and Pods wine glasses with ruby stain, one with etching. 4⅛ × 2 inches (10.5 × 5.1 cm). No. 5602 is illustrated in the Factory B Catalogue on a page with the heading "United States Glass Company, Factory B." It may have been introduced by U.S. Glass after the consolidation.

64.4. Fashion tumbler with ruby stain. 3½ × 2⅝ inches (8.9 × 6.7 cm).

64.5. Earl Ind. Boat with rose stain. 1⅛ × 4½ × ¾ inches (2.9 × 11.4 × 1.9 cm). *Collection of Kathy Grant.*

65 Fashion butter

Crystal with rose stain. 5 × 7⅝ × 7⅝ inches (12.7 × 19.4 × 19.4 cm).

Pert (omn), circa 1883

Aka Ribbed Forget-Me-Not

Pert is a documented pattern illustrated in the Factory B Catalogue. Bryce Brothers made a Pert table set, mug, and mustard pot in crystal, amber, blue, and canary. The lid of the Pert mustard pot (cat. 66) has a notch for a spoon, and Butler Brothers sometimes advertised it as including a boxwood spoon.[33] Pert was made as early as 1883, based on an illustration of a Pert table set in a Butler Brothers catalogue.[34]

Pert is a small set. The Pert cream pitcher, at 3⅞ inches high, is significantly smaller than the 5¼-inch-high Regal cream pitcher introduced about the same time. Pert may have been designed for smaller, more intimate gatherings or possibly as an individual set. Butler Brothers advertised it as a "Tete-a-Tete" set, "a little beauty in both shape and workmanship."[35]

66 Pert footed mustard pot

4⅜ × 2½ × 3⅜ inches (11.1 × 6.4 × 8.6 cm).
Collection of Mary Lamica.

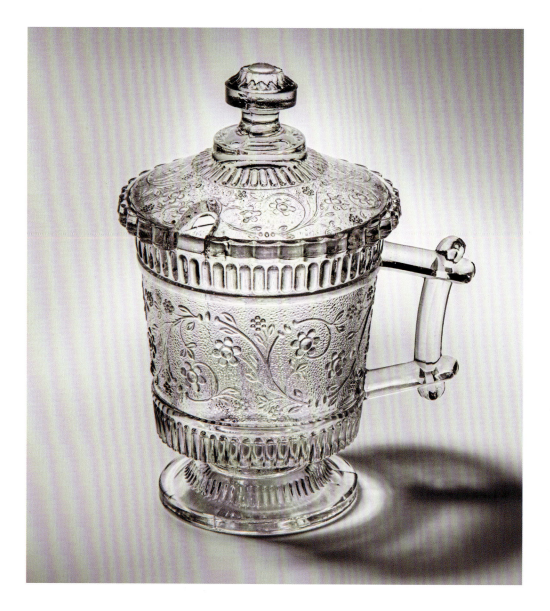

Monarch (omn), 1884

Aka Flat Oval

Period trade journals reported the introduction of new lines but usually did not describe them in detail. The Monarch line, introduced by Bryce Brothers in 1884, was an exception. It is not illustrated in the known pages of the Factory B Catalogue, and there are no known period illustrations. However, it was a unique design and the *American Pottery & Glassware Reporter* published such a detailed description of the pattern that it has been possible to identify tableware in that pattern:

> Bryce Brothers have now ready their new set, Monarch, and the name is an appropriate one, for it surpasses all their previous efforts. The sides of the pieces are plain glass, of oval shape, and they overlap the ends, which are moderately convex in form. This is a novel feature, and can be found in no other set. The pieces rest on four separate feet, diverging from nearly a common center, and they have no stem. There is not much figuring on this line, but what there is is of tasteful pattern. The sides being of clear glass give ample opportunity for the engraver's art, and they have skillfully availed themselves of it. The glass is very clear and brilliant and without flaw or crease, and it has a remarkably fine effect when held up to the light.[36]

Monarch was available plain or engraved and was made in crystal, amber, blue, canary, and amethyst. Monarch berry bowls have also been found in light amber and periwinkle blue.

67 Monarch berry bowls

Amethyst, amber, blue, canary. 4¼ × 3 × 3 inches (10.8 × 7.6 × 7.6 cm).
67.1, 67.4 *Collection of Brad Gougeon.*

Argent (omn), 1884

Aka Rope Band

Argent is a documented pattern illustrated in the Factory B Catalogue. Bryce Brothers introduced it in 1884, as reported in the *American Pottery & Glassware Reporter* (January 10, 1884): "Their new table set, Argent, is now ready, both plain and engraved, and it is a very handsome addition to their already large variety of sets. They are making no fewer than twenty-five different lines at present, so that the dealer must be exceptionally hard to please who cannot get what he wants here."

The medallion on the Argent plate (cat. 68) was used to decorate the top of the foot of the Argent standard (cat. 69). The same standard was used with an octagonal Fashion plate made in crystal, amber, blue, and canary, but Argent was made only in crystal.

68 Argent plate

1 × 7¼ × 7¼ inches (2.5 × 18.4 × 18.4 cm).

69 Argent high-footed bowl

8¾ × 9¾ inches (22.2 × 24.8 cm).

Argyle (omn), circa 1885

Aka Beaded Oval Window, Oval Medallion

An Argyle goblet is illustrated in the Factory B Catalogue; the pattern was made as early as 1885, based on a Butler Brothers' illustration of an Argyle footed comport.[37] Argyle was made in crystal, amber, blue, canary, and amethyst.

Some Argyle bread plates have a center medallion of a Maltese Cross encircled by the words "GIVE US THIS DAY / OUR DAILY BREAD" (cat. 71). Bread plates with this inscription were a popular Victorian novelty.

70 Argyle goblets

Blue, amethyst, amber, canary.
6⅛ × 3⅛ inches (15.6 × 7.9 cm).
Collection of Brad Gougeon.

71 Argyle oval bread plate, "GIVE US THIS DAY / OUR DAILY BREAD"

1½ × 8½ × 12½ inches
(3.8 × 21.6 × 31.8 cm).

Lorne (omn), circa 1885

The only form produced in the Lorne pattern was a butter made in crystal, amber, blue, canary, and amethyst. It was illustrated in the Factory B Catalogue and made as early as 1885, based on an illustration in Spelman Brothers.[38] The Lorne butter was advertised as late as 1915 in the U.S. Glass Mexican–South American catalogue, presumably old stock that was still available.

In 1882, Princess Louise, one of Queen Victoria's nine children, was the first English princess to visit California, where she stayed for several months. Her husband, John Campbell, Duke of Argyll, Marquis of Lorne, and 4th Governor General of Canada from 1878 to 1883, accompanied her. Bryce Brothers may have commemorated their royal visit by naming four patterns Princess, Regal, Argyle, and Lorne, and by producing a Star of Garter novelty plate (cat. 123).

72 Lorne butter

Canary. 4 × 7½ × 5½ inches (10.2 × 19.1 × 14 cm).

No. 1000 (omn), circa 1885

Aka Diamond Quilted

No. 1000 aka Diamond Quilted is a documented pattern illustrated in the Factory B Catalogue. Bryce Brothers made it in crystal, amber, blue, canary, and amethyst, as well as some additional colors not typically found in Bryce production—light amber, periwinkle blue, and light amethyst. Some mugs and pitchers have different colors on the handles and the bodies of the pieces (cats. 74.2, 74.6). The handle of this light amethyst half-gallon pitcher shows traces of darker amethyst that was not fully mixed into the batch (cat. 74.3).

The Diamond Quilted pattern appears on the body of the pieces, and flat pieces have a diagonal Fine Cut design on the base, as shown on the water tray (cat. 73). Some lids in this pattern have an unusually large hollow knob.[39]

Diamond Quilted was made as early as 1885 and was heavily promoted in wholesale catalogues of the late 1880s. Butler Brothers called it the new "Optic" pattern and illustrated several pieces described as "brilliant and beautiful beyond description . . . good enough for the 'Queen's table.'"[40]

Bryce Brothers' No. 900 and No. 1000 are sister lines. The pieces are the same shapes but No. 900 is plain where No. 1000 has quilted diamonds on the body of the piece.

73 No. 1000 water tray

Canary. 1⅝ × 13¾ × 14 inches (4.1 × 34.9 × 35.6 cm).
Collection of Brad Gougeon.

74 No. 1000 goblets, mugs, pitcher

74.1. Light amethyst goblet. 6⅝ × 3¼ inches (16.8 × 8.3 cm).

74.2. Amethyst mug with canary handle. 3⅝ × 2¾ inches (9.2 × 7 cm).

74.3. Light amethyst half-gallon pitcher. 9¼ × 8¾ × 5¾ inches (23.5 × 22.2 × 14.6 cm).

74.4. Periwinkle blue goblet. 6⅝ × 3¼ inches (16.8 × 8.3 cm).

74.5. Amethyst goblet. 6⅝ × 3¼ inches (16.8 × 8.3 cm).

74.6. Canary mug with blue handle. 3⅝ × 2¾ inches (9.2 × 7 cm).

74.7. Blue goblet. 6⅝ × 3¼ inches (16.8 × 8.3 cm).

Collection of Brad Gougeon.

75 No. 1000 table set, celery

Canary.
75.1. Sugar bowl. 9½ × 4⅝ inches (24.1 × 11.7 cm).
75.2. Celery. 8⅞ × 4½ inches (22.5 × 11.4 cm).
75.3. Spoon holder. 6 × 3¾ inches (15.2 × 9.5 cm).
75.4. Butter. 6¾ × 6⅝ inches (17.1 × 16.8 cm).
75.5. Cream pitcher. 6¾ × 5¾ × 3½ inches (17.1 × 14.6 × 8.9 cm).
Collection of Brad Gougeon.

76 Assorted tableware

Amethyst.
76.1. Orion goblet. 6⅛ × 3 inches (15.6 × 7.6 cm).
76.2. No. 1000 sugar bowl. 9½ × 4⅝ inches (24.1 × 11.7 cm). *Collection of Brad Gougeon.*
76.3. Orion high-footed bowl with ruffled rim. 6½ × 9¼ inches (16.5 × 23.5 cm). *Collection of Mary Lamica*
76.4. Bucket cream pitcher. 4⅜ × 5½ × 3¼ inches (11.1 × 14 × 8.3 cm).
76.5. No. 1000 comport. 4¼ × 9¼ inches (10.8 × 23.5 cm).

Orion (omn), 1886

Aka Cathedral

Orion is a documented pattern illustrated in the Factory B Catalogue. In 1886 the *Pottery & Glassware Reporter* described Bryce Brothers' colorful new line: "Their new line, which is now complete, is called the Orion, and they have this also in crystal, as well as colors, the latter including canary, amber, amethyst, blue, green and combinations of these colors. They have the nappies and bowls of this line scalloped as well as plain, and the former shape gives an agreeable contrast to the general run of ware. It will have a big run if merit is recognized as it should be."[41] Orion also was made in crystal with ruby or rose stain.

Orion may be the only Bryce Brothers pattern described in the trade journals as available in green.

Bryce Brothers produced a colorful collection of fish-shaped pickle dishes in the Orion pattern called Earl Pickles and a small fish-shaped nappy called the Duke Nappy (cats. 107–9). It also made a 12½-inch Canoe Celery and a boat-shaped 4½-inch Earl Ind. Boat in the Orion pattern (cats. 113.1, 114).

77 Orion bowls

77.1. Light amber footed bowl. 6¾ × 9¾ inches (17.1 × 24.8 cm).
77.2. Amethyst footed covered bowl. 7¼ × 10⅝ inches (18.4 × 27 cm).
77.3. Blue footed bowl with ruffled rim. 6⅝ × 9¼ inches (16.8 × 23.5 cm).

Puritan (omn), circa 1887

Puritan is a documented pattern illustrated in the Factory B Catalogue that was made in crystal, amber, blue, and crystal with ruby stain. It is dated circa 1887, based on the illustration of a Puritan celery in Butler Brothers, *"Our Drummer"* (Dull Season 1887). It was widely advertised in the wholesale catalogues of the late 1880s. Puritan is a cane design with alternating rows of diamonds and octagons, sometimes with an elaborate sixteen-pointed star with a raised center on the bottom. Bryce Brothers made both square and round versions of the Puritan table set.

Puritan is also the name given to a Daisy and Button canoe-shaped celery tray (cat. 111), but it is not known why the two seemingly unrelated items were given the same name.

78 Puritan nappy

4½ × 9½ inches (11.4 × 24.1 cm).

79 Puritan cream pitcher, celery, spoon holder

79.1. Amber cream pitcher. 5⅛ × 5⅜ × 3 inches (13 × 13.7 × 7.6 cm).
79.2. Blue celery. 4½ × 4⅜ × 3 inches (11.4 × 11.1 × 7.6 cm).
79.3. Crystal with ruby stain spoon holder. 4 × 3 × 3 inches (10.2 × 7.6 × 7.6 cm).
79.1–79.2 *Collection of Brad Gougeon.*

Wreath (omn), circa 1887

Aka Willow Oak

Wreath is a documented pattern illustrated in the Factory B Catalogue that was made in crystal, amber, blue, and canary. Wreath is dated circa 1887, based on wholesale catalogues. Butler Brothers advertised an eight-piece crystal water set in this pattern, including a half-gallon pitcher, 11-inch tray, and six tumblers, as "the cheapest set in the world," wholesaling for thirty-nine cents a set.[42]

In February 1888, the *American Potter & Illuminator* advertised the Wreath butter (cat. 80) as the "Oak Leaf Butter Dish. A fine piece with four handles, this will add to the usefulness of the article. A bargain to sell at 10 cents."[43]

80 Wreath butter

Amber. 5½ × 7¾ × 7¾ inches (14 × 19.7 × 19.7 cm).

81 Wreath high-footed covered bowl, celery, pitcher

Blue.
81.1. High-footed covered bowl. 11½ × 7¼ inches (29.2 × 18.4 cm).
81.2. Celery. 8 × 4 inches (20.3 × 10.2 cm).
81.3. Half-gallon pitcher. 9⅛ × 7½ × 4½ inches (23.2 × 19.1 × 11.4 cm).

Duquesne (omn), circa 1887

Aka Wheat and Barley

Duquesne is a documented pattern illustrated in the Factory B Catalogue that was made in crystal, amber, blue, and canary.[44] It was produced as early as 1887, based on the illustration of a Duquesne table set in a Butler Brothers catalogue, where it was described as "A new set that will immediately pave its way into the good graces of the bargain-seeking merchants. It is full size, handsomely designed, and at this price will prove a ready 'money maker,'" retailing at twenty-five cents a set.[45]

82 Duquesne handled bread plate

1 × 11 × 9¼ inches (2.5 × 27.9 × 23.5 cm).

83 Duquesne jelly

Blue. 4½ × 4½ inches (11.4 × 11.4 cm).

Sultan (omn), 1888

Aka Curtain

The *Crockery & Glass Journal* (June 28, 1888) reported the introduction of the Sultan pattern: "Bryce Bro. have their new tableware line completed. They call it the 'Sultan' and in shape and pattern it is a credit to the firm. This is a line to command the attention of the trade."

Sultan is not illustrated in the known pages of the Factory B Catalogue but it appears in multiple wholesale catalogues of the late 1880s. Butler Brothers called it the Dewdrop pattern,

"the newest and richest perfection of art in glass making," and illustrated it in its "Swell" assortment: "When we can give to the *masses* a lot of *real gems* at a price *equally low* with ordinary *common place ware* then we feel at liberty to call it our *Swell Assortment*."[46]

The amber Sultan mug is an uncommon example of Sultan in color (cat. 84).

84 Sultan mug

Amber. 3¾ × 3⅛ inches (9.5 × 7.9 cm).
Collection of Brad Gougeon.

85 Sultan high-footed covered bowl

12⅞ × 8½ inches (32.7 × 21.6 cm).

Magic (omn), 1889

Aka Rosette

Magic is a documented pattern illustrated on multiple pages of the Factory B Catalogue. It was a moderately-priced line Bryce Brothers introduced in 1889 along with Coral and the higher-priced Atlas line. Magic is generally found in crystal, but a rare blue spoon holder is pictured in *Early American Pattern Glass*.[47]

The *Pottery & Glassware Reporter* (December 20, 1888) described the new lines: "They have now ready two entirely new lines of tableware, the 'Coral' and the 'Magic.' These are elegant patterns and are to be offered at moderate prices. One is a handsome figured set, decorated with spangles and other devices and it will have a big run."[48] The *Crockery & Glass Journal* described Bryce Brothers' new offerings as "equaled by few and eclipsed by none."[49]

86 Magic pickle dish

1 × 4¾ × 8¼ inches (2.5 × 12.1 × 21 cm).

Coral (omn), 1889

Aka Fishscale

Coral is also known as Fishscale because the pattern looks like the overlapping scales of a fish. It is a documented pattern illustrated on multiple pages of the Factory B Catalogue. Bryce Brothers produced it in crystal, and occasionally it is found in crystal with ruby stain. It was a moderately priced tableware line introduced in 1889 with Magic and Atlas. The *Pottery & Glassware Reporter* described this pattern: "[Coral] is an exceedingly attractive design, the pieces being shapely and tasteful with the ornamentation consisting chiefly of alternate perpendicular stripes of clear and what appears the same as frosted glass. The effect is very fine and besides it is out of the common."[50]

Two years before the introduction of the Coral tableware line, Bryce Brothers used the pattern in its Small Slipper Nappy aka Slipper on a Tray, a novelty consisting of a Daisy and Button Small Slipper attached to a Coral tray (cat. 104), made as early as 1887.[51] Unlike Coral tableware, the Slipper on a Tray was made in colors.

87 Coral pickle dish

1⅛ × 8⅜ × 4⅛ inches
(2.9 × 21.3 × 10.5 cm).

88 Coral nappy and cover

4¾ × 7 inches
(12.1 × 17.8 cm).

Atlas (omn), 1889

Aka Crystal Ball

Henry J. Smith patented the Atlas tableware design and assigned the patent to Bryce Brothers on November 12, 1889 (Design Patent No. 19,427; fig. 64). Smith described his design as having "projecting spherical knobs or bosses arranged in a series around the vessel at the base thereof. These knobs or bosses are partly above the base-line of the body portion and partly below it, so as to impart to them the appearance of pendent knobs or drops" with "a star figure within the circle formed by the knobs, having radially-directed spikes."

89 Atlas engraved goblet

6 × 2⅞ inches (15.2 × 7.3 cm).

The *Pottery & Glassware Reporter* (January 31, 1889) described the Atlas pattern:

> The glass glistens like polished silver and is without streak or flaw, and the whole effect is brilliant. The shapes are round, and the only figuring is a large star on the bottoms. Encircling each piece is a row of balls, very clear and bright and solidly attached and the effect of them is so striking that the pieces look almost as well plain as engraved, for they have the line in both. The pitchers are very handsome and the whole design original. It is a large line, comprising set, low and footed bowls, both straight and flaring pitchers of the usual sizes, comports, nappies, salts with mounted tops, celeries and so forth. Nothing finer than this has been got out this season and that it will have a big sale is a matter of course.

The Factory B Catalogue includes more than ninety images of plain and engraved Atlas articles. "[Atlas] is one of the best-selling lines in the market and always stood on its merits; with the new additions [of tankards and stemware] it is one of the most extensive lines in the country, and a better shaped and finished, more tasteful and more elegant pattern cannot be got."[52]

Atlas was a higher-priced line introduced with Coral and Magic, both moderately priced lines.[53] It was not made in color, but opaque white toothpick holders and a few pieces with ruby stain have been found.

Fig. 64. Illustration of the Atlas design, 1889.
Design Patent No. 19,427.

Amazon (omn), 1890

Aka Sawtooth Band

Bryce Brothers introduced Amazon for the 1890 selling season, and fifteen pages of the Factory B Catalogue illustrate this pattern.[54] It was sold plain or engraved and advertised as available in sixty-five different pieces. Amazon is decorated with bands of Sawtooth, a design Bryce had been producing since the 1850s. It was made in crystal with a limited number of forms in opaque white or with ruby stain.

> Bryce Bros. will show two new patterns to the trade the coming season which will be "eye-openers" in every respect. The first of these, which they have styled the "Amazon," is mostly plain, with sharp diamond-shaped ornaments around the upper edges of the pieces. Those articles having lids have the diamonds pendent from them, and this is a most attractive feature of the design, which is altogether original and unique. The glass is of the clearest and most brilliant kind and altogether free from mold marks, and they contemplate having this pattern engraved in many elegant designs, for which it is appropriately suited. There will be a full line of this ware, comprising set and the other customary articles and besides these there will be a bouquet holder, of new and attractive shape, one of the most beautiful things in the line, salad, cake basket, comports in three sizes of original shapes, and entirely new, orange bowls and other pieces. This line is bound to be the attraction of the season and dealers coming to town should see it the first thing.[55]

The opaque white covered deep dish (cat. 90) has lion heads on the handles and finial (see fig. 34). It was illustrated in an 1890 Bryce Brothers advertisement (see fig. 51). Lion-head handles were also used on nappies in this pattern.

90 Amazon covered deep dish with lion-head handles and finial

Opaque white. 5½ × 9⅜ × 6 inches (14 × 23.8 × 15.2 cm). Also made in a smaller size with a 7-inch (17.8 cm) bowl. *Collection of Brad Gougeon.*

Brazil (omn), 1890

Aka Paneled Daisy

Brazil is a documented pattern illustrated on seven pages of the Factory B Catalogue. It was made in crystal, amber, blue, and opaque white. Most pieces are pressed, but the sugar shaker and syrup (cats. 92.1–2) are blown-molded.

Bryce Brothers introduced Brazil and Amazon together for the 1890 selling season: "Bryce Bros. have two complete new lines for the spring season, and they take a place second to none and to this there is no exception. They are the 'Amazon' and the 'Brazil,' the former a plain line and the latter a figured one."[56]

The *Crockery & Glass Journal* noted that "Brazil, which is a low-priced line, is also doing well being the thing for those who want or need a line at a cheap price. The outlook altogether is of a very hopeful nature."[57]

Butler Brothers advertised an opaque white Brazil table set in 1891 as "Our 'Purity' Opal Table Set. Best 50-Cent Value Yet Offered. A beautiful product of pure white opal, exquisitely molded and ornamented with handsome raised pattern. The richest thing ever offered for the 50-cent trade."[58]

91 Brazil dish

1¾ × 8½ × 6 inches (4.4 × 21.6 × 15.2 cm).
Also made in 7-, 9-, and 10-inch sizes (17.8, 22.9, and 25.4 cm).

92 Brazil sugar shaker, syrup, table set

Opaque white.
92.1. Sugar shaker with metal lid. 4½ × 3 inches (11.4 × 7.6 cm).
92.2. Syrup with metal lid. 7½ × 4⅞ × 3½ inches (19.1 × 12.4 × 8.9 cm).
92.3. Sugar bowl. 7¼ × 4 inches (18.4 × 10.2 cm).
92.4. Cream pitcher. 5¾ × 5 × 3¼ inches (14.6 × 12.7 × 8.3 cm).
92.5. Spoon holder. 4¾ × 3½ inches (12.1 × 8.9 cm).
92.6. Butter. 5 × 6 inches (12.7 × 15.2 cm). The Factory B Catalogue also illustrates a Brazil butter with an openwork flange.
Collection of Brad Gougeon.

Troy (omn), circa 1891

Aka Maltese Cross in Circle

Bryce Brothers made the Troy butter in crystal and opaque white (cat. 94). It also made 8- and 10-inch companion bread plates. Like the butter, the edge of the bread plate is rippled and decorated with arches and circles with Maltese Crosses in the circles (cat. 93). The Troy butter and bread plates are illustrated in the Factory B Catalogue.

93 Troy bread plate

1 × 7¾ inches (2.5 × 19.7 cm).

94 Troy butter

Opaque white. 5½ × 7¾ inches (14 × 19.7 cm).
Collection of Brad Gougeon.

Pittsburgh (omn), 1891

Aka Prism and Globules

Pittsburgh is a documented pattern illustrated in the Factory B Catalogue. Bryce Brothers introduced it for the 1891 selling season. The *Pottery & Glassware Reporter* (January 15, 1891) described the new pattern:

> The pattern is a harmonious combination of the bead and flute, and by the adoption of concave and convex figure, secures the light-deflecting brightness which make cut glass and sharp clear lined pressed crystal so attractive. The line is very full, comprising the regular table set, comport, handled jelly, straight and flared nappies, from 4 to 8 inches; covered nappies from 5 to 8 inches; celery, goblet, wine and tumbler; individual and shaker salts; half gallon pitcher; open and covered bowls from 5 to 8 inches; salver 8, 9 and 10 inches; saucer 7 to 10 inches; flower vase, cake basket, oblong dish from 7 to 10 inches; molasses can, etc. The line is well adapted for engraving, and the large plain ground of the pitcher shows off the engraver's work to good advantage.

The *Crockery & Glass Journal* described it as "a large and complete line, and its beauty develops as each additional piece comes out. They have given special care to this pattern and it is a lovely one in all respects."[59] Pittsburgh was Bryce Brothers' most popular line in 1891.[60] It was also one of the last patterns Bryce Brothers introduced before the U.S. Glass consolidation.

The double flower vase (cat. 97) is illustrated in the Factory B Catalogue. It would have been pressed in a mold for a salver (cake stand) such as the one shown here (cat. 96). After it was removed from the mold, the glass maker would fold up the sides and join them together to create the appearance of a vase with two bowls. There are also examples where a salver was folded into a vase with three bowls. Sometimes, instead of joining the two sides, the glassmaker would simply fold up the sides to create an elongated basket that Bryce Brothers called a cake basket and collectors sometimes call a banana bowl.

95 Pittsburgh double flower vase superimposed on a salver

96 Pittsburgh salver

6⅝ × 9½ inches (16.8 × 24.1 cm).
Also made in 8- and 10-inch diameters (20.3 and 25.4 cm).

97 Pittsburgh double flower vase

9¼ × 7¼ × 4½ inches (23.5 × 18.4 × 11.4 cm).

98 Pittsburgh high-footed covered bowl

11½ × 7¼ inches (29.2 × 18.4 cm).
Also made in 5-, 6-, and 8-inch diameters (12.7, 15.2, and 20.3 cm).

NOTES

1. United States Glass Company, "Factory B" (Bryce Brothers) section, composite catalogue (Jan. 1892). There are at least three extant versions of the composite catalogue, containing parts of the Factory B Catalogue, but they are not identical and none is complete. See "Company History" (pp. 60–62 in this volume) and "Authenticating Bryce Glassware" (p. 71 in this volume).

2. Page with Bryce, Richards & Co. patterns, ca. 1854, Rakow Research Library, Corning Museum of Glass, Corning, NY. See fig. 24 (p. 40 in this volume).

3. For more on methods of authentication, see "Authenticating Bryce Glassware" (p. 71 in this volume).

4. Bill Jenks, Jerry Luna, and Darryl Reilly, *Identifying Pattern Glass Reproductions* (Radnor, PA: Wallace Homestead, 1993).

5. *J. F. Diffenbacher's Directory of Pittsburgh and Allegheny Cities for 1890* (Pittsburgh, PA: Diffenbacher & Thurston, 1890), 745; George H. Thurston, *Directory of Pittsburgh and Allegheny Cities, 1862–3* (Pittsburgh, PA: George H. Thurston, 1862), 286.

6. An opaque white Tulip butter is pictured in S. T. Millard, *Opaque Glass* (Des Moines, IA: Wallace-Homestead, 1975), plate 135; and Regis F. Ferson and Mary F. Ferson, *Yesterday's Milk Glass Today* (Pittsburgh, PA: R. Ferson, 1981), 62.

7. Spelman Brothers, *Special Bargain Catalogue* (Spring 1886): 2.

8. Paul Kirk, Jr., *Homestead Glass Works: Bryce, Higbee & Company, 1879–1907* (Atglen, PA: Schiffer Publishing, 2016), 56.

9. An opaque white Grape Band pitcher is pictured in Millard, *Opaque Glass*, plate 263.

10. Brad Gougeon, "Annie W. Henderson and Loop and Dart . . . a pattern glass mystery," *NewsJournal* (Early American Pattern Glass Society) 20, no. 1 (Spring 2013): 10–11; Richard Edwards, *Industries of Pittsburgh: Trade, Commerce and Manufactures; Historical and Descriptive Review for 1879–1880* (Pittsburgh, PA: Richard Edwards, 1879), 52.

11. A crystal Strawberry high-footed covered bowl with an egg-and-dart border around the foot is pictured in John Welker and Elizabeth Welker, *Pressed Glass in America: Encyclopedia of the First Hundred Years, 1825–1925* (Ivyland, PA: Antique Acres Press, 1985), fig. 15–216, 449.

12. Jenks, Luna, and Reilly, *Identifying Pattern Glass Reproductions*, 286.

13. *American Pottery & Glassware Reporter*, Sept. 4, 1879; *Crockery & Glass Journal*, Sept. 18, 1879, 30.

14. *J. F. Diffenbacher's Directory of Pittsburgh and Allegheny Cities for 1890*, 745; Thurston, *Directory of Pittsburgh and Allegheny Cities, 1862–3*, 286.

15. *Crockery & Glass Journal*, Mar. 9, 1882, 20; *American Pottery & Glassware Reporter*, Mar. 16, 1882.

16. *American Pottery & Glassware Reporter*, Mar. 16, 1882.

17. *Crockery & Glass Journal*, Mar. 9, 1882, 20.

18. *American Potter & Illuminator* (Feb. 1888): 30.

19. Spelman Brothers, *Special Bargain Catalogue* (Spring 1886): 2.

20. Sid Lethbridge, "Daisy & Button: Were Bryce Bros. First?" *All About Glass* 9, no. 3 (October 2011): 19–21.

21. Lethbridge, "Daisy & Button."

22. Butler Brothers, *"Our Drummer"* (85th Trip 1886): 34 (amber, blue, canary).

23. Butler Brothers, *"Our Drummer"* (86th Trip 1886): 32, 35.

24. Butler Brothers, *"Our Drummer"* (Santa Claus Edition 1887): 38.

25. Butler Brothers, *"Our Drummer"* (85th Trip 1886): 25.

26. Butler Brothers, *"Our Drummer"* (Santa Claus Edition 1887): 7.

27. Butler Brothers, *"Our Drummer"* (Dull Season 1887).

28. Butler Brothers, *"Our Drummer"* (Santa Claus Edition 1887): 38.

29. Butler Brothers, *"Our Drummer"* (Santa Claus Edition 1887): 38.

30. Spelman Brothers catalogue (Fall 1886): 22.

31. Butler Brothers, *"Our Drummer"* (86th Trip 1886): 35.

32. *Missouri Glass Company's Commercial Solicitor* 32, no. 377 (May 1887): 12.

33. Butler Brothers, *"Our Drummer"* (85th Trip 1886): 25.

34. Butler Brothers, *"Our Drummer"* (75th Trip 1883): 20.

35. Butler Brothers, *"Our Drummer"* (75th Trip 1883): 20.

36. *American Pottery & Glassware Reporter*, Feb. 21, 1884.

37. Butler Brothers, *"Our Drummer"* (82nd Trip 1885): 16.

38. Spelman Brothers, *Special Bargain Catalogue* (ca. 1885): 8. The known pages of this catalogue are not dated, but it includes items not introduced until 1885.

39. Brad Gougeon, "Diamond Quilted, aka Bryce's '1000' (omn) pattern," *NewsJournal* (Early American Pattern Glass Society) 16, no. 3 (2009): 6–10, 6. The article includes a list of known pieces in this pattern.

40. Butler Brothers, *"Our Drummer"* (83rd Trip 1885): 28.

41. *Pottery & Glassware Reporter*, Jan. 21, 1886, 13.

42. Butler Brothers, *"Our Drummer"* (Santa Claus Edition 1887): 37.

43. *American Potter & Illuminator* (Feb. 1888): 23.

44. Duquesne is a well-known name in the Pittsburgh area. The French built a fort at the confluence of the Allegheny and Monongahela Rivers in 1754 and called it Fort Duquesne. When the English won control after a bloody battle in 1758, they rebuilt the fort and renamed it Fort Pitt. But the name Duquesne lives on in Pittsburgh area landmarks, streets, and cultural and educational institutions.

45. Butler Brothers, *"Our Drummer"* (Santa Claus Edition 1887): 37.

46. Butler Brothers, *"Our Drummer"* (Sept. 1889): 61.

47. Bill Jenks and Jerry Luna, *Early American Pattern Glass 1850–1910* (Radnor, PA: Wallace-Homestead, 1990), 242.

48. *Pottery & Glassware Reporter*, Dec. 20, 1888, 12.

49. *Crockery & Glass Journal*, Jan. 10, 1889, 17.

50. *Pottery & Glassware Reporter*, Dec. 20, 1888, 12.

51. Illustrated in Butler Brothers, *"Our Drummer"* (Santa Claus Edition 1887): 38.

52. *Pottery & Glassware Reporter*, July 18, 1889, 38.

53. *Pottery & Glassware Reporter*, Feb. 28, 1889, 12.

54. *Crockery & Glass Journal*, Jan. 23, 1890, 20.

55. *Pottery & Glassware Reporter*, Dec. 19, 1889, 12.

56. *Crockery & Glass Journal*, Jan. 23, 1890, 20.

57. *Crockery & Glass Journal*, Feb. 6, 1890, 21.

58. Butler Brothers, *"Our Drummer"* (Mar. 1891): 68.

59. *Crockery & Glass Journal*, Dec. 25, 1890.

60. *Crockery & Glass Journal*, Apr. 9, 1891, 21.

Fig. 65. Crystal Bryce Brothers
National bread plate with gilt
profile of Lady Liberty on a black
oval applied to the back of the
plate, 1886. 1⅜ × 9½ × 12¾ inches
(3.5 × 24.1 × 32.4 cm).

Novelties

THE 1880S BROUGHT A BURST OF COLOR AND whimsy to the Bryce Brothers product lineup. Novelties surged in popularity, and Bryce Brothers began producing new and unusual forms, including buckets, boats, shoes, flies, and fish. Bryce often found inspiration in nature, decorating its novelties with birds, animals, trees, and butterflies. Sometimes it memorialized current events and the latest trends. It produced toothpick and match holders in the form of a doghouse, torch, kettle, fan, basket, and many other objects. Children's mugs and toy sets were popular.

Bryce Brothers' showroom was filled with a wide array of colorful glassware, but novelties were the chief attraction: "The firm makes also an extensive and very inviting line of knick-knacks and miscellaneous goods, small and large, some for ornament others for use, and yet others both combined, but all pretty, tasteful and well finished. . . . It would take a whole page to contain a list of each separate article made here and then it would still be incomplete."[1]

Sometimes Bryce Brothers novelties were marketed with perfume bottles. Wholesale catalogues of the 1880s illustrate perfume bottles inside Bryce Brothers' Chinese Shoe on Toboggan (fig. 71), Large Boot (fig. 73), Liberty Torch (fig. 74), Daisy toy mug (cat. 132.9), and hanging Wall Pocket (fig. 77).

Many Bryce Brothers novelties have been authenticated through wholesale catalogues and trade journal reports. But not all recorded novelties have been found, including a glass savings bank: "Bryce Bros. have a novelty in the way of a glass savings bank, which is the neatest thing out. It is of crystal and the contents are always visible, thus ensuring the detection of insidious pillage, and as it cannot be readily emptied at the whim of the proprietor, the permanence of the savings is greatly encouraged."[2]

The Old Oaken Bucket, 1885

How dear to my heart are the scenes of my childhood,
When fond recollection presents them to view!
The orchard, the meadow, the deep-tangled wildwood,
And every loved spot which my infancy knew;
The wide-spreading pond, and the mill which stood by it,
The bridge, and the rock where the cataract fell;
The cot of my father, the dairy-house nigh it,
And e'en the rude bucket which hung in the well—
The old oaken bucket, the iron-bound bucket,
The moss-covered bucket which hung in the well.

So goes *The Old Oaken Bucket*, a poem written by Samuel
Woodworth (1784–1842) in 1817 and set to music in 1826.
The song enjoyed a resurgence in popularity in the late 1800s
and it may have been the inspiration for Bryce Brothers'
enormously popular Old Oaken Bucket series introduced
in 1885.[3]

The Old Oaken Bucket became one of Bryce Brothers'
most beloved novelties. Bucket forms included jellies, a table
set, a half-gallon pitcher, a toy tea set, three sizes of open toy
buckets, and a toy bucket with a glass cover. Bryce Brothers'
buckets were widely written up in the trade journals as
selling in enormous quantities.[4] The *Crockery & Glass Journal*
described this popular new offering: "Bryce Bros. have out
a miniature glass water pail which beats anything got ready
for juveniles yet. The graining of the sides and even the
rivets in the hoops are true to the original, down to even
knots in the wood. They have pretty plated handles and are
really excellent representations. . . . The demand is big for
these novelties."[5]

Bucket jellies with tin lids (cat. 99) were sold in grocery
stores and often bought for the glass containers themselves:
"It is the neatest jelly glass in the market, and the handiest,
and even the retail groceries can largely increase their sales
of jellies by using these cans, for many will buy jellies
merely for the purpose of getting the pretty glass for a table
ornament, or for their children. It is a decided hit."[6]

The Factory B Catalogue illustrates bucket jellies in
four sizes: quart, pint, one-half pint, and one-third pint
(fig. 66). All are shown with tin lids that have two different
versions of "The Old Oaken Bucket" logo impressed on
the lids. On another page the catalogue notes that the half-

Fig. 66. Novelties page from the
"Factory B" (Bryce Brothers)
section of the United States Glass
Company composite catalogue
(Jan. 1892). 8¾ × 11½ inches (22.2
× 29.2 cm). *Courtesy of the Carnegie
Library of Pittsburgh, PA.*

99 Old Oaken Buckets

99.1. Crystal half-pint Bucket Jelly with tin lid. 3¾ × 3¼ inches (9.5 × 8.3 cm).
99.2. Amber Toy Bucket. 3⅜ × 2⅞ inches (8.6 × 7.3 cm).
99.3. Amethyst Toy Bucket. 1⅞ × 2 inches (4.8 × 5.1 cm).
99.4. Canary Toy Bucket. 2⅝ × 2⅝ inches (6.7 × 6.7 cm).
99.5. Blue one-third pint Bucket Jelly with tin lid. 3¼ × 2⅞ inches (8.3 × 7.3 cm).

pint jelly is 10 ounces and the one-third pint jelly is 6 ounces. Those measurements are based on Imperial pints and Imperial ounces, a different measurement system from that used in the United States today. An Imperial pint is 20 percent larger than a U.S. pint.

Bucket jellies were made in crystal, amber, blue, canary, and amethyst. Some of the buckets have the word "PATENTED" in raised letters along the bottom rim, but no date is specified and the patent has not been identified. Bryce Brothers' buckets have knots in the wood graining, which also decorates the bottom of the bucket. The bands around the buckets end in points with two rivets and the wire handle is squared off at the top, a characteristic of the handles Bryce Brothers used on its novelties.[7]

Bryce Brothers also made a half-gallon pitcher and a four-piece table set in the Bucket pattern (cat. 100), all of which are illustrated in the Factory B Catalogue. The Bucket table set includes a cream pitcher, sugar bowl, butter, and spoon holder. The body of each piece consists of realistic vertical oak-grained staves, some with knot holes, and two impressed horizontal bands. The spoon holder, cream pitcher, sugar bowl, and half-gallon pitcher also have impressed handles, and the butter and sugar bowl have oak-grained glass lids.

The Bucket table set was made in crystal, amber, blue, canary, and amethyst. A colored set retailed for twice the price of a crystal set. In 1885, Butler Brothers advertised the Bucket table set as available in "assorted blues, canaries and old gold. A splendid set to retail for a Half Dollar." The same issue advertised a crystal Bucket table set for a retail price of twenty-five cents.[8]

Bryce Brothers made a "toy tea set of similar design and equally well fashioned."[9] A crystal toy cream pitcher and toy spoon holder, both 2½ inches high, are shown here (cats. 100.6–7). The toy table set also included a sugar bowl, butter, and spoon.[10]

A Factory B Catalogue page (fig. 66) illustrates three sizes of open Toy Buckets: No. 1, No. 2, and No. 3. It also illustrates a toy bucket with a glass cover labeled "No. 4 Bucket & Cover." It is footed and similar in shape to the sugar bowl in the Bucket table set (cat. 100.5). Like the other Toy Buckets and unlike the sugar bowl, it has a wire handle.

Bucket jellies have a rim around the top to accommodate the lid. As illustrated in the Factory B Catalogue, Toy Buckets have graining all the way to the top and no band around the top rim. Some Toy Buckets in the smallest size also have been found with a rim around the top edge to accommodate a lid and were probably used to distribute condiments.

Toy Buckets were made in crystal, amber, blue, canary, amethyst, and ruby-stained, and sometimes have "PATENTED" in raised letters on the bottom rim.

100 Bucket table set, pitcher, toy cream pitcher and spoon holder

100.1. Canary cream pitcher. 4⅜ × 5⅜ × 3⅜ inches (11.1 × 13.7 × 8.6 cm).

100.2. Crystal spoon holder. 4⅜ × 3¼ inches (11.1 × 8.3 cm).

100.3. Amethyst half-gallon pitcher. 8¼ × 7¾ × 5¼ inches (21 × 19.7 × 13.3 cm).

100.4. Amber butter. 4¼ × 7⅜ × 5⅞ inches (10.8 × 18.7 × 14.9 cm).

100.5. Blue sugar bowl. 6¼ × 4 inches (15.9 × 10.2 cm).

100.6. Crystal toy cream pitcher. 2½ × 2 × 3 inches (6.4 × 5.1 × 7.6 cm).

100.7. Crystal toy spoon holder. 2½ × 2 inches (6.4 × 5.1 cm).

Slippers, Shoes, Sandals, and Boots, 1886

Some of Bryce Brothers' most endearing novelties are little glass shoes in fanciful forms and vibrant colors. The trade journals noted in 1886 that Bryce Brothers was making "boots, shoes, and slippers in all colors, shapes, and sizes."[11] Bryce Brothers made several types of shoes, including a Large Slipper, Small Slipper, Small Slipper Nappy, Chinese Shoe, Chinese Shoe on Toboggan, Sandal, Roller Skate, and Large and Small Boots.

But Bryce Brothers was not the sole shoemaker. The Pittsburgh glassmaker George Duncan & Sons also produced glass slippers.

On October 19, 1886, two patents were issued, each providing a different method for making hollow glass slippers. Both patents were assigned to both Bryce Brothers and George Duncan & Sons. The ability to manufacture hollow glass slippers was a significant innovation because a slipper could not be removed from the mold unless the toe and part of the ball of the shoe were solid glass. Hollow slippers were lighter and more aesthetically pleasing.

The patents set forth similar methodologies, which involved molding a shoe with a fully formed heel but leaving the upper part, known as the vamp, open. After the shoe was removed from the mold, it was reheated and the sides were pressed down and joined over a wooden or cast-iron form called a last (fig. 68), which was then removed.

The difference in methodologies relates to the toe. Patent No. 351,197 issued to John E. Miller (fig. 67) provided for opening the vamp all the way to the toe so when the sides were sealed, a single seam ran down the top of the shoe. This is the method Duncan used for its shoes. Patent No. 351,216 issued to Henry J. Smith (fig. 68) provided for "having the toe-piece separated from the side pieces and then bent down, whereby the toe is completely closed and given the appearance of a tip to the shoe." Bryce Brothers used the Smith method for its slippers.

The Smith patent illustrates a Daisy and Button Large Slipper with horizontal ribs above the heel. It also shows corresponding horizontal ribs across the turned-back toe of the slipper. Horizontal ribs in a narrow vertical strip on the back of the shoe above the heel distinguish Bryce-made slippers from those of other manufacturers, including those made by Duncan. Horizontal ribs above the heel are found on Bryce Brothers' Large Slippers, Small Slippers, and Chinese Shoes.

Fig. 67. J. E. Miller, patent assigned to both Bryce Brothers and George Duncan & Sons, 1886. Patent No. 351,197.

Fig. 68. H. J. Smith, patent assigned to both Bryce Brothers and George Duncan & Sons, 1886. Patent No. 351,216.

101 Large Slippers

Blue, crystal, amethyst, canary, amber. 1¾ × 7½ × 2½ inches (4.4 × 19.1 × 6.4 cm).

102 Small Slippers, Sandals, Chinese Shoes, Large Boots

Top row: Small Slippers. Amber, crystal, amethyst, canary, blue. 2 × 4¾ × 1⅞ inches (5.1 × 12.1 × 4.8 cm).
Middle row: Sandals. Canary, amethyst, blue, amber, crystal. 1⅜ × 4½ × 1⅝ inches (3.5 × 11.4 × 4.1 cm).
Bottom row: Chinese Shoes. Blue, crystal, amber, canary, amethyst. 1¾ × 4¾ × 1⅜ inches (4.4 × 12.1 × 3.5 cm).
Sides: Large Boots. Amethyst, canary, blue, amber. 5½ × 4⅜ × 1¾ inches (14 × 11.1 × 4.4). The blue boot has
"WOODSIDES BOOTS & SHOES" on the base.
Amethyst and canary sandals collection of Mary Lamica.

Bryce Brothers slippers sometimes have a circular patent date marked "PAT'D OCT. 19 1886"on the sole of the shoe near the heel, but not always. Duncan slippers have the same patent date, but it appears in two horizontal lines on the bottom of the sole, also near the heel.

Bryce Brothers' Large Slippers are in the Daisy and Button pattern, which also decorates the bottom sole and heel of that slipper (cat. 101). They are 7½ inches long and were made in crystal, amber, blue, canary, amethyst, ruby-stained, and crystal with amber buttons.

Bryce Brothers made Small Slippers in the Daisy and Button pattern that were 4¾ inches long and made in crystal, amber, blue, canary, amethyst, and ruby-stained (cat. 102). Handwritten notes in the 1888 F. H. Lovell & Co. *Export*

Catalogue[12] label it Bryce Brothers' "Small Slipper," and according to Ruth Webb Lee, it was illustrated in her Bryce Brothers catalogue.[13] The wholesaler G. Sommers described the Small Slipper as useful for matches or toothpicks, "or can be used on a lady's work-table for her buttons."[14]

Butler Brothers advertised it as a Cinderella Slipper, "a beautiful mantel ornament," available in four colors and retailing for five cents.[15] Spelman Brothers called it a "Pompadour Slipper," a style of shoe with a heel that curves in and under the shoe. It was named for the beautiful Madame de Pompadour (1721–1764), official mistress of King Louis XV of France. Spelman Brothers illustrated both a "Pompadour Slipper" and a Bryce Brothers Sandal in an assortment with documented Bryce Brothers patterns (fig. 69).

Assortment No. 263.

Our Miniature Bric-a-Brac Assortment.

Containing two dozen Fashion Toothpicks, two dozen Duke Creams, two dozen Pompadour Slippers, two dozen Scalloped Nappies, two dozen Diamond Egg Glasses, and two dozen 4½-inch Sandals.

Assorted in equal quantities of blue, amber, and canary.

12 doz. in box. Price, 48c per doz.
Box, 05c extra.

At least half of these articles are 10c leaders. All are gems. Artistic in style and brilliant in color.

Fig. 69. Sandal and "Pompadour Slipper" with documented Bryce Brothers patterns, illustrated in a Spelman Brothers catalogue (Fall 1886): 22.

THE BELL SEDALIA MO
CALKINS-WHITE BROS. FURNITURE CO.
CINDERELLA STOVES & RANGES
EARL THEATRE
WM. ERLANGER & CO.
FONTIUS
FORT WAYNE OUTFITTERS CO.
JOS. KUHN & SON
H. J. LOEB PUNXSUTAWNEY, PA.
MEIS' STORE
MICHAELSON'S
MILLER'S DEPARTMENT STORE
SEL-ON-SITE GREAT CLEANER
SUREFIT SHOE STORE 76 FRANKSTOWN AVE
YOUNG'S NEW PIER

Fig. 70. Company names found on advertising slippers in the Bryce form.

The United States Glass Company made Small Slippers after 1891 in additional colors. In 1897, Butler Brothers advertised a gold-edged slipper with a gold toe and heel.[16] A year later, it advertised "Emerald Green Glass Offerings," including the small slipper. The catalogue noted: "The latest fad in bric-a-brac is this new green."[17] Small Slippers in opaque white and frosted crystal have also been found.

Glass advertising slippers were another interesting novelty that businesses ordered from glass manufacturers to give to customers as a promotional souvenir. These slippers were made by inserting a plate with the advertiser's name into the mold before pressing the shoe. The names listed in fig. 70 have been found on the bottom of advertising slippers made in the Bryce molds.[18] Based on the operating dates of the companies advertised on the slippers, it is likely some were made by U.S. Glass after 1891.

A small blue advertising slipper (cat. 103) has "CINDERELLA / STOVES & RANGES" in raised letters on the sole and a large raised *C* on the bottom of the heel. Cinderella advertising slippers were made in crystal, amber, and blue, and they are the only advertising slippers in the Bryce form found in color.

Bryce Brothers also produced a novelty it described as an ash tray by attaching its Small Slipper to a tray in the Coral aka Fishscale pattern (cat. 104).[19] Handwritten notes in the 1888 F. H. Lovell & Co. *Export Catalogue* identify it as Bryce

Brothers' Small Slipper Nappy, but it is more commonly known as Slipper on a Tray. It was made in crystal, amber, blue, and canary. Butler Brothers advertised it as a "Shoe Ash Receiver. A shoe on a permanent plate. A new and useful article that cannot fail to be immediately appreciated," available in assorted colors.[20]

Bryce Brothers made a shoe in the Cane pattern with a pointed, upturned toe decorated with horizontal ribs. Ruth Webb Lee says it is illustrated in her Bryce Brothers catalogue with the name "Chinese Shoe."[21] Because of the upturned toe, it was not possible to use the patented method for manufacturing hollow shoes, so these shoes have solid toes. They are 4¾ inches long and were made in crystal, amber, blue, canary, and amethyst. They have been found in two widths, one almost ¼ inch wider than the other.[22]

Lee includes a line drawing of another Bryce Brothers novelty she labels Double Chinese Shoes.[23] That drawing is of two Chinese shoes joined together side-by-side, but examples have not been found.

Perhaps the most novel of all the Bryce Brothers shoes is the Chinese Shoe on Toboggan. The toboggan has two pairs of impressed snowshoes: a larger pair on the bottom of the toboggan and a smaller crossed pair on the curved front of the toboggan. The introduction of the Chinese Shoe on Toboggan coincided with the 1887 tobogganing craze, when cities across the world were building toboggan runs. The Chinese Shoe on

103 Small Slipper with advertising

Blue Small Slipper with raised "CINDERELLA / STOVES & RANGES" advertising on the sole and a large raised C on the bottom of the heel. 1¾ × 4⅞ × 1¾ inches (4.4 × 12.4 × 4.4 cm).

104 Small Slipper Nappy

Amber. 1⅞ × 5⅜ × 4 inches (4.8 × 13.7 × 10.2 cm). The slipper is in the Daisy and Button pattern with a patent date on the sole; the tray is in the Coral pattern.

105 Chinese Shoe on Toboggan, Toboggan without a shoe

105.1–105.3. Blue, amber, crystal Chinese Shoe on Toboggan. 2⅛ × 5⅛ × 1⅞ inches (5.4 × 13 × 4.8 cm).
105.4. Amber toboggan without a shoe, bottom. 1½ × 5⅛ × 1⅞ inches (3.8 × 13 × 4.8 cm).
105.4 *Collection of Mary Lamica.*

Toboggan was made in crystal, amber, and blue. Ruth Webb Lee notes that the Chinese Shoe on Toboggan is pictured in her Bryce Brothers catalogue with other novelties.[24]

The bottom of an amber toboggan without a shoe is pictured here (cat. 105.4). Lee says the toboggan was also sold separately, but it has two raised areas clearly intended as a mount for the shoe.[25]

Bryce Brothers also made 4½-inch open sandals in the Daisy and Button pattern in crystal, amber, blue, canary, and amethyst (cat. 102). Unlike Bryce slippers, the sandals do not have horizontal ribs on the back above the heel. L. G. Wright reproductions of the Bryce Brothers sandal can be distinguished from the originals by their shape: the Wright sandal is wider and has a pointier toe.

Bryce Brothers made Large Boots in the Cane pattern with thirteen buttons up the right side of the hollow shank and scallops around the top rim. The boots are 5½ inches high and 4⅜ inches long. The heel and toe rest on a fiddle-shaped base with wood graining and the words "BOUQUET HOLdER PAT.

Fig. 71. Chinese Shoe on Toboggan with perfume bottle, illustrated in Spelman Brothers, *Fancy Goods Graphic* 10, no. 2 (Sept. 1889): 106.

APPLIED FOR." or "BOUQUET HOLdER PATENTED DEC. 1886." The lowercase d in "HOLdER" appears on the originals.

The referenced patent is Design Patent No. 17,023, applied for on September 25, 1886, and issued on December 14, 1886, to H. Tappan (fig. 72). Herman Tappan ran a large perfume company in New York. In this instance, the word "bouquet" refers to a fragrance, rather than a floral arrangement.[26] The Large Boot was designed to hold a small bottle of perfume (fig. 73).

The Large Boot is attributed to Bryce Brothers based on its illustration in a Butler Brothers assortment with documented Bryce Brothers products, including a Large Slipper and other articles in the Fashion pattern. The assortment is described as "The Novelty Colored Glass Assortment. All Parlor or Dining-Room Beauties to Sell at 10 Cents Each." The boot is described as useful for "matches, lamplighters, etc."[27]

Bryce Brothers made the Large Boot in crystal, amber, blue, canary, and amethyst. A rare apple green boot is pictured in *Shoes of Glass, 2*.[28]

A blue Bryce Brothers boot with "WOODSIDES BOOTS & SHOES" advertising on the base is pictured here (cats. 102,

Fig. 72. Illustration of a Large Boot, 1886. Design Patent No. 17,023.

Fig. 73. Large Boot with a perfume bottle, illustrated in Spelman Brothers, *Bazaar and Bargain Catalogue* (1888): 14.

106.1). The Woodsides advertising boot was also made in amber.[29] It is the only known Bryce Brothers Large Boot with advertising.

Fenton reproduced this boot in the mid-1960s in additional colors not made by Bryce Brothers. The reproductions usually have no writing on the base and the indentation at the top is shaped differently from the Bryce Brothers version.[30] There are other reproductions that are thicker and heavier than the originals and do not have an open space between the heel and the sole.

Ruth Webb Lee attributes a Small Boot to Bryce based on a Bryce Brothers catalogue in her possession.[31] That Small Boot is in the same diamond block pattern as the Daisy toy mug and Coal Bucket (cats. 132.9–10). It is 4 inches high and 3¾ inches long and has the same patent date as the Large Boot.

Lee says, "The Bryce catalogue lists this as 'Small Boot. Right & Lefts,'" indicating there was a right boot and a left boot (cats. 106.2, 106.4).[32] The right boot has a row of twelve buttons up the right side of the hollow shank and "PATENTED DEC. 1886" with the N backwards along the left top edge (И). The left boot is the reverse—the buttons go up the left side of the shank with the patent date along the right top edge. The heel sits on a circular base marked "TRADE MARK" around the edge with a T bisecting an H in the center for Herman Tappan, holder of that patent.

This boot came with a small perfume bottle that has the identical diamond block design on the lower part of the bottle and fits neatly inside the shank. The boot and perfume bottle are pictured in *Shoes of Glass, 2*, where the author notes "it is the very first known bottle with matching shoe."[33]

The Small Boot was made in crystal, amber, blue, canary, and amethyst.[34] There is an advertising Small Boot in crystal, amber, and blue with "SOLLERS & CO" along the row of buttons on the right side, the patent date along the left top edge, and "FINE SDS SHOES" on the heel plate (cat. 106.2).[35]

The Small Boot is 1½ inches shorter than the Large Boot, but the two share some common characteristics. Both reference the same patent, the heel and toe are the same shape, both have a V on the tip of the toe, both have a row of buttons up one side with scallops around the top rim, and both were made in amethyst.

The Small Boot was also placed on rollers to create a roller skate (cat. 106.3). It has buttons on the left side, and the top right edge is marked "PATENTED DEC. 1886" with the N backwards. The roller skate has been found in crystal, amber, and blue.

106 Large Boot, Small Boots, Roller Skate

106.1. Blue Large Boot with "WOODSIDES BOOTS & SHOES" advertising. 5½ × 4⅜ × 1¾ inches (14 × 11.1 × 4.4).
106.2. Blue Small Boot (right boot) with "SOLLERS & CO" advertising. 4 × 3¾ × 1¼ inches (10.2 × 9.5 × 3.2 cm).
106.3. Amber Roller Skate. 4⅜ × 3⅝ × 1 inches (11.1 × 9.2 × 2.5 cm).
106.4. Blue Small Boot (left boot). 4 × 3¾ × 1¼ inches (10.2 × 9.5 × 3.2 cm).

Fish, 1886

Bryce Brothers made fish-shaped pickle dishes and nappies in the Orion and Fashion patterns. The Factory B Catalogue describes two fish-shaped pieces in the Orion pattern that may have been intended to be used with the Canoe Celery, also in the Orion pattern (cat. 113.1): an 8¼-inch Earl Pickle and a 5¾-inch Duke Nappy (cat. 108). Earl Pickles in rose, crystal, amber, canary, blue, and amethyst are pictured here (cats. 107, 109.1). The smaller Duke Nappy was produced with both a plain bottom, like that found on the larger Earl Pickles, and with a square decorative device on the bottom, like that found on Orion bowls (cat. 108).

The Factory B Catalogue also illustrates a fish-shaped nappy in the Fashion pattern, described as "4½ in. Fashion Nappy." That fish in blue is pictured here (cat. 109.2) and would have complemented the Puritan Boat (cats. 110–11, 113.2). It was also made in crystal, amber, canary, and amethyst (see fig. 40).

The glassmaker would have flipped up and shaped the fish tail by hand after the piece was removed from the mold, so the exact shape and height of each tail are not identical. The tail height of the Earl Pickles pictured here varies from 3 to 3⅜ inches.

107 Earl Pickles

107.1. Crystal with rose. 3⅛ × 8¼ × 4¼ inches (7.9 × 21 × 10.8 cm).
107.2. Rose. 3 × 8¼ × 4¼ inches (7.6 × 21 × 10.8 cm).

108 Duke Nappy

2⅝ × 5¾ × 4 inches
(6.7 × 14.6 × 10.2 cm).

109 Earl Pickles, Fashion Nappy

109.1. Rose, crystal, amber, canary, blue, amethyst Earl Pickles. 3–3⅜ × 8¼ × 4¼ inches (7.6–8.6 × 21 × 10.8 cm).
109.2. Blue Fashion Nappy. 2⅜ × 4 × 6 inches (6 × 10.2 × 15.2 cm).

Boats, 1886

The sixth running of the America's Cup yacht race launched from New York City harbor in 1885. The American yacht *Puritan* sought to defend the title previously won by fellow American *Mischief*. The British challenger, *Genesta*, sought to gain a competitive advantage by keeping details about its ship a secret until race day. During a trial run, *Puritan* fouled *Genesta* and the judges ruled that *Genesta* could run the course alone. But in a show of good sportsmanship that endeared the British ship to Americans, *Genesta* agreed to forego the default and race *Puritan* for the trophy. In the end, *Puritan* won the prestigious international competition,[36] *Genesta* founded a tradition of pre-race secrecy that endured for more than 125 years, and a wave of colorful new novelties appeared.

Bryce Brothers launched its fleet in 1886. It produced the Puritan Boat and two sizes of Genesta Boat in the Fashion aka Daisy and Button pattern. All are illustrated in the Factory B Catalogue. The Puritan Boat is shaped like a canoe (cats. 110–111, 113.2). At 11½ inches long, it was a large piece intended for celery or pickles. Bryce Brothers made it in crystal, amber, blue, canary, amethyst, and green.[37] It was also made in crystal with ruby, rose, or amber stain, or decorated with gold trim.[38] Butler Brothers advertised the Puritan Boat as "Our Indian Canoe Dish. For mantel ornament, or for use in other ways."[39]

Like the Puritan Boat, the Genesta Boat is canoe-shaped, but unlike the Puritan Boat it is flat on one side and has holes in each end for hanging on a wall: "The Genesta Boat is a boat cut in two, as it were, lengthwise, and intended to be suspended over a dressing case or on a wall for the reception of combs, toothbrushes, etc."[40]

The Genesta Boat came in two sizes—a 12-inch size labeled "Genesta Boat" in the Factory B Catalogue and a smaller 8¼-inch size labeled "No. 2 Genesta Boat" (cat. 113.3). They are described in the catalogue as "wall pockets for flowers, matches, etc." They were made in crystal, amber, blue, canary, amethyst, and crystal with rose, ruby, or amber stain. The smaller No. 2 Genesta Boat was also available in green, retailing for ten cents.[41] Spelman Brothers advertised the Genesta Boat Whisk Broom Holder, available in four colors.[42] That piece is a No. 2 Genesta with the bottom of the hull removed for insertion of a whisk broom (cat. 112).

The Puritan and No. 2 Genesta were reproduced by L. G. Wright, including in additional colors.[43]

Bryce Brothers produced two boats in the Orion pattern—the Canoe Celery and the Earl Ind. Boat. Both are illustrated in the Factory B Catalogue. The Canoe Celery (cat. 113.1) was advertised in the *American Potter & Illuminator* (February 1888): "Large size, 12 inch cut pattern. Canoes, assorted colors, a beautiful big piece that can be used for rolls, biscuits, celery, fruit or preserves."[44] It was made in crystal, amber, blue, canary, amethyst, and crystal with ruby, rose, or amber stain.

The Earl Ind. Boat (cat. 114) is 4½ inches long and has a pointed bow at one end and a rudder at the stern. The Earl retailed for five cents and was made in crystal, amber, blue, canary, amethyst, green, and crystal with ruby, rose, or amber stain (see cat. 64.5).[45] Butler Brothers advertised it as a "splendid little miniature boat" match or ash stand.[46]

110 Puritan Boat on a silver-plated stand

Crystal with rose stain Puritan Boat. 3¼ × 11½ × 4½ inches (8.3 × 29.2 × 11.4 cm).
Stand marked "Barbour Bros. Co. N.Y. White metal, Quadruple Plate." 9 × 9¾ × 4⅛ inches (22.9 × 24.8 × 10.5 cm).

111 Puritan Boats

Amethyst, crystal, amber, canary, blue. 3¼ × 11½ × 4½ inches (8.3 × 29.2 × 11.4 cm).

112 Genesta Boat Whisk Broom Holder, top view

Blue. 2¼ × 8¼ × 4⅜ inches (5.7 × 21 × 11.1 cm).
Collection of Sid Lethbridge.

113 Canoe Celery, Puritan Boat, No. 2 Genesta Boat

113.1. Crystal Canoe Celery. 3¼ × 12½ × 4⅝ inches (8.3 × 31.8 × 11.7 cm). *Collection of Kathy Grant.*
113.2. Canary Puritan Boat. 3¼ × 11½ × 4½ inches (8.3 × 29.2 × 11.4 cm).
113.3. Blue No. 2 Genesta Boat. 2½ × 8¼ × 4⅜ inches (6.4 × 21 × 11.1 cm).

114 Earl Ind. Boats

Amber, light amber, canary, blue.
1⅛ × 4½ × 1¾ inches
(2.9 × 11.4 × 4.4 cm).
114.1 *Collection of Mary Lamica.*

Patriotic Trio: National Bread Plate (omn), Banner Butter (omn), Liberty Torch (omn), 1886

Bryce Brothers often looked to current events for inspiration in designing new novelties. In 1886, it introduced a trio of colorful patriotic-themed novelties to commemorate the dedication of the Statue of Liberty: the National bread plate, Banner butter, and Liberty Torch.

The *Crockery & Glass Journal* reported that Bryce Brothers introduced "a new bread plate patriotically designed in the shape of a shield, with the goddess of liberty, stars and stripes artistically arranged upon the face of it."[47] *American Potter & Illuminator* (February 1888) advertised it as retailing for twenty-five cents.[48]

The image of Lady Liberty on the bread plate is a copy of the image on the Morgan silver dollar, designed by George T. Morgan (1845–1925) and introduced into circulation in 1878.[49] Morgan based the image on Anna Willess Williams (1857–1926) of Philadelphia, whom he described as having the most perfect profile he had seen in England or America. The eighteen-year-old "Silver Dollar Girl" shunned the notoriety that followed her brief, high-profile modeling assignment, rejecting offers for public appearances and acting jobs in favor of the quiet life of an unmarried schoolteacher.

115 National bread plates

Blue, amber, canary, crystal, amethyst. 1⅜ × 9½ × 12¾ inches (3.5 × 24.1 × 32.4 cm).

The National bread plate is illustrated in the Factory B Catalogue (see fig. 50). Like the Morgan silver dollar, the catalogue image has the word "Liberty" written on the figure's headband, but it is not on the actual pressed piece. Lady Liberty is looking in the opposite direction in the catalogue image because the artist was drawing from the mold where the image would have been cut in reverse (except in this case the letters are not shown in reverse).

At 12¾ inches, the plate is large and was made in crystal, amber, blue, canary, and amethyst. An unusual example has been found in crystal with a gilt profile of Lady Liberty in a black oval applied to the back of the plate (fig. 65).

Amethyst, amber, canary, crystal, blue. 3⅝ × 7½ × 5¾ inches (9.2 × 19.1 × 14.6 cm).

The *Pottery & Glassware Reporter* (June 10, 1886) noted the introduction of the Banner butter: "[Bryce Brothers] have several new and stylish butters ready now, including the Banner pattern, which is an elegant one" (cat. 116). The Banner butter is illustrated in the Factory B Catalogue on a page with eight other butter dishes (see fig. 41). It was made in crystal, amber, blue, canary, and amethyst.

The Banner butter's similarity to the National bread plate is unmistakable when they are viewed side by side. Both are shaped like shields with a field of Daisy and Button stars at the top and similar vertical Fine Cut stripes in the field. The Banner butter is comprised of three separate shields—the lid, the base, and the finial. The shield finial has six stars across the top and three vertical stripes below.

Amber, crystal, blue. 4¼ × 2 inches (10.8 × 5.1 cm).
117.2 *Collection of Kathy Grant.*

Fig. 74. Liberty Torch with a perfume bottle, illustrated in Spelman Brothers, *Bazaar and Bargain Catalogue* (Feb. 1891): 513. Note that the flames in this image go in the reverse direction from the flames on the pressed piece, but the hand is in the same position on both.

The third item in the patriotic trio is the Liberty Torch, also known as Hand with Torch (cat. 117). It is a 4¼-inch-high hand holding a hollow torch. When French sculptor Frédéric Auguste Bartholdi (1834–1904) was unable to complete the entire Statue of Liberty in time for the Centennial Exposition in Philadelphia in 1876, he sent over her hand with the torch, which was featured at the exposition and later in Manhattan. It is likely that display inspired this novelty.

The Liberty Torch has been found in crystal, amber, and blue. Like the National bread plate and Banner butter, it may also have been made in canary and amethyst, but examples in those colors have not yet been published.

An image of the Liberty Torch is included in Butler Brothers' 1887 "Our 'Modern Elite' 5-Cent Assortment" with documented Bryce Brothers novelties, where it is described as "Torch Mantle Stand—Representing a hand holding a hollow torch, which serves as a match receptacle" (fig. 76).[50] It is also illustrated in the 1888 F. H. Lovell & Co. *Export Catalogue*, where it is described as a No. 749 Candlestick, wholesaling for sixty cents a dozen. Handwritten notes on that catalogue page identify it as a "Liberty Torch" made by Bryce Brothers.[51] Spelman Brothers added a perfume bottle inside the torch and described it as: "No. 855. Fancy Glass Vase or Toothpick Holder, with bottle of perfume. 1 dozen in box, 95c dozen."[52]

Wall Bracket (omn), 1886

Aka Daisy and Button Shelf

Bryce Brothers introduced the Wall Bracket in 1886. It was made in crystal, amber, blue, canary, and crystal with stained dots. One of its notable characteristics is its large size—10¾ inches by 7½ inches. The horizontal shelf is wood grained, and the shelf support has vertical ribs and a diagonal Fine Cut design. The Wall Bracket is illustrated in Butler Brothers with the Puritan Boat, Genesta Boat, and Fashion No. 1120 Basket.[53]

It was advertised as "something entirely new in the glassware line," available in three colors. The trade journals took note of this novelty:

Perhaps the neatest and most useful thing out in glass is a wall bracket for holding vases, small statues or other ornaments, just completed by this firm. The portion of the bracket that faces the wall is either crystal or decorated with colored octagonal dots; the table is made resembling oak wood and the whole is very tastefully got up. There are two holes in the glass near the top in which to insert nails, screws or other suitable fastenings, and they are quite strong and will bear a considerable weight. They will make a fine parlor ornament in themselves, besides affording a handsome background for anything placed on them.[54]

118 Wall Bracket

Blue. 7½ × 10¾ × 4 inches
(19.1 × 27.3 × 10.2 cm).

Fly (omn), 1886

The *Pottery & Glassware Reporter* (April 29, 1886) noted Bryce Brothers' introduction of the Fly butter (cats. 119–20): "They have just out a new butter, the Fly, an exact representation of that ubiquitous insect, but much enlarged of course. They have it plain and in many colors." The Fly was made in crystal, amber, blue, canary, and amethyst.[55] The Factory B Catalogue pictures the Fly base and lid as separate items. The lid is labeled a Fly Pickle and the base a Fly Dish.

Butler Brothers whimsically referred to this piece as a Butterfly Butter and sold it as part of its "Tiffany" 10-cent Assortment: "Butterfly Butter Dish with Cover. This novel and artistic new pattern of glass is a genuine bargain at this price."[56]

119 Fly pickle, dish

Blue. Fly pickle (top): ¾ × 6⅞ × 4¾ inches (1.9 × 17.5 × 12.1 cm);
Fly dish (bottom): 1⅜ × 8½ × 6⅛ inches (3.5 × 21.6 × 15.6 cm).

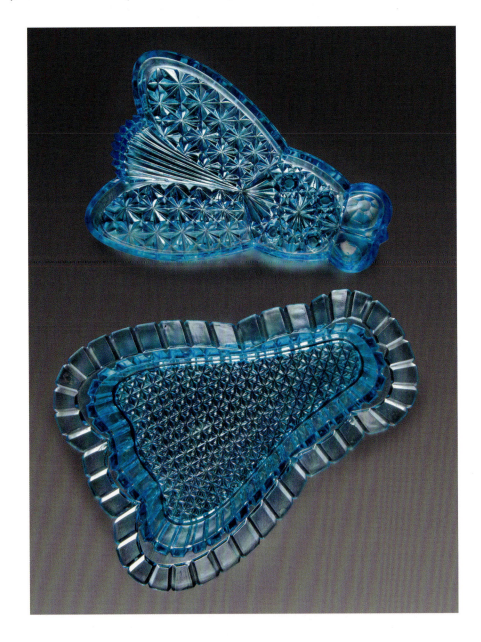

120 Fly butters

Amber, crystal, canary, blue, amethyst.
2½ × 8½ × 6⅛ inches (6.4 × 21.6 × 15.6 cm).

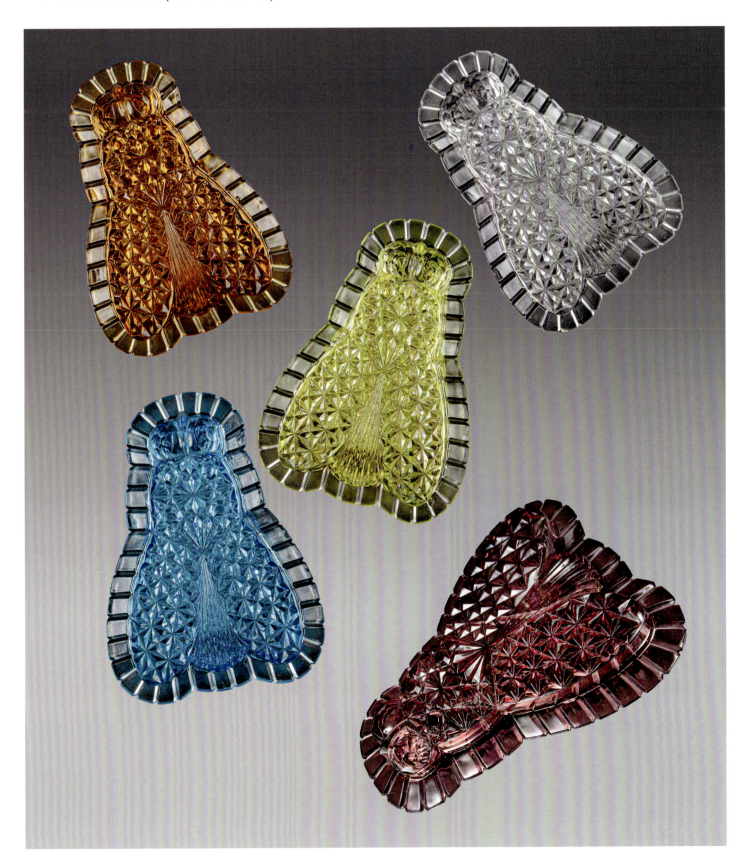

Sword Pickle (omn), mid-1880s

The Sword Pickle is illustrated in the Factory B Catalogue and dated to the mid-1880s based on its production in amber and blue, as well as crystal (cat. 121).

The flaming sword, believed to have supernatural powers, has existed in myths and legends for thousands of years. According to the Bible, a flaming sword was left to guard the gates of Paradise after Adam and Eve were banished: "So He drove out the man; and he placed at the east of the garden of Eden Cherubims, and a flaming sword which turned every way, to keep the way of the tree of life."[57]

121 Sword Pickle

Amber. ⅞ × 10½ × 4¼ inches (2.2 × 26.7 × 10.8 cm).
Collection of Mary Lamica.

Fish Cream with Tilting Glass Cover (omn), circa 1886

This Fish Cream pitcher is illustrated in the Factory B Catalogue, where it is labeled "Fish Cream with Tilting Glass Cover." The cover would open when the cream was tipped and resume its place when the cream was set down. The glass cover shown in the catalogue illustration is missing from the example shown here (cat. 122). The *Pottery & Glassware Reporter*'s (January 21, 1886) description of a jug with a tilting glass cover without any metallic fixtures may be a reference to the cover used on the Fish Cream.

122 Fish Cream with Tilting Glass Cover

Canary. Missing tilting glass cover.
7¾ × 5½ × 3½ inches
(19.7 × 14 × 8.9 cm).
Collection of Carmen Keehn.

Star of Garter (omn), mid-1880s

This Star of Garter plate is illustrated in the Factory B Catalogue (see fig. 50). It was made in crystal, amber, blue, canary, and amethyst.

England's King Edward III was inspired by the tales of King Arthur and the Knights of the Round Table to set up his own group of honorable knights in the year 1348. He called them the Order of the Garter, which is now the oldest and most senior Order of Chivalry in Britain. Its emblem is the Star of Garter, depicting the cross of St. George, patron saint of soldiers and of England, within an eight-pointed star. The motto

"HONI SOIT QUI MAL Y PENSE" in Old Norman French encircles the center cross. It translates to "Shame on anyone who thinks evil of it."

No record has been found explaining what inspired Bryce Brothers to produce this novelty for the mass market. It may have been another nod to the 1882 royal visit from Princess Louise and her husband John Campbell, Duke of Argyll and Marquis of Lorne, who was later appointed to the Order of the Garter in 1911.

123 Star of Garter plate

Amethyst. ⅞ × 7⅞ inches (2.2 × 20 cm).

A.B.C. Plate (omn), circa 1886

This 7-inch A.B.C. Plate is illustrated in the Factory B Catalogue (see fig. 50) and was made in crystal, amber, blue, canary, and amethyst. It has a scalloped edge with the letters of the alphabet around the rim and an interior ring of Arabic numbers. The center is a clock with Roman numerals and minute marks. It was produced as early as 1886, based on its illustration in Butler Brothers where it was described as a "New ABC Clock Plate."[58]

This plate has been reproduced using a different font for the letters and numbers.

124 A.B.C. Plate

Canary. ¾ × 7 inches (1.9 × 17.8 cm).

Leaf Flanged Butter (omn), circa 1886

The Leaf flanged butter (cat. 125) is illustrated in the Factory B Catalogue (fig. 41). It is decorated with leaves and two butterflies, and has a twig for the knob. In April 1886, the *American Potter & Illuminator* advertised it in an assortment of six butter dishes, three of which were advertised as available in amber, blue, and amethyst—the Leaf, Avon, and Lorne butters. All three were also made in canary. At a wholesale price of $1.66 a dozen, Leaf was the most expensive of the three, followed by Lorne at $1.48 a dozen and Avon at $1.26 a dozen.[59]

125 Leaf flanged butter

Canary. 4¾ × 7 inches (12.1 × 17.8 cm).

Openwork Dish with Dolphin Standard (aka), circa 1887

This openwork dish with dolphin stem and oval foot was made in crystal, amber, blue, canary, and amethyst (cat. 127). It can be attributed to Bryce Brothers because the dish, which was also sold separately, is illustrated in a Butler Brothers assortment with documented Bryce Brothers patterns.[60] Butler Brothers called it an Open Work Flaring Dish but its original manufacturer's name is not known.

Bryce Brothers used the identical dolphin standard with different decoration around the oval foot with a Maltese bowl (cat. 33).

126 Openwork Dish with Dolphin Standard

Blue. 9⅜ × 10 × 10 inches (23.8 × 25.4 × 25.4 cm).

127 Openwork Dishes with Dolphin Standards

Amethyst, canary, crystal, blue, amber.
9⅜ × 10 × 10 inches (23.8 × 25.4 × 25.4 cm).
Amethyst from the collection of the Bennington Museum, Bennington, VT;
photograph courtesy of the Bennington Museum.

128 Openwork Dish

Blue. 2¾ × 10 × 10 inches (7 × 25.4 × 25.4 cm).

Just Out Table Salt (aka), circa 1888

This little salt depicts a chick emerging from a broken egg. It is attributed to Bryce Brothers and dated based on its illustration in an 1888 *Falker & Stern's Trade Journal and Reliable Price List* assortment with documented Bryce Brothers patterns. Falker & Stern called it a "Just Out Table Salt" but its original manufacturer's name is not known.[61]

 This novelty salt was made in crystal, amber, and blue. The head of the amber chick pictured here has been painted (cat. 129).

129 Just Out Table Salts

Crystal, amber with painted head. 2½ × 3¾ × 2¼ inches (6.4 × 9.5 × 5.7 cm).

Perfumery Stand (aka), circa 1888

The Perfumery Stand is a large piece, 10 inches high and 6½ inches wide, and was made in crystal, amber, and blue. It was designed to hold twelve bottles of extracts that Spelman Brothers provided with each stand (fig. 75).[62] It is dated based on its illustration in a Spelman Brothers catalogue.[63]

The maker of the Perfumery Stand has not been documented; however, the stand shares several identical elements with Bryce Brothers products. First, the panel on the back of the stand is in Bryce Brothers' Puritan pattern introduced by 1887. Second, the shelves have wood graining with knots like that of the Old Oaken Buckets (cat. 99) and Wall Bracket. Third, the bottom front panel is in the Cane pattern used by Bryce Brothers on other novelties. Finally, the sides of the stand have a diagonal Fine Cut design that was also used on Bryce Brothers' Wall Bracket shelf support (cat. 118).

130 Perfumery Stand

Blue. 10 × 6½ × 5¾ inches (25.4 × 16.5 × 14.6 cm).

Fig. 75. Perfumery Stand with twelve bottles, illustrated in Spelman Brothers, *Fancy Goods Graphic* 10, no. 2 (Sept. 1889): 106.

Toothpick and Match Holders, mid-1880s

"The Pervasive Toothpick"

The tablecloth was fresh and neat,
The china bright, the viands sweet,
And slim and straight beside the meat
Stood proudly up—the toothpick.

Stood stiffly, as a toothpick ought,
Which once was shunned but now is sought,
For time has turned and forward brought
To prominence the toothpick.
The dinner done they passed it round,
And none said "Nay," and no one frowned,
But all, with dignity profound,
Applied the nimble toothpick.

Oh, other things of meaner sphere,
Comb! tweezers! brush! The time draws near,
Perchance, when each shall be the peer
Of the promoted toothpick.[64]

The 1880s were the time for toothpicks. It became fashionable to carry a toothpick in your mouth, possibly to create the impression that the bearer was wealthy enough to dine on meat, which required a post-meal toothpick. Not only was it popular among men, but women also took to it.

> The fashion of holding a toothpick in the mouth and chewing it in public has been adopted by ladies only within the last two years [1882]. Previous to that time the fashion was confined exclusively to men. At the present time no lady at a watering place hotel seems to regard her toilet as complete unless she carries a toothpick between her lips, and it is said that some ladies have become so addicted to the habit that they cannot feel at ease on rising in the morning unless they consume two or three toothpicks before breakfast.[65]

But toothpick chewing was not always a benign pastime. The *New York Times* reported in 1884 that a man had met an untimely death by toothpick. Upon seeing his former wife for the first time in several years, he spontaneously embraced her and tried to kiss her, neglecting the toothpick in her mouth. The unfortunate result was that her toothpick pierced the gentleman's eye, penetrating to his brain and killing him on contact. The *New York Times* noted that "the number of eyes that have been seriously injured by feminine toothpicks is painfully large, but hitherto no toothpick wound has proved fatal." The article speculated on the purpose of feminine toothpicks:

> It may be suggested in view of the fate of the leading citizen of Chicago, above referred to, that women carry toothpicks in order to protect themselves against unwelcome kisses. Undoubtedly the presence of a toothpick between lips presumably fair is admirably adapted to drive all thoughts of kissing from the minds of all but the most reckless men. Still, the fact that among women addicted to the toothpick habit are those who are ready to remove their toothpicks at the slightest prospect of a display of ardent affection forbids us to believe that toothpicks are carried in self-defense. Among the most ardent devotees of the toothpick are New-England spinsters of advanced years and Emersonian views. To suppose that such women need any defense against sudden kisses is too preposterous to deserve consideration.[66]

In any case, with the popularity of toothpicks surging, there was a market for glass novelty toothpick and match holders.

In *Victorian Glass*, Ruth Webb Lee attributes twenty toothpick and match holders to Bryce Brothers based on "old trade catalogues" in her possession. She says, "Because so many collectors have inquired about the history of these objects, it was decided to illustrate a number of them, while it is still possible to state accurately when and where they were produced. At least, it is possible in most cases because a large number of the pictures were taken directly from old trade catalogues."[67]

Several times Lee refers to a Bryce Brothers catalogue in her possession and describes statements and particular pages from that catalogue. Her references are specific enough to conclude that her attributions are based on her review of a Bryce Brothers catalogue and therefore authoritative. Many, but not all, of Lee's attributions have been corroborated by secondary sources such as wholesale catalogues. Unfortunately, her Bryce Brothers catalogue has not been located.

According to Lee, Bryce Brothers listed the Dog Kennel (cat. 131) as a novelty.[68] It is illustrated in Butler Brothers' 1887 Santa Claus Edition "'Tiffany' 10-Cent Assortment. Of 'High Art Colored Ware.'" That assortment includes the Dog Kennel and documented Bryce Brothers products, including the Fly butter (cats. 119–20). It describes the Dog Kennel as "Dog House Match Box—An entirely new and original production, representing a dog-house, the top of which lifts off and shows

131 Dog Kennel

Blue. 3 × 4¼ × 2⅝ inches (7.6 × 10.8 × 6.7 cm). The dog's head projects from the door and the top lifts off so toothpicks or matches can be stored inside.

a receptacle for matches." The Dog Kennel was made in crystal, amber, blue, and canary.

Butler Brothers' 1887 Santa Claus Edition illustrates additional Bryce Brothers toothpick and match holders, all of which came in assorted colors and wholesaled for five cents (fig. 76). They are advertised as "Our 'Modern Elite' 5-Cent Assortment. All High Class Gems of Colored Glass" and described as follows:

Fan Tooth Pick Stand—A new and beautiful article of household utility.

Torch Mantel Stand—Representing a hand holding a hollow torch, which serves as a match receptacle.

Fancy Hairpin or Burnt Match Basket—To see it is enough. It sells itself.

Wall Tooth Pick or Match Holder—Has a handle on back; a new and taking design.

Cut Glass Tumbler—A perfect imitation of the real cut glass.

Gypsy Kettle with Wire Handle—This beautiful article of use and ornament is a gypsy kettle with 3 feet and a bright wire handle.

Fancy Rolled up Dish—A beautiful and artistically "tony" sauce dish.

Handled Cup—A beauty for children or for custards, etc.

Fancy Bird Tooth Pick Stand—A gem seller and one that needs but a place upon your counter to sell itself.

Cut Diamond Cream Pitcher—Beautifully patterned and a cream favorite.

Our "MODERN ELITE" 5-Cent Assortment.

ALL HIGH CLASS GEMS OF COLORED GLASS.

The importance of this collection of *colored beauties* will be sufficient to make for it in the fall season alone a sale of *more than 1,200 packages.* Each piece here indicated is a *perfect model of utility and beauty,* and while we name them as 5 cent sellers, yet at a dime the larger portion of them will prove equally strong as low price arguments.

The basket in the Butler Brothers assortment (cat. 132.1) is described as a "Fancy Hairpin or Burnt Match Basket." The same form was made by other manufacturers, including Cambridge Glass of Cambridge, Ohio. Bryce Brothers made other baskets, including Wicker Baskets and a footed basket with a wire handle called Basket Compote. The *Pottery & Glassware Reporter* (April 29, 1886) noted Bryce Brothers' production of baskets: "Among other things they have small baskets with twisted handles."

Butler Brothers describes the Fan (cat. 132.2) as a toothpick stand, but at 4 inches high it is large for a toothpick holder. The Bryce Brothers Fan is in the Cane pattern and was made in crystal, amber, blue, canary, and opaque white (sometimes with gold decoration). Other manufacturers made a similar-shaped fan in a Daisy and Button pattern.

The hanging Wall Pocket aka Wall Basket (cat. 132.3) is sometimes found with a small mirror in the circle on the front of the basket. It was made in crystal, amber, blue, canary, and frosted crystal.[69] It is illustrated with a perfume bottle inside it in an 1889 Spelman Brothers wholesale catalogue (fig. 77).

The Monkey aka Monkey on a Stump (cat. 132.4) is attributed to Bryce Brothers based on *Victorian Glass* and its illustration in a G. Sommers assortment with documented Bryce Brothers patterns.[70] It is dated circa 1887 based on its illustration in the *Missouri Glass Company's Commercial Solicitor.*[71] It was made in crystal, amber, blue, and opaque white. It has been reproduced in additional colors with less detail of hair and toes and a more rounded upper rim.[72]

The Gypsy Kettle (cat. 132.5) is in the Cane pattern and sits on three legs. It has raised rays on the bottom and came covered and uncovered in crystal, amber, blue, and canary.[73] The 1888 F. H. Lovell & Co. *Export Catalogue* describes this novelty as a Glass Kettle for Flowers available in two sizes: No. 1 Gypsy Kettle (2 × 2½ inches, 5.1 × 6.4 cm) and No. 2 Gypsy Kettle (2⅜ × 3 inches, 6 × 7.6 cm). Handwritten notes

indicate it was made by Bryce Brothers. Other manufacturers made gypsy kettles in a Daisy and Button pattern, sometimes with a lid.

Bryce Brothers made open Toy Buckets in three sizes in crystal, amber, blue, canary, and amethyst (fig. 66). The smallest Toy Bucket is pictured here (cat. 132.6). It has also been found in crystal with rose stain, as pictured in *Glass Toothpick Holders.*[74]

The Happy Thought mug (cat. 132.7) has a handle with a finger-grip and was made in crystal, amber, and blue. It is in the same wicker pattern as the Bird Basket next to it. It is illustrated in the 1893 U.S. Glass *Catalogue of Pressed Tumblers and Beer Mugs* where is it labeled "Old No. B., Happy Thought." U.S. Glass used the designation "Old No. B" to identify an item previously produced by Bryce Brothers, followed by its original manufacturer's name or number.

Bryce Brothers produced a novelty hand lamp by fastening a Happy Thought mug to a small, ribbed font (cat. 146). This combination furnished the lamp with a handle, and the mug could be used as a match holder. It was made in crystal, amber, blue, and opaque white, so the Happy Thought mug without the lamp may also have been made in opaque white.

Fig. 77. Wall Pocket with a perfume bottle, illustrated in Spelman Brothers, *Fancy Goods Graphic* 10, no. 2 (Sept. 1889): 106.

132 Toothpick and match holders

Blue.

132.1. Basket. 3⅝ × 3⅜ × 3½ inches (9.2 × 8.6 × 8.9 cm).

132.2. Fan. 4 × 3¼ × 1⅞ inches (10.2 × 8.3 × 4.8 cm).

132.3. Wall Pocket. 3⅜ × 2 × 2⅛ inches (8.6 × 5.1 × 5.4 cm).

132.4. Monkey. 2½ × 2¼ inches (6.4 × 5.7 cm).

132.5. No. 2 Gypsy Kettle with wire handle. 2⅜ × 3 inches (6 × 7.6 cm).

132.6. Toy Bucket with wire handle. 1⅞ × 2 inches (4.8 × 5.1 cm).

132.7. Happy Thought mug. 2⅛ × 1⅞ × 3⅛ inches (5.4 × 4.8 × 7.9 cm).

132.8. Bird Basket. 2½ × 3¼ × 2 inches (6.4 × 8.3 × 5.1 cm).

132.9. Daisy toy mug. 2 × 1⅞ × 2½ inches (5.1 × 4.8 × 6.4 cm).

132.10. Coal Bucket with wire handle. 2½ × 2¾ × 2¼ inches (6.4 × 7 × 5.7 cm).

132.2, 132.7 *Collection of Mary Lamica.*

Amber.
133.1. Coal Hod. 3¼ × 2⅜ inches
 (8.3 × 6 cm).
133.2. Match Safe. 5 × 3 × 1⅞ inches
 (12.7 × 7.6 × 4.8 cm).
133.3. Dolphin Match Holder.
 4⅜ × 2 inches (11.1 × 5.1 cm).

The Bird Basket (cat. 132.8) was made in crystal, amber, blue, and opaque white. It has been reproduced, but the originals are easily distinguishable because they have tiny feet on the bottom of the bird and the reproductions are smooth on the bottom.

The Daisy toy mug is illustrated in the Factory B Catalogue (cat. 132.9; fig. 66). It was made in crystal, amber, blue, and amethyst.[75] The U.S. Glass Co. *Packers' & Confectioners' Catalogue 1893* described it as No. 3812, "Old No. B Daisy. Also Made With Tin Cap." This cup was probably used to distribute condiments and afterwards could be used as a child's toy. A Daisy toy mug with a bottle of perfume is illustrated in Spelman Brothers.[76]

The Daisy toy mug and the companion Coal Bucket next to it (cat. 132.10) are in the same diamond block pattern, which was also used on the Small Boot. Lee attributes the Coal Bucket to Bryce Brothers based on her trade catalogues.[77] It was made in crystal, amber, and blue. Lee also attributes the Coal Hod (cat. 133.1) to Bryce Brothers based on her trade catalogues. It was made in crystal, amber, blue, and canary.

Lee says the Match Safe (cat. 133.2) was listed in her Bryce Brothers catalogue under the title "Novelties." The *Crockery & Glass Journal* was probably describing this item in its report that "among the other specialties [Bryce Brothers] have match safes for suspending against the wall."[78] Butler Brothers advertised it as "Our Colored Glass Match Safe" with a corrugated front,

available in four colors.[79] It has been found in crystal, amber, blue, canary, and opaque white.

The Dolphin Match Holder (aka) (cat. 133.3) has three vertical dolphins around the stem and a sixteen-pointed star on the base. There are four bands around the barrel that go from right to left, end in points, and have two rivets near the point, similar to the bands on Bryce Brothers' buckets. The Dolphin Match Holder was made in crystal, amber, blue, and canary. Lee illustrates that piece without the dolphins around the stem and attributes it to Bryce Brothers with the original manufacturer's name "Barrel."[80] Falker & Stern also used the name "Barrel" for the Dolphin Match Holder illustrated in its October 1890 catalogue.

Lee attributes additional novelties to Bryce Brothers based on her catalogue, including Basket Compote, Cannon, Ice Cream Freezer, Tripod, and Wicker Baskets.

Lee does not discuss Fashion toothpicks (cat. 134), but Fashion is a documented Bryce Brothers pattern illustrated in the Factory B Catalogue. Fashion toothpick holders appear in several wholesale catalogue assortments with Bryce Brothers products (fig. 69). Fashion toothpicks have several variations in the hand finishing, including one shaped like a pineapple and another with a turned-down rim. They were made in crystal, amber, blue, canary, amethyst, and crystal with ruby or rose stain. A Fashion toothpick with an allover ornate metal cage is pictured in *Glass Toothpick Holders*.[81]

134 Fashion toothpicks

134.1. Blue. 3 × 2⅞ × 2¼ inches (7.6 × 7.3 × 5.7 cm).

134.2. Canary. 2⅜ × 3 inches (6 × 7.6 cm).

134.3. Amber. 2⅝ × 2⅞ inches (6.7 × 7.3 cm).

134.4. Amethyst. 3 × 2⅞ × 2¼ inches (7.6 × 7.3 × 5.7 cm).

134.5. Amber. 2⅝ × 2⅞ inches (6.7 × 7.3 cm).

134.6. Crystal. 2¾ × 2⅝ inches (7 × 6.7 cm).

134.7. Crystal with rose stain. 2¾ × 2⅝ inches (7 × 6.7 cm).

134.1–134.2, 134.4 *Collection of Mary Lamica.*

The *Crockery & Glass Journal* noted Bryce, Walker's production of novelty mugs as early as 1881: "Bryce, Walker & Co.'s latest novelty is a new line of mugs of various designs, which correspond with the style now in demand."[82] This may be a reference to a set of three graduated, footed mugs with Eastlake handles that Bryce produced in the early 1880s in crystal, blue, opaque white, and opaque blue.[83] The Eastlake mug set (cat. 135) is not illustrated in the Factory B Catalogue, and its original manufacturer's name is not known. It is attributed to Bryce Brothers and dated based on illustrations in wholesale catalogues.

The largest Eastlake mug is 3⅜ inches high and known as Boy with Begging Dog. It is illustrated with documented Bryce products in both B. Sommers and Butler Brothers assortments from 1883.[84] One side of the mug shows a boy with a dog sitting up begging (cat. 135.2), and the other side shows a boy on his hands and knees with a dog's food bowl (cat. 135.4). This is one of the few depictions of a person on a Bryce Brothers product. The National bread plate with the profile of Lady Liberty is another (cat. 115).

The mid-sized mug is 2⅝ inches high. It is illustrated with the Boy with Begging Dog mug in an 1884 Spelman Brothers assortment with documented Bryce patterns, including Derby and Pert.[85] This mug is commonly called Heron and Peacock, based on the bird images on each side (cats. 135.1, 135.3). It is possible, however, that Bryce was depicting a crane and a peacock, protagonists in one of Aesop's fables. In that tale, the peacock struts before a crane and brags about its beauty. The crane replies that it can use its feathers to fly, not just to strut. The moral is "Fine feathers don't make fine birds." Reproductions made after 1972 by Degenhart Crystal Art Glass Company of Cambridge, Ohio, can be identified by its trademark *D* inside a heart.[86]

The smallest mug in this series is 2 inches high and commonly called Deer and Cow (cats. 135.5–6). However, Bryce may have intended this to be a depiction of the stag and bull in the Brothers Grimm fairy tale *The Glass Coffin*.

135 Eastlake mugs

135.1. Crystal Heron and Peacock mug (peacock side). 2⅝ × 3½ × 2½ inches (6.7 × 8.9 × 6.4 cm).

135.2. Blue Boy with Begging Dog mug (begging dog side). 3⅜ × 4¼ × 3 inches (8.6 × 10.8 × 7.6 cm).

135.3. Blue Heron and Peacock mug (heron side). 2⅝ × 3½ × 2½ inches (6.7 × 8.9 × 6.4 cm).

135.4. Crystal Boy with Begging Dog mug (boy with dog's bowl side). 3⅜ × 4¼ × 3 inches (8.6 × 10.8 × 7.6 cm).

135.5. Crystal Deer and Cow mug (cow side). 2 × 2¾ × 1⅞ inches (5.1 × 7 × 4.8 cm).

135.6. Blue Deer and Cow mug (deer side). 2 × 2¾ × 1⅞ inches (5.1 × 7 × 4.8 cm).

135.1–135.3 *Collection of Mary Lamica.*

136 Two sets of graduated mugs, one with flat handles, the other with beaded handles

136.1. Amber No. 1303 aka Dog Chasing Deer. 3¾ × 4½ × 3¼ inches (9.5 × 11.4 × 8.3 cm).

136.2. Amethyst No. 1203 aka Robin in a Tree. 3¾ × 4½ × 3¼ inches (9.5 × 11.4 × 8.3 cm).

136.3. Canary No. 1202 aka Grape Bunch. 3⅜ × 4½ × 3 inches (8.6 × 11.4 × 7.6 cm).

136.4. Blue No. 1302 aka Bird on a Branch. 3⅜ × 4½ × 3 inches (8.6 × 11.4 × 7.6 cm).

136.5. Blue No. 1201 aka Feeding Deer and Dog. 2⅝ × 3½ × 2⅜ inches (6.7 × 8.9 × 6 cm).

136.6. Amber No. 1301 aka Pointing Dog. 2⅝ × 3½ × 2⅜ inches (6.7 × 8.9 × 6 cm).

136.7. Crystal No. 1300 aka Gliding Swan. 2 × 2¾ × 1⅞ inches (5.1 × 7 × 4.8 cm).

136.8. Amber No. 1200 aka Pugs and Chicks. 2 × 2¾ × 1⅞ inches (5.1 × 7 × 4.8 cm).

Bryce Brothers made two sets of four graduated mugs with naturalistic designs, including animals, birds, and fruits (cat. 136). One set has flat handles and the other has beaded handles. Both sets are illustrated in the Factory B Catalogue.

The set with flat handles was made in crystal, amber, blue, canary, and amethyst. The flat-handled mugs have an eight-pointed star on the bottom. The Factory B Catalogue (fig. 66) illustrates one side of the mugs; the other side is pictured here (cat. 136).

The largest mug, No. 1203 aka Robin in a Tree, is 3¾ inches high (cat. 136.2). It has a downward-facing robin with open wings on a branch on one side and a bird on a branch looking over its shoulder on the other side. Butler Brothers advertised this mug in 1885 as "Extra Large Mug, new; very large bird pattern on side."[87] The Robin in a Tree mug was widely reproduced by Mosser Glass of Cambridge, Ohio, between 1973 and 1993. Those reproductions sometimes have an *M* inside an outline of the state of Ohio or sometimes a very tiny *M* by itself on the bottom.[88] The reproductions were made in additional colors not produced by Bryce Brothers.

The second-largest mug, No. 1202 aka Grape Bunch, is 3⅜ inches high, and depicts the same design of leaves with grapes on both sides (cat. 136.3). There is another flat-handled mug of the same size and shape known as Strawberry and Pear (cat. 137). One side features a group of three strawberries with leaves, and the other side a pear with a grape bunch. It is not illustrated in the Factory B Catalogue as part of the set, but it shares the same characteristics as the other flat-handled mugs, including the eight-pointed star on the bottom. It is attributed to Bryce Brothers based on its similarities to the other flat-handled mugs and its production in amethyst. The Strawberry and Pear mug was reproduced in the 1940s with a star on the bottom that had twenty-four points instead of eight.[89]

The second-smallest flat-handled mug, No. 1201 aka Feeding Deer and Dog, is 2⅝ inches high (cat. 136.5). It has a deer with antlers reaching for some branches on one side and a running dog on the other. The smallest mug, No. 1200 aka Pugs and Chicks, is 2 inches high and has two dancing chicks on one side and two frolicking pugs on the other side (cat. 136.8).

Bryce Brothers' set of four graduated mugs with beaded handles is illustrated in the Factory B Catalogue (fig. 78) and has been found in crystal, amber, blue, opaque white, and frosted crystal.[90] These mugs date from the mid-1880s based on their production in color. Unlike the Eastlake and flat-handled mugs, each mug in this set has three images rather than two.

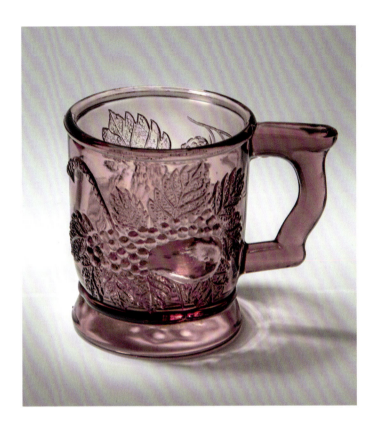

137 Strawberry and Pear mug

Amethyst. 3⅜ × 4½ × 3 inches (8.6 × 11.4 × 7.6 cm).

The largest mug, No. 1303 aka Dog Chasing Deer, is 3¾ inches high (cat. 136.1). The three images on this mug are a running dog, a doe and two stags running, and a stag looking over its shoulder, all framed by trees. No. 1302 aka Bird on a Branch is 3⅜ inches high (cat. 136.4). It depicts a bird on a branch, an owl on a branch, and a crouching bird on a branch. Butler Brothers advertised this mug in 1891 as "Our 'Purity' Opal Mug. A Milk-White Table Gem. Good size, pure white, neatly stamped designs in relief on the sides."[91]

The next smaller size, No. 1301 aka Pointing Dog, is 2⅝ inches high (cat. 136.6). It has a hunting dog pointing at a bird, a bird crouching on a branch, and a dog looking over its left shoulder. The smallest mug is No. 1300 aka Gliding Swan at 2 inches high (cat. 136.7). It has a swimming swan gliding among cattails, a duck flapping its wings, and a duck swimming among water grasses.[92]

Fig. 78.

Top: Four graduated mugs with beaded handles, illustrated in the "Factory B" (Bryce Brothers) section of the United States Glass Company composite catalogue (Jan. 1892).

Bottom: A different side of the four graduated mugs with beaded handles, illustrated in the United States Glass Company catalogue, 1907.

Another mug with naturalistic designs illustrated in the Factory B Catalogue is No. 4 Mug (omn) aka Birds and Insects (fig. 66). It is decorated with seven birds and two butterflies, and the design on its handle resembles the bark of a tree branch. An amber example of this mug is pictured in *Pattern Glass Mugs*.[93]

Bryce Brothers made other novelty cups that were not part of a set. The No. 175 Toy Cup & Saucer (cat. 138) is illustrated in the Factory B Catalogue (fig. 66) and was made in crystal, amber, blue, canary, and amethyst.[94] Spelman Brothers advertised it as early as 1886.[95] The cup

is 2 inches high and 2¼ inches in diameter. The saucer is 3⅝ inches in diameter.

A cat on a cushion is depicted on one side of the cup, and a dog running in front of a picket fence on the other. The center of the saucer features a pair of boots with a cat in one of the boots, a nod to "Puss in Boots," a sixteenth-century Italian fairy tale about a cat who uses trickery and deceit to gain power, wealth, and fame for its penniless master. The amber saucer pictured here has a decorative border around the rim (cat. 138.2), but the saucer was also made without a border.

138 No. 175 Toy Cup & Saucer

138.1. Blue cup. 2 × 3 × 2¼ inches (5.1 × 7.6 × 5.7 cm).
138.2. Amber saucer. ⅝ × 3⅝ inches (1.6 × 9.2 cm).
138.3. Amber cup. 2 × 3 × 2¼ inches (5.1 × 7.6 × 5.7 cm).

Bryce Brothers made a paneled hobnail mug it called No. 1205, available in crystal, amber, and blue (cat. 139). It is larger than some of the other toy mugs, but still only 2¼ inches high and 3 inches in diameter. It is octagonal in shape and features eight panels separated by rope cables, with hobnail decoration on the panels and the bottom. It is related to Bryce Brothers' Acme aka Paneled Cable pattern. Sugar bowls, spoon holders, and cream pitchers in that pattern are also octagonal with rope cables separating eight panels. In Acme, the panels are smooth without hobnail decoration. Acme cream pitchers have the same unusual handles as the paneled hobnail mugs.

No. 1205 is illustrated in the Factory B Catalogue and dated circa 1888 based on its illustration in *Falker & Stern's Trade Journal and Reliable Price List*, no. 2 (1888). Butler Brothers advertised it as a "pretty octagonal mug," available in amber, blue, and crystal, retailing for five cents.[96] U.S. Glass renumbered the mug as U.S. Glass No. 3811 and listed it with toy mugs in its 1893 *Catalogue of Pressed Tumblers and Beer Mugs*.

Many companies used the hobnail design, which was originally known as Dewdrop, but the octagonal shape of this Bryce Brothers paneled mug and its handle are unique.

139 No. 1205 mugs

Amber. 2¼ × 4⅛ × 3 inches (5.7 × 10.5 × 7.6 cm).

NOTES

1. *Crockery & Glass Journal*, Dec. 1, 1887, 107.
2. *China, Glass & Lamps*, Apr. 8, 1891.
3. Bryce Brothers Old Oaken Buckets are sometimes mistakenly attributed to Bryce, Higbee & Company, perhaps due to the similarity in the company names.
4. "They have sold enormous quantities of their popular bucket jellies, which they make in several different sizes and colors. These glasses are sure to greatly enhance the sale of any fruit put up in them, as people will buy them as readily for the sake of having the glass as for its contents if not more so." *Crockery & Glass Journal*, July 16, 1885, 14.
5. *Crockery & Glass Journal*, Apr. 9, 1885, 16.
6. *Crockery & Glass Journal*, May 7, 1885, 14.
7. The handles on novelties can easily be removed and switched to other pieces. A Bryce Brothers' wire handle on a piece is no guarantee the glass was made by Bryce Brothers. Similarly, Bryce Brothers glass can be found with handles that originated on other manufacturers' ware.
8. Butler Brothers, *"Our Drummer"* (83rd Trip 1885): 29, 31.
9. *Crockery & Glass Journal*, Apr. 9, 1885, 16.
10. Doris Anderson Lechler, *Toy Glass* (Marietta, OH: Antique Publications, 1989), 197 (sugar bowl 3¾ inches; butter 2⅜ inches); Neila Bredehoft, Tom Bredehoft, Jo Sanford, and Bob Sanford, *Glass Toothpick Holders, Second Edition* (Paducah, KY: Collector Books, 2005), 28.
11. *Pottery & Glassware Reporter*, June 10, 1886.
12. Copies of the annotated Lovell catalogues are at the Sandwich Glass Museum, Sandwich, MA.
13. Ruth Webb Lee, *Victorian Glass, Specialties of the Nineteenth Century* (Rutland, VT: Charles E. Tuttle Company, 1944), 476–77.
14. G. Sommers & Co., *Our Leader*, no. 40 (Early Fall Edition 1887): 19.
15. Butler Brothers, *"Our Drummer"* (86th Trip 1887): 19.
16. Butler Brothers, *"Our Drummer"* (Spring and Summer 1897): 63.
17. Butler Brothers, *"Our Drummer"* (Spring and Summer 1898): 65.
18. Libby Yalom, *Shoes of Glass, 2* (Marietta, OH: Glass Press dba Antique Publications, 1998), 102–3.
19. Ruth Webb Lee, *Victorian Glass*, 447, says that Bryce Brothers listed this as an ash tray. Bryce Brothers' Slipper on a Tray in the Coral pattern was made as early as 1887, but the full-line Coral tableware pattern was not introduced until two years later in 1889. The Coral tray attached to the slipper came in crystal, amber, blue, and canary, while Coral tableware was made in crystal and rarely crystal with ruby stain.
20. Butler Brothers, *"Our Drummer"* (Santa Claus Edition 1887): 38.
21. Lee, *Victorian Glass*, 475. Lee frequently refers with specificity to a Bryce Brothers catalogue in her possession, but it has not been located.
22. Yalom, *Shoes of Glass, 2*, 106.
23. Lee, *Victorian Glass*, 486, plate 206A.
24. Lee, *Victorian Glass*, 462.
25. Lee, *Victorian Glass*, 462.
26. One of Herman Tappan's popular perfumes was called "Sweet Bye & Bye Bouquet."
27. Butler Brothers, *"Our Drummer"* (86th Trip 1887): 34.
28. Yalom, *Shoes of Glass, 2*, 51.
29. Yalom, *Shoes of Glass, 2*, 126.
30. Yalom, *Shoes of Glass, 2*, 126–27.
31. Lee, *Victorian Glass*, plate 206A.
32. Lee, *Victorian Glass*, 471.
33. Yalom, *Shoes of Glass, 2*, 34, no. 168.
34. Yalom, *Shoes of Glass, 2*, 34, 117.
35. Yalom, *Shoes of Glass, 2*, 117.
36. Almanac for 1886 Supplement to *The Baltimore Sun* 98, no. 47 (1887): 14.
37. Butler Brothers, *"Our Drummer"* (85th Trip 1886): 25; G. Sommers & Co., *Our Leader*, no. 40 (Early Fall Edition 1887): 19.
38. Sid Lethbridge, "The Bryce Bros. Glass Flotilla of '86," *All About Glass* 12, no. 2 (2014): 8–9.
39. Butler Brothers, *"Our Drummer"* (85th Trip 1886): 25.
40. *Pottery & Glassware Reporter*, Jan. 21, 1886, 13.
41. Butler Brothers, *"Our Drummer"* (85th Trip 1886): 25.
42. Spelman Brothers catalogue (Fall 1886): 4.
43. Lethbridge, "Flotilla," 9.
44. *American Potter & Illuminator* 7, no. 2 (Feb. 1888): 29.
45. Butler Brothers, *"Our Drummer"* (85th Trip 1886): 25; Lethbridge, "Flotilla."
46. Butler Brothers, *"Our Drummer"* (85th Trip 1886): 25.
47. *Crockery & Glass Journal*, Feb. 11, 1886, 17.
48. *American Potter & Illuminator* 7, no. 2 (Feb. 1888): 29.
49. Thanks to Rick Ciralli for pointing out the similarity between Bryce Brothers' National bread plate and the Morgan silver dollar.
50. Butler Brothers, *"Our Drummer"* (Santa Claus Edition 1887): 38.
51. F. H. Lovell & Co., *Export Catalogue* (1888): 17.
52. Spelman Brothers, *Bazaar and Bargain Catalogue* (Feb. 1891): 513.
53. Butler Brothers, *"Our Drummer"* (86th Trip 1886): 35.
54. *Pottery & Glassware Reporter*, June 10, 1886.
55. An amethyst Fly is in the collection of the Metropolitan Museum of Art, New York (46.140.290a, b).
56. Butler Brothers, *"Our Drummer"* (Santa Claus Edition 1887): 38.
57. Genesis 3:24 (King James Version).
58. Butler Brothers, *"Our Drummer"* (85th Trip 1886): 25.
59. *American Potter & Illuminator* 5, no. 4 (Apr. 1886): 28.
60. Butler Brothers, *"Our Drummer"* (Santa Claus Edition 1887): 38.
61. *Falker & Stern's Trade Journal and Reliable Price List*, no. 2 (1888).
62. Spelman Brothers, *Fancy Goods Graphic* 10, no. 2 (Sept. 1889): 106.
63. Spelman Brothers, *Bazaar and Bargain Catalogue* (Feb. 1888): 14.
64. *Current Literature* 9, no. 2 (1892): 305. Originally published in the *St. Louis Republic*.
65. "A Toothpick Tragedy," *New York Times*, Sept. 3, 1884, 4.
66. "A Toothpick Tragedy."
67. Lee, *Victorian Glass*, 294–305. See plate 103, nos. 14, 15; plate 104, no. 19.
68. Lee, *Victorian Glass*, 300.
69. Bredehoft et al., *Glass Toothpick Holders*, 28.
70. G. Sommers & Co., *Our Leader*, no. 70 (Fall, Winter, and Holiday Edition 1891): 51.
71. *Missouri Glass Company's Commercial Solicitor* 32, no. 377 (May 1887): 12.
72. Bredehoft et al., *Glass Toothpick Holders*, 197.
73. Bredehoft et al., *Glass Toothpick Holders*, 195.
74. Bredehoft et al., *Glass Toothpick Holders*, 26.
75. Brad Gougeon, "Bryce's Amethyst. The Third 'A' in the ABC Era," *NewsJournal* (Early American Pattern Glass Society) 27, no. 3 (Fall 2020): 8.
76. Spelman Brothers, *Fancy Goods Graphic* (Feb. 1891): 513.
77. Lee, *Victorian Glass*, 298, plate 105, no. 7.
78. *Crockery & Glass Journal*, Nov. 4, 1886, 18.
79. Butler Brothers, *"Our Drummer"* (86th Trip 1886): 19.
80. Lee, *Victorian Glass*, 302, plate 104, no. 18.
81. Bredehoft et al., *Glass Toothpick Holders*, 26–27.
82. *Crockery & Glass Journal*, Aug. 28, 1881, 27.
83. The name Eastlake likely refers to the English architect and designer Charles Locke Eastlake (1836–1906), whose work was influential in America in the 1870s and 1880s.
84. B. Sommers & Co., *Our Leader*, no. 9 (1883): 14; Butler Brothers, *"Our Drummer"* (75th Trip 1883): 19.
85. Spelman Brothers, *Fancy Goods Graphic* 4, no. 9 (Apr. 1884): 534.
86. John B. Mordock and Walter L. Adams, *Pattern Glass Mugs* (Marietta, OH: Glass Press dba Antique Publications, 1995), 18.
87. Butler Brothers, *"Our Drummer"* (83rd Trip, Cold Weather Edition 1885): 26.
88. Mordock and Adams, *Pattern Glass Mugs*, 21.
89. Mordock and Adams, *Pattern Glass Mugs*, 26.
90. A frosted No. 1301 Pointing Dog is pictured in Lechler, *Toy Glass*, 31.
91. Butler Brothers, *"Our Drummer"* (Mar. 1891): 42.
92. According to Mordock and Adams, *Pattern Glass Mugs*, 18, this mug is shown in a Federal Glass Company Packers' Catalogue from 1914 and was used to distribute condiments.
93. Mordock and Adams, *Pattern Glass Mugs*, 18.
94. Gougeon, "Bryce's Amethyst," 3–8. A canary cup and saucer is pictured in Jo Sanford and Bob Sanford, *Victorian Glass Novelties* (Atglen, PA: Schiffer Publishing, 2003), 72.
95. Spelman Brothers catalogue (Fall 1886): 4.
96. Butler Brothers, *"Our Drummer"* (92nd Trip, Sept. 1889): 20.

Fig. 79. Crystal Bryce Brothers Liberty Torch, ca. 1887. 4¼ × 2 inches (10.8 × 5.1 cm). F. H. Lovell & Co. described the Liberty Torch as a candlestick in its 1888 *Export Catalogue*.

Lamps

GLASS OIL LAMPS WERE AN IMPORTANT PART OF Bryce's business and were mentioned specifically in early advertisements. By late 1880, Bryce, Walker was shipping the largest consignments of lamps in the history of the company.[1] "Messrs. Bryce, Walker & Co. send out very large quantities of plain and ornamental lamps. The demand for this class of goods is very large, showing that the people of the West are determined to have 'new light.' It is pleasant to know they are becoming en-light-ened."[2]

Fig. 80. Tulip with Sawtooth lamp, 1860–70. 10⁵⁄₁₆ inches (26.2 cm). Tulip with Sawtooth is one of the earliest patterns made by Bryce. *The Metropolitan Museum of Art, New York City, Gift of Mrs. Emily Winthrop Miles, 1946 (46.140.808). Image copyright © The Metropolitan Museum of Art. Image source: Art Resource, NY.*

Bryce's success in the lamp business was due in part to efficient production and lower prices: "They have just completed a new set of plain oil glass lamps, in which branch of the trade they have a decided lead. They are produced in such large quantities that they can be sold cheaply, and cheapness is the popular notion. Yet it must be borne in mind that this old and reliable firm produces nothing which will not compare favorably with anything in the country."[3]

Tulip is the earliest Bryce pattern found on lamps (fig. 80), and Bryce, McKee may have made Tulip lamps as early as 1850. Bryce lamp fonts have been found in several tableware patterns of the 1870s, but lamps made in the 1880s are difficult to identify. Bryce may have been using different font patterns that are not also found on tableware and therefore difficult to authenticate as Bryce production in the absence of a lamp catalogue.

On November 17, 1874, John Bryce obtained a patent (No. 156,976) for a method of manufacturing glass lamp pedestals that eliminated the metal connector used to attach the font to the pedestal. His innovation provided for manufacturing a pedestal with a socket at the top into which the stem of the font could be inserted and secured with plastic cement, providing a neat finish and an almost imperceptible joint that was less likely to crack or detach. The patent drawings illustrate the technique (fig. 81).

The lamp pedestal illustrated in the patent is pictured here (cat. 140). "PAT NOV 17TH 1874" in raised letters is on the bottom of the pedestal. The font is in the Diamond Sunburst pattern, also patented by John Bryce in 1874.

Fig. 81. Illustration of the manufacture of glass-lamp pedestals, 1874. Patent No. 156,976.

140 Diamond Sunburst lamp

Brass collar, opaque white pedestal, 1874. 10 × 5⅜ inches (25.4 × 13.7 cm).
Both the font and pedestal designs were patented by John Bryce in 1874.

141 Palmette, Grape Band lamps

141.1. Palmette font with brass collar, opaque white pedestal, early 1870s. 9¾ × 4½ inches (24.8 × 11.4 cm).
141.2. Palmette font with brass collar, crystal scalloped pedestal, early 1870s. 8½ × 4½ inches (21.6 × 11.4 cm).
141.3. Grape Band font missing collar, opaque white pedestal, 1869. 9 × 5 inches (22.9 × 12.7 cm).

142 Geddes lamp

Brass collar, metal base, ca. 1877. 8½ × 5½ inches (21.6 × 14 cm).

Fig. 82. Lamp with a Geddes font, illustrated in F. H. Lovell & Co., *Catalogue of 1877 & 8*, plate 124. *Courtesy of the Sandwich Glass Museum, Sandwich, MA.*

Bryce, Walker's Palmette pattern of the early 1870s was also used on lamp fonts (cats. 141.1–2). The Palmette lamp on the left has an opaque white pedestal with a brass connector between the font and pedestal—the type of connector the new Bryce patented methodology sought to replace. The Palmette lamp in the center (cat. 141.2) has a graceful crystal pedestal with six scallops. This lamp was made in 8½- and 9½-inch heights and may have come in additional sizes. Bryce, Walker used the same lamp pedestal with different fonts, and this crystal scalloped pedestal was also used with a Diamond Sunburst font.[4]

The lamp on the right (cat. 141.3) has a different style of opaque white base that also uses a connector to join the font and pedestal. This font is in the Grape Band pattern, the first naturalistic design patented by John Bryce in 1869.

A lamp with a Geddes aka Star Band font and metal base came in a height of 8½ inches (cat. 142), as well as a larger 9-inch size. F. H. Lovell & Co.'s *Catalogue of 1877 & 8* illustrated a Geddes font with a decorative globe and a different style of metal base (fig. 82).[5]

143 Geddes hand lamp

Brass collar, applied handle, ca. 1877. 3¼ × 4 × 5⅛ inches (8.3 × 10.2 × 13 cm).

Bryce also made hand lamps with handles that could be carried easily from room to room. A Geddes hand lamp with an applied handle is pictured here (cat. 143).

The World's Columbian Exposition, also known as the 1893 Chicago World's Fair, was a highly anticipated celebration of the four-hundredth anniversary of Christopher Columbus's landing in America. The fairgrounds were dedicated in 1892, but not opened to the public until 1893. One of the great innovations of that event was the widespread use of electric power to illuminate the fairgrounds. It foreshadowed a world where electricity would replace light sources such as the lamps Bryce Brothers was producing. The public enthusiastically embraced the spectacle and Bryce Brothers seized the opportunity to promote its new line of World's Fair lamps in 1890:

> Bryce Bros. are out strong in new lamps. . . . There are four new patterns and four sizes and four colors of each. These are called the "World's Fair" lamps. They are in crystal, opal, amber and blue and the bowls can be unscrewed from the feet, which will greatly facilitate packing, taking less room and preventing breakage. . . . Bowls and feet of the same lamp can be had of different colors if required.[6]

The 1893 U.S. Glass *Clinch Collar Lamps Catalogue* illustrates three lamps in four sizes, described as "World's Fair Lamps, made in Amber, Blue, Crystal and Opal. Pegs and Feet connected by means of Screw Sockets."[7] The fonts on those lamps are named for American cities—Chicago, New York, and St. Louis, all cities that had competed to host the exposition. The catalogue shows the fonts with two different styles of pedestals, both pictured here (cat. 144). An example of the fourth World's Fair lamp referenced in the journal report has not yet been identified, and its font name and pattern are not known. Presumably it was made in the same colors with the same pedestals.

Shown here is a group of three World's Fair lamps, two with blue New York fonts and one with an opaque white St. Louis font (cat. 144). The fonts of these lamps are threaded and can be unscrewed from the base. Butler Brothers advertised the 9½-inch blue lamp on the right as an "Evening Lamp," retailing for twenty-five cents, noting that it has "the Safety Screw Socket, which makes safe packing and a safe lamp to use."[8] It also advertised a larger 12-inch version of that lamp as a "Home Circle" lamp, retailing for fifty cents. These lamps are sometimes called "Pittsburgh" lamps because they share some design features with Bryce Brothers' Pittsburgh pattern (see cats. 95–98), introduced the following year. The prism design on the font and the decoration on the stem were also used on the Pittsburgh pattern.

144 World's Fair lamps

1890

144.1. Blue New York font with brass collar, opaque white pedestal. 9¾ × 5⅝ inches (24.8 × 14.3 cm).

144.2. Opaque white St. Louis font with brass collar, blue pedestal. 11¼ × 5⅞ inches (28.6 × 14.9 cm).

144.3. Blue New York font with brass collar, blue pedestal. 9½ × 4½ inches (24.1 × 11.4 cm).

Fig. 83. Advertisement for World's Fair lamps in H. Leonard & Sons, *Illustrated Price List of House Furnishing Goods*, no. 105 (1891): 67. *From the Collections of The Henry Ford, Dearborn, MI.*

145 Chicago lamp

Brass collar, tin base, engraved chimney (replaced), ca. 1890. 18 × 6¼ inches (45.7 × 15.9 cm).

H. Leonard & Sons advertised World's Fair lamps with Chicago and New York fonts (fig. 83). Chicago fonts are also found with bases that are not illustrated with the World's Fair lamps in the U.S. Glass lamp catalogue. A lamp with a Chicago font, tin base, and an engraved chimney (replaced) is pictured here (cat. 145).

Bryce Brothers combined a smaller New York font with its Happy Thought mug to create a novelty night lamp (cat. 146). It has a conical shade with vertical ribs and a matching font with a sunburst design on the base. The attached mug provided a handle for the lamp and a convenient place for matches. G. Sommers described it as "Our 'Happy Thought' Night Lamps—A night lamp with globe, burner, etc., and a glass match safe combined. A new idea which strikes one at sight. Assorted colors."[9] Butler Brothers advertised it as a "Combination" lamp, "A New and Artistic Combination of Lamp and Match Safe," available in crystal, blue, and amber, retailing for twenty-five cents.[10] It was also made in opaque white.

China, Glass & Lamps described another new Bryce Brothers lamp on July 15, 1891: "The 'Vesta'" is the name of a new night lamp got out by Bryce Bros. It is of antique pattern, something after the style of those seen in early prints, when the oil was burned in an open vessel with the wick placed loosely therein." This was one of the last lamps designed by Bryce Brothers.

146 Happy Thought Night Lamp

Amber, brass collar, attached mug, ca. 1890. 7¾ × 6⅛ × 3¼ inches (19.7 × 15.6 × 8.3 cm).

NOTES
1. *Crockery & Glass Journal*, Oct. 28, 1880, 12.
2. *Crockery & Glass Journal*, Sept. 2, 1880, 19.
3. *Crockery & Glass Journal*, July 14, 1881, 12.
4. Catherine M. Thuro, *Oil Lamps: The Kerosene Era in North America* (Radnor, PA: Wallace-Homestead, 1976), 98. The same pedestal is also pictured with a font Thuro calls "Beaded Scroll," a pattern that may also have been made by Bryce.
5. Catherine M. Thuro, *Oil Lamps II: Glass Kerosene Lamps* (Toronto, ON: Thorncliffe House; Paducah, KY: Collector Books, 1983), 86, pictures a Geddes font with a different metal base and a catalogue illustration of a Geddes font with a different metal base and decorative globe.
6. *Pottery & Glassware Reporter*, June 5, 1890.
7. The Corning Museum of Glass has copies of several pages from the 1893 U.S. Glass *Clinch Collar Lamps Catalogue*.
8. Butler Brothers, *"Our Drummer"* (Santa Claus Edition 1890): 27.
9. G. Sommers & Co., *Our Leader* 70 (Fall, Winter, and Holiday Edition 1891): 52.
10. Butler Brothers, *"Our Drummer"* (Santa Claus Edition 1890): 29.

Fig. 84. Bryce, Walker
No. 80 salver, 1880.

Compendium

THE PRESSED GLASS PATTERNS, NOVELTIES, and lamps listed in this Compendium were designed and produced by the successive Bryce companies between 1850 and 1891. This list is not exhaustive because a complete catalogue record of Bryce's production has not been located. Additionally, the "Factory B" (Bryce Brothers) section of the United States Glass Company composite catalogue released in January 1892 (Factory B Catalogue) includes pages of tumblers, goblets, wines, cordials, candy dishes, salts, and syrups that are not included here.

The chapter "Authenticating Bryce Glassware" (see p. 71) describes the methods of authentication used here. Each Compendium entry identifies the basis for the Bryce attribution, the approximate date of introduction, and supporting references. If a pattern is authenticated based on primary sources, such as a company catalogue, illustrated advertisement, or patent, it is described as *documented*. If it is authenticated based on secondary sources, such as trade journal reports, wholesale catalogues, or identical elements with authenticated Bryce patterns, it is described as *attributed*.

If the year of introduction is not known with certainty, the date is described as *circa* (ca.). If an item is illustrated in the Factory B Catalogue but no more specific dating information is available, the date is described as *ca. 1891*.

Compendium entries are listed alphabetically based on the original manufacturer's name (omn) identified in a primary source. If the omn is unknown or the pattern is commonly known by another name, it is described as *aka* (also known as). The names of various forms of shoes are prefaced with "Shoes" and grouped together. Forms of boats, boots, fish, and mugs are similarly prefaced and grouped. Entries designated by an original manufacturer's number, rather than a name, are grouped together under "No."

Illustrated items were made in crystal. If a pattern is known to have been produced in color as well as crystal, the colors are noted. Identification of colors produced is based on wholesale catalogues, trade journal reports, photographs, and personal observations.

Drawings newly created for this Compendium are identified as "New image." The remaining images are from the Factory B Catalogue unless otherwise noted.

Citations of Ruth Webb Lee, *Victorian Glass, Specialties of the Nineteenth Century* (Rutland, VT: Charles E. Tuttle, 1944), are shortened to Lee, *Victorian Glass*. Citations of Butler Brothers catalogues omit the catalogue name *"Our Drummer"* but identify the issue and date.

A.B.C. Plate (omn), ca. 1886
Cat. 124, fig. 50
Amber, blue, canary, amethyst
Documented: Factory B Catalogue.
Dated based on illustration in Butler
Brothers (85th Trip 1886): 25.

Acme (omn), ca. 1888
Aka Paneled Cable
Documented: Factory B Catalogue.
Dated based on illustration in Falker
& Stern's *Trade Journal and Reliable
Price List*, no. 2 (1888).
See Mugs—No. 1205.

Acorn (omn), ca. 1891
Mustard
Documented: Factory B Catalogue.

Albany (omn), ca. 1891
Fig. 41
Butter
Documented: Factory B Catalogue.

Albion (omn), 1881
Butter, footed and not footed
Documented: Factory B Catalogue.
Introduced by Bryce, Walker in 1881,
as reported in *American Pottery &
Glassware Reporter*, Feb. 3, 1881.

Amazon (omn), 1890
Aka Sawtooth Band
Cat. 90; figs. 34, 51
Plain and engraved
Opaque white, crystal with ruby stain
Documented: Factory B Catalogue.
Introduced for 1890 selling season, as
reported in *Crockery & Glass Journal*,
Dec. 26, 1889.

Ambidextrous (aka), 1881
Cat. 57, fig. 62
Table set
Documented and dated based on
Design Patent No. 12,189, issued to
Henry J. Smith, Assignor to Bryce,
Walker, Mar. 15, 1881.
Image: Patent drawing.

Argent (omn), 1884
Aka Rope Band
Cats. 68–69
Plain and engraved
Documented: Factory B Catalogue.
Introduced in 1884, as reported in
American Pottery & Glassware Reporter,
Jan. 10, 1884.

Argyle (omn), ca. 1885
Aka Beaded Oval Window,
Oval Medallion
Cats. 70–71
Amber, blue, canary, amethyst
Documented: Factory B Catalogue.
Dated based on illustration in
Spelman Brothers, *Special Bargain
Catalogue* (ca. 1885): 5.

Ashburton (aka), ca. 1854
Fig. 24
Documented: Bryce, Richards page,
ca. 1854.
Possibly made by Bryce, McKee as
early as 1850.
Image: Bryce, Richards page.

Atlas (omn), 1889
Aka Crystal Ball
Cat. 89, fig. 64
Plain and engraved
Crystal with ruby stain; opaque white
toothpick holders
Documented: Factory B Catalogue.
Dated based on Design Patent No.
19,427 issued to H. J. Smith, Assignor
to Bryce Brothers, Nov. 12, 1889.

Avon (omn), ca. 1886
Butter, footed and not footed
Amber, blue, canary, amethyst
Documented: Factory B Catalogue.
Dated based on illustration in
American Potter & Illuminator 5, no. 4
(Apr. 1886).

Banner (omn), 1886
Cat. 116, fig. 41
Butter
Amber, blue, canary, amethyst
Documented: Factory B Catalogue.
Introduced in 1886, as reported
in *Pottery & Glassware Reporter*,
June 10, 1886.

Basket (omn), ca. 1887
Cat. 132.1, fig. 76
Toothpick or match holder
Colors
Attributed to Bryce Brothers and
dated based on illustration in an
assortment with documented Bryce
Brothers products in Butler Brothers
(Santa Claus Edition 1887): 38.
New image.

Basket Butter (omn), ca. 1888
Fig. 41
Documented: Factory B Catalogue.
Dated based on illustration in
F. H. Lovell & Co., *Export Catalogue*
(1888): 15.

Basket Compote (omn), ca. 1887
Aka Glass Basket with Handle
Amber, blue
Attributed to Bryce Brothers and
dated based on illustration in an
assortment with documented Bryce
Brothers products in Butler Brothers
(Santa Claus Edition 1887): 36.
Image: Butler Brothers.

Beaded Oval and Scroll (aka), ca. 1881
Aka Dot
Cats. 53–54
Attributed to Bryce, Walker based on
identical elements (finial, standard,
center medallion) with Jasper, a
documented Bryce, Walker pattern.
Dated based on illustration in
Spelman Brothers, *Fancy Goods
Graphic* (Feb. 1881): 171.
Image: Spelman Brothers.

Birch Leaf (aka), ca. 1870
Cat. 21
Opaque white
Attributed to Bryce, Walker based on
identical element (standard) with
Filley and Tulip with Sawtooth, both
documented Bryce patterns.
Dated based on illustration in a
Chauncy I. Filley catalogue (ca.
1870).
Image: Chauncy I. Filley.

Bird Basket (omn), ca. 1887
Aka Chickie
Cat. 132.8, fig. 76
Toothpick or match holder
Amber, blue, opaque white
Attributed to Bryce Brothers and
dated based on illustration in an
assortment with documented Bryce
Brothers products in Butler Brothers
(Santa Claus Edition 1887): 38.
New image.

Boats—Canoe Celery (omn), 1886
Cat. 113.1
Orion pattern
Amber, blue, canary, amethyst; crystal
with ruby or amber stain
Documented: Factory B Catalogue.
Dated the same as Orion pattern.

Boats—Earl Ind. Boat (omn), 1886
Cats. 64.5, 114; fig. 38
Orion pattern
Amber, light amber, blue, canary,
amethyst, green; crystal with ruby,
rose, or amber stain
Documented: Factory B Catalogue.
Dated the same as Orion pattern.

Boats—Genesta Boat, No. 2
Genesta Boat (omn), 1886
Cats. 112, 113.3
Fashion aka Daisy and Button pattern
Two sizes
Amber, blue, canary, amethyst, green;
crystal with ruby, rose, or amber stain
Documented: Factory B Catalogue.
Introduced in 1886, as reported in
Pottery & Glassware Reporter, Jan. 21,
1886.
Smaller No. 2 Genesta also offered
with an opening in the bottom for
use as a whisk broom holder.

Boats—Puritan Boat (omn), 1886
Cats. 110–11, 113.2
Fashion aka Daisy and Button pattern
Amber, blue, canary, amethyst, green;
crystal with ruby, rose, or amber
stain, or gold trim
Documented: Factory B Catalogue.
Introduced in 1886, as reported in
Pottery & Glassware Reporter, Jan. 21,
1886.

Boots—Large Boot (omn), 1886
Cats. 102, 106.1; figs. 72–73
Amber, blue, canary, amethyst, apple
green
Attributed to Bryce Brothers based
on illustration in an assortment
with documented Bryce Brothers
products in Butler Brothers (86th
Trip 1886): 34.
Dated based on Design Patent No.
17,023, issued to H. Tappan of New
York, Dec. 14, 1886.
Image: Patent drawing.

Boots—Roller Skate (aka), 1886
Cat. 106.3
Amber, blue
Attributed to Bryce Brothers because identical to Small Boot but with roller skates on the bottom.
Dated based on Design Patent No. 17,023, issued to H. Tappan of New York, Dec. 14, 1886.
New image.

Boots—Small Boot (omn), 1886
Cats. 106.2, 106.4
Right and Left Boots with twelve buttons going up opposite sides of the shank
Amber, blue, canary, amethyst
Attributed to Bryce Brothers by Lee (*Victorian Glass*, 471), based on her Bryce Brothers catalogue.
Dated based on Design Patent No. 17,023, issued to H. Tappan of New York, Dec. 14, 1886.
New image.

Brazil (omn), 1890
Aka Paneled Daisy
Cats. 91–92
Amber, blue, opaque white
Documented: Factory B Catalogue.
Introduced for 1890 selling season, as reported in *Crockery & Glass Journal*, Dec. 26, 1889.

Bucket (omn), 1885
Aka Old Oaken Bucket
Cats. 99–100, 132.6; figs. 5, 39, 66
Bucket jellies with tin lids with "The Old Oaken Bucket" logo, table set, half-gallon pitcher, child's table set, toy buckets
Amber, blue, canary, amethyst
Documented: Factory B Catalogue.
Introduced in 1885, as reported in *Crockery & Glass Journal*, Apr. 9, 1885, 16.

Cameo (omn), ca. 1888
Fig. 41
Butter, dishes
Opaque white
Documented: Factory B Catalogue.
Dated based on illustration in Falker & Stern's *Trade Journal and Reliable Price List*, no. 2 (1888).

Charm (omn), ca. 1883
Butter
Documented: Factory B Catalogue.
Dated based on illustration in G. Sommers & Co., *Our Leader*, no. 9 (1883): 14.

Coal Bucket (omn), mid-1880s
Cat. 132.10
Toothpick or match holder
Amber, blue
Attributed to Bryce Brothers by Lee (*Victorian Glass*, 303) and by similarities to Daisy toy mug.
Dated based on its production in color.
New image.

Coal Hod (omn), ca. 1887
Cat. 133.1
Toothpick or match holder
Amber, blue, canary
Attributed to Bryce Brothers by Lee (*Victorian Glass*, 301–2).
Dated based on illustration in R. P. Wallace & Co., *Pioneer Lamp & Glass House* (1887): 57.
New image.

Colossus (aka), ca. 1880
Aka Lacy Spiral
Cat. 52
Attributed to Bryce, Walker and dated based on identical elements (finial, standard, center medallion) with Jasper, a documented Bryce, Walker pattern.
New image.

Coral (omn), 1889
Aka Fishscale
Cats. 87–88
Crystal with ruby stain
Documented: Factory B Catalogue.
Introduced in 1889, as reported in *Pottery & Glassware Reporter*, Feb. 28, 1889, 12.

Curled Leaf (aka), 1869
Cats. 12–13; fig. 57
Documented and dated based on Design Patent No. 3,759, issued to John Bryce, Nov. 23, 1869.
Image: Patent drawing.

Derby (omn), 1882
Aka Pleat and Panel
Cat. 58
Amber, blue, canary, amethyst
Documented: Factory B Catalogue.
Introduced in 1882, as reported in *American Pottery & Glassware Reporter*, Mar. 16, 1882.
Image: Butler Brothers (82nd Trip 1885): 17.

Diamond (omn), ca. 1854
Aka Sawtooth
Cats. 7–9, 50.2
Amber, blue, canary, amethyst, green
Documented: Bryce, Richards page, ca. 1854; Factory B Catalogue.
Possibly made by Bryce, McKee as early as 1850.

Diamond Cut Custard Cup (aka), ca. 1886
Cat. 63.7, fig. 76
Fashion aka Daisy and Button pattern
Amber, blue, canary; crystal with ruby stain
Attributed to Bryce Brothers based on illustration in an assortment with documented Bryce Brothers products in Butler Brothers (Santa Claus Edition 1887): 38.
Dated based on illustration in Spelman Brothers (Fall 1886): 4.
Image: Butler Brothers.

Diamond Sunburst (aka), 1874
Cats. 24–26, 34, 140; figs. 26–27, 32–33, 60
Opaque white
Documented and dated based on Design Patent No. 7,948, issued to John Bryce, Dec. 22, 1874.
Image: Reprint of a description of Bryce, Walker & Co. published between 1875 and 1879 (see fig. 33).

Dog Kennel (omn), ca. 1887
Aka Dog House
Cat. 131
Toothpick or match box
Amber, blue, canary
Attributed to Bryce Brothers and dated based on illustration in an assortment with documented Bryce Brothers products in Butler Brothers (Santa Claus Edition 1887): 38.
New image.

Dolphin Match Holder (aka), mid-1880s
Cat. 133.3
Amber, blue, canary
Lee (*Victorian Glass*, 302) attributes identical piece without dolphins to Bryce Brothers with an omn of Barrel.
Dated based on its production in color.
New image.

Duke Cream (aka), ca. 1886
Cat. 63.8, fig. 69
Fashion aka Daisy and Button pattern
Amber, blue, canary; crystal with ruby stain
Attributed to Bryce Brothers and dated based on illustration in an assortment with documented Bryce Brothers products in Spelman Brothers (Fall 1886): 22.
Image: Spelman Brothers.

Duquesne (omn), ca. 1887
Aka Wheat and Barley
Cats. 82–83
Amber, blue, canary
Documented: Factory B Catalogue.
Dated based on illustration in Butler Brothers (Santa Claus Edition 1887): 37.

Excelsior (aka), ca. 1854
Fig. 24
Documented: Bryce, Richards page, ca. 1854.
Possibly made by Bryce, McKee as early as 1850.
Image: Bryce, Richards page.

Fan (omn), ca. 1887
Cat. 132.2, fig. 76
Toothpick
Cane pattern
Amber, blue, canary, opaque white (sometimes with gold decoration)
Attributed to Bryce Brothers based on illustration in an assortment with documented Bryce Brothers products in Butler Brothers (Santa Claus Edition 1887): 38.
Image: Butler Brothers.

Fashion (omn), mid-1880s
Aka Daisy and Button
Cats. 62–65, 134; figs. 37–38, 40–41, 69
Amber, blue, canary, amethyst; crystal with ruby or rose stain
Documented: Factory B Catalogue.
Dated based on illustration in Butler Brothers (85th Trip 1886): 34.

Filley (omn), ca. 1870
Aka Texas Bull's Eye
Cat. 20
Opaque white
Documented: Factory B Catalogue.
Dated based on illustration in a Chauncey I. Filley catalogue (ca. 1870).

Fish—Duke Nappy (omn), 1886
Cat. 108
Orion pattern
Amber, blue, canary, amethyst
Documented: Factory B Catalogue.
Dated the same as Orion pattern.

Fish—Earl Pickle (omn), 1886
Cats. 107, 109.1; fig. 37
Orion pattern
Amber, blue, canary, amethyst; crystal
with ruby or rose stain
Documented: Factory B Catalogue.
Dated the same as Orion pattern.

**Fish—Fashion Nappy (omn),
mid-1880s**
Cat. 109.2; figs. 37, 40
Amber, blue, canary, amethyst
Documented: Factory B Catalogue.
Dated the same as Fashion pattern.

**Fish Cream with Tilting Glass
Cover (omn), ca. 1886**
Cat. 122
Canary, probably other colors
Documented: Factory B Catalogue.
Dated based on its production in
color and reference to a tilting glass
cover in *Pottery & Glassware Reporter*,
Jan. 21, 1886.

Fly (omn), 1886
Cats. 119–20
Top is a Fly Pickle, bottom is a Fly
Dish, both together are a Fly Butter.
Amber, blue, canary, amethyst
Documented: Factory B Catalogue.
Introduced in 1886, as reported in
Pottery & Glassware Reporter, Apr. 29,
1886.

Geddes (aka), ca. 1877
Aka Star Band
Cats. 39, 142–43; fig. 82
Attributed to Bryce, Walker based on
identical elements with Diamond
Sunburst (finial) and No. 80 (center
medallion), both documented Bryce,
Walker patterns.
Dated based on illustration in F. H.
Lovell, *Catalogue of 1877 & 8*, plate
124.
Image of lamp front: F. H. Lovell.
Courtesy of the Sandwich Glass
Museum, Sandwich, MA.

Grape Band (aka), 1869
Cats. 10–11, 34, 141.3; figs. 32, 56
Opaque white
Documented and dated based on
Design Patent No. 3,716, issued to
John Bryce, Oct. 19, 1869.
Image: Patent drawing.

Gypsy Kettle (omn), ca. 1887
Cat. 132.5, fig. 76
Toothpick or match holder
Cane pattern
Two sizes, No. 1 and No. 2
Amber, blue, canary
Attributed to Bryce Brothers and
dated based on illustration in an
assortment with documented Bryce
Brothers products in Butler Brothers
(Santa Claus Edition 1887): 38.
Image: Butler Brothers.

**Happy Thought Night Lamp
(omn), ca. 1890**
Cat. 146
Amber, blue, opaque white
Attributed to Bryce Brothers based on
Happy Thought mug.
Dated based on illustration in Butler
Brothers (Santa Claus Edition 1890):
29.
Image: Butler Brothers.
See Mugs—Happy Thought.

Harp (aka), ca. 1854
Aka Lyre
Fig. 24
Documented: Bryce, Richards page,
ca. 1854.
Possibly made by Bryce, McKee as
early as 1850.
Image: Bryce, Richards page.

Huber (aka), ca. 1854
Fig. 24
Documented: Bryce, Richards page,
ca. 1854.
Possibly made by Bryce, McKee as
early as 1850.
Image: Bryce, Richards page.

Jasper (omn), ca. 1880
Aka Belt Buckle, Late Buckle
Cat. 51
Amber, blue
Documented: Factory B Catalogue.
Dated based on identical elements
(finial, standard, center medallion)
with Beaded Oval and Scroll and
Colossus.

Jersey (omn), ca. 1887
Table set
Plain and engraved
Attributed to Bryce Brothers based
on illustration in an assortment with
documented Bryce Brothers products
in Butler Brothers (Santa Claus
Edition 1888): 41.
Dated based on illustration in
Pitkin & Brooks, *Glassware Catalogue*
(ca. 1887).
Image: Butler Brothers.

Just Out Table Salt (aka), ca. 1888
Cat. 129
Amber, blue
Attributed to Bryce Brothers and dated based on illustration in an assortment with documented Bryce Brothers products in *Falker & Stern's Trade Journal and Reliable Price List*, no. 2 (1888).
New image.

Kitchen Jar Set (omn), 1890
Set of six graduated jars
Documented: Factory B Catalogue.
Introduced in 1890, as reported in *Crockery & Glass Journal*, Apr. 17, 1890, 20.

Lager Beer Mug (aka), 1860
Documented and dated based on illustration in Patent No. 29,666, issued to Robert Bryce, Aug. 21, 1860.
Image: Patent drawing.

Leaf (omn), ca. 1886
Cat. 125, fig. 41
Flanged butter
Amber, blue, canary, amethyst
Documented: Factory B Catalogue.
Dated based on illustration in *American Potter & Illuminator* 5, no. 4 (Apr. 1886).

Liberty Torch (omn), ca. 1887
Aka Hand with Torch
Cat. 117; figs. 74, 76, 79
Toothpick or match holder
Amber, blue
Attributed to Bryce Brothers and dated based on illustration in an assortment with documented Bryce Brothers products in Butler Brothers (Santa Claus Edition 1887): 38. Handwritten notes in F. H. Lovell & Co., *Export Catalogue* (1888): 17, identify it as a "Liberty Torch" candlestick made by Bryce Brothers.
Image: Butler Brothers.

Loop and Dart (aka), 1869
Cat. 14.2
Attributed to Bryce, Walker based on identical elements (finial, star on the foot) with Palmette, an attributed Bryce, Walker pattern.
Dated based on Design Patent No. 3,515, issued to Annie W. Henderson, June 1, 1869.
New image.

Lorne (omn), ca. 1885
Cat. 72
Butter
Amber, blue, canary, amethyst
Documented: Factory B Catalogue.
Dated based on illustration in Spelman Brothers, *Special Bargain Catalogue* (ca. 1885): 6.

Magic (omn), 1889
Aka Rosette
Cat. 86
Blue (rare spoon holder)
Documented: Factory B Catalogue.
Introduced in 1889, as reported in *Pottery & Glassware Reporter*, Feb. 28, 1889, 12.

Maltese (omn), 1876
Aka Jacob's Ladder, Imperial
Cats. 26.2, 28–35, 50.4; figs. 4, 27, 32, 61
Amber, blue, canary, amethyst, opaque white
Documented and dated based on Design Patent No. 9,335, issued to John Bryce, June 13, 1876.

Match Safe (omn), 1886
Cat. 133.2
Amber, blue, canary, opaque white
Attributed to Bryce Brothers by Lee (*Victorian Glass*, 302).
Attributed to Bryce Brothers and dated based on report in *Crockery & Glass Journal*, Nov. 4, 1886, 18.
New image.

Monarch (omn), 1884
Aka Flat Oval
Cat. 67
Plain and engraved
Amber, light amber, blue, periwinkle blue, canary, amethyst
Attributed to Bryce Brothers and dated based on a report of its introduction in *Crockery & Glass Journal*, Feb. 28, 1884, 12.
New image.

Monkey (omn), ca. 1887
Aka Monkey on a Stump
Cat. 132.4
Toothpick or match holder
Amber, blue, opaque white
Attributed to Bryce Brothers based on illustration in an assortment with documented Bryce Brothers products in G. Sommers & Co., *Our Leader* (Oct. 1891): 51.
Dated based on illustration in *Missouri Glass Company's Commercial Solicitor* (May 1887): 12.
New image.

Mugs—Beaded Handles
No. 1300 (omn), mid-1880s
Aka Gliding Swan
Cat. 136.7, fig. 78
Smallest mug in a four-piece
graduated set
Amber, blue, opaque white, frosted
crystal
Documented: Factory B Catalogue.
Dated based on its production
in color.

Mugs—Beaded Handles
No. 1301 (omn), mid-1880s
Aka Pointing Dog
Cat. 136.6, fig. 78
Second-smallest mug in a four-piece
graduated set
Amber, blue, opaque white, frosted
crystal
Documented: Factory B Catalogue.
Dated based on its production
in color.

Mugs—Beaded Handles
No. 1302 (omn), mid-1880s
Aka Bird on a Branch
Cat. 136.4, fig. 78
Second-largest mug in a four-piece
graduated set
Amber, blue, opaque white, frosted
crystal
Documented: Factory B Catalogue.
Dated based on its production
in color.

Mugs—Beaded Handles
No. 1303 (omn), mid-1880s
Aka Dog Chasing Deer
Cat. 136.1, fig. 78
Largest mug in a four-piece
graduated set
Amber, blue, opaque white, frosted
crystal
Documented: Factory B Catalogue.
Dated based on its production
in color.

**Mugs—Daisy Toy Mug (omn),
mid-1880s**
Aka Cross Hatching
Cat. 132.9, fig. 66
Amber, blue, amethyst
Documented: Factory B Catalogue.
Dated based on its production in
color.
Image: U.S. Glass catalogue
(ca. 1907): 59.

Mugs—Eastlake Handles
Boy with Begging Dog (aka), ca. 1883
Cats. 135.2, 135.4
Largest mug in a three-piece
graduated set
Blue, opaque white, opaque blue
Attributed to Bryce Brothers and
dated based on illustration in an
assortment with documented Bryce
products in Butler Brothers (75th
Trip 1883): 19.
Image: Spelman Brothers, *Special
Bargain Catalogue* (ca. 1885): 5.

Mugs—Eastlake Handles
Heron and Peacock (aka), ca. 1883
Cats. 135.1, 135.3
Mid-sized mug in a three-piece
graduated set
Blue, opaque white, opaque blue
Attributed to Bryce Brothers and
dated based on illustration in an
assortment with documented Bryce
products in Spelman Brothers,
Fancy Goods Graphic 4, no. 9 (Apr.
1884): 534.
New image.

Mugs—Eastlake Handles
Deer and Cow (aka), ca. 1883
Cats. 135.5–6
Smallest mug in a three-piece
graduated set
Blue, opaque white, opaque blue
Attributed to Bryce Brothers and
dated based on identical elements
with Boy with Begging Dog and
Heron and Peacock mugs.
New image.

Mugs—Flat Handles
No. 1200 (omn), ca. 1885
Aka Pugs and Chicks
Cat. 136.8, fig. 66
Smallest mug in a four-piece
graduated set
Amber, blue, canary, amethyst
Documented: Factory B Catalogue.
Dated the same as No. 1203.

Mugs—Flat Handles
No. 1201 (omn), ca. 1885
Aka Feeding Deer and Dog
Cat. 136.5, fig. 66
Second-smallest mug in a four-piece
graduated set
Amber, blue, canary, amethyst
Documented: Factory B Catalogue.
Dated the same as No. 1203.

Mugs—Flat Handles
No. 1202 (omn), ca. 1885
Aka Grape Bunch
Cat. 136.3, fig. 66
Second-largest mug in a four-piece
graduated set
Amber, blue, canary, amethyst
Documented: Factory B Catalogue.
Dated the same as No. 1203.

Mugs—Flat Handles
No. 1203 (omn), ca. 1885
Aka Robin in a Tree
Cat. 135.2, fig. 66
Largest mug in a four-piece
graduated set
Amber, blue, canary, amethyst
Documented: Factory B Catalogue.
Dated based on illustration in Butler
Brothers (Cold Weather Edition, 83rd
Trip 1885): 26.

Mugs—Flat Handles

Strawberry and Pear (aka), ca. 1885
Cat. 137
Amber, blue, canary, amethyst
Attributed to Bryce Brothers and dated based on identical elements (shape, flat handle, star on the bottom) with flat-handled mug set. New image.

Mugs—Happy Thought (omn), mid-1880s

Cat. 132.7
Amber, blue, possibly opaque white
Documented: U.S. Glass, *Pressed Tumblers and Beer Mugs Catalogue* (1893), where it is labeled "Old No. B., Happy Thought," indicating it was made by Bryce Brothers and its omn was "Happy Thought."
Dated based on its production in color.
Image: U.S. Glass catalogue.
See Happy Thought Night Lamp.

Mugs—No. 4 (omn), mid-1880s

Aka Birds and Insects
Fig. 66
Amber, possibly other colors
Documented: Factory B Catalogue.
Dated based on its production in color.

Mugs—No. 1205 (omn), ca. 1888

Aka Paneled Hobnail
Cat. 139
Amber, blue
Documented: Factory B Catalogue.
Dated based on illustration in Falker & Stern's *Trade Journal and Reliable Price List*, no. 2 (1888).
Image: U.S. Glass Catalogue (ca. 1907): 59.
See Acme.

National (omn), 1886

Aka Lady Liberty
Cat. 115; figs. 50, 65
Bread plate
Amber, blue, canary, amethyst
Documented: Factory B Catalogue.
Introduced in 1886, as reported in *Crockery & Glass Journal*, Feb. 11, 1886, 17.

New York (omn), ca. 1870s

Cat. 27
Documented: Factory B Catalogue.
Dated based on identical element (standard) with Palmette, an attributed Bryce, Walker pattern of the 1870s.

No. 79 (omn), 1879

Aka Chain with Star
Cat. 43
Documented: Factory B Catalogue.
Introduced in 1879, as reported in *American Pottery & Glassware Reporter*, Sept. 4, 1879.

No. 80 (omn), 1880

Aka Star in Honeycomb, Leverne
Cats. 44–47; figs. 21, 84–85
Assorted colors
Documented: Factory B Catalogue.
Introduced in 1880, as reported in *American Pottery & Glassware Reporter*, Feb. 12, 1880.

No. 85 (omn), 1880

Aka Double Vine
Cat. 48, fig. 54
Bread plate, pickle dish
Documented: Factory B Catalogue.
Dated based on description in *Crockery & Glass Journal*, July 8, 1880.

No. 87 (omn), ca. 1880

Aka Teasel
Goblet, cruets with and without handles
Documented: Factory B Catalogue.
Dated ca. 1880 because Nos. 80, 85, 90, and 95 were all introduced in 1880.

No. 88 (omn), ca. 1880

Documented: Factory B Catalogue.
Dated ca. 1880 because Nos. 80, 85, 90, and 95 were all introduced in 1880.

No. 90 (omn), 1880

Aka Hand and Bar
Cats. 49–50; fig. 49
Plain and engraved
Documented: Factory B Catalogue.
Introduced in 1880, as reported in *American Pottery & Glassware Reporter*, June 24, 1880.
The Hand and Bar design was also used for cruet stoppers in colors, and the Princess two-bottle caster handle (cat. 60) has a similar hand and ring design.

No. 95 (omn), 1880
Aka Inominata
Documented: Factory B Catalogue.
Introduced in 1880, as reported in
American Pottery & Glassware Reporter,
June 24, 1880.
Image: R. P. Wallace & Co., *Pioneer
Lamp & Glass House* (ca. 1887): 53.

No. 103 (omn), ca. 1881
Aka Prism and Diamond Points
Cats. 50.1, 50.5
Amber, possibly other colors
Attributed to Bryce, Walker based
on the "B 103" designation in a U.S.
Glass catalogue (ca. 1907), 143.
Dated based on pattern number.
Image: U.S. Glass catalogue.

**No. 118—Altar Set, Tray & 118
Catsup (omn), ca. 1882**
Documented: Factory B Catalogue.
Dated based on the introduction of
No. 114 colognes in 1881.

No. 159 (omn), mid-1880s
Aka Greenfield Swirl
Stemware
Amber, blue, canary, amethyst
Documented: Factory B Catalogue.
Dated based on its production in
color and illustration in F. H. Lovell
& Co., *Export Catalogue* (1888): 14.

**No. 175 Toy Cup & Saucer
(omn), ca. 1886**
Cat. 138, fig. 66
Amber, blue, canary, amethyst
Documented: Factory B Catalogue.
Dated based on illustration in
Spelman Brothers (Fall 1886): 4.

No. 900 (omn), mid-1880s
Aka Floral Diamond Band
Plain and engraved
Colors
Documented: Factory B Catalogue.
Dated based on its production
in color.
There are two No. 900 syrups with
different shapes and handles, and the
same decoration around the neck.

No. 900 (omn), ca. 1885
Colors
Documented: Factory B Catalogue.
Dated based on similarities to No.
1000 (identical shape as No. 1000
without quilted diamonds on the
body of the piece).

No. 1000 (omn), ca. 1885
Aka Diamond Quilted
Cats. 73–76, fig. 39
Amber, light amber, blue, periwinkle
blue, canary, amethyst, light amethyst
Documented: Factory B Catalogue.
Dated based on illustration in Butler
Brothers (Cold Weather Edition, 83rd
Trip 1885): 28.

Nos. 1112–15 (omn), 1886
Lemonade glasses in four sizes with
and without a handle at the base
Colors
Documented: Factory B Catalogue.
Dated based on description in *Pottery
& Glassware Reporter*, Apr. 29, 1886.

**No. 1120 Basket (omn),
ca. 1887**
Cat. 63.6
Fashion aka Daisy and Button pattern
Amber, blue, canary
Documented: Factory B Catalogue
along with related forms (Nos.
1121–25) hand-tooled from the same
mold.
Dated based on illustration in
Butler Brothers (Santa Claus Edition
1887): 38.

Openwork Dish (aka), ca. 1887
Cats. 126–28, fig. 53
Dish sold separately and with a
dolphin stem with oval foot
Amber, blue, canary, amethyst
Attributed to Bryce Brothers and
dated based on illustration of
the dish in an assortment with
documented Bryce Brothers products
in Butler Brothers (Santa Claus
Edition 1887): 38.
Image: cat. 128.

Orient (omn), ca. 1877
Aka Buckle and Star
Cats. 36–38, fig. 1
Amber, blue, amethyst
Documented: Factory B Catalogue.
Dated based on illustration in F. H.
Lovell & Co., *Catalogue of 1877 & 8*,
plate 102.

Orion (omn), 1886
Aka Cathedral
Cats. 76–77, fig. 39
Amber, blue, canary, amethyst, green; crystal with ruby or rose stain
Documented: Factory B Catalogue.
Introduced in 1886, as reported in *Pottery & Glassware Reporter*, Jan. 21, 1886.

P. D. and Pilot Caster Sets (omn), ca. 1889
Two different three-bottle sets with the same base
Documented: Factory B Catalogue.
Dated based on illustration in Butler Brothers (Sept. 1889): 21.
Image of Pilot Caster.

Palmette (aka), early 1870s
Cats. 14–17, 141.1–141.2
Opaque white
Attributed to Bryce, Walker and dated based on identical element (standard) with Grape Band, Strawberry, and Thistle, all patented Bryce, Walker patterns of the early 1870s.
Image: cat. 15.

Perfumery Stand (aka), ca. 1888
Cat. 130, fig. 75
Amber, blue
Attributed to Bryce Brothers based on identical elements with other Bryce Brothers products.
Dated based on illustration in Spelman Brothers, *Bazaar and Bargain Catalogue* (Feb. 1888): 14.
Image: Spelman Brothers, *Fancy Goods Graphic* 10, no. 2 (Sept. 1889): 106.

Persian (omn), 1889
Documented: Factory B Catalogue.
Introduced in 1889, as reported in *Pottery & Glassware Reporter*, Dec. 19, 1889, 12 (new "Parisian" rose bowl and nut dish).

Pert (omn), ca. 1883
Aka Ribbed Forget-Me-Not
Cat. 66
Table set, mug, mustard pot
Amber, blue, canary
Documented: Factory B Catalogue.
Dated based on illustration in Butler Brothers (75th Trip 1883): 20.

Pittsburgh (omn), 1891
Aka Prism and Globules
Cats. 95–98
Documented: Factory B Catalogue.
Introduced for 1891 selling season, as reported in *Crockery & Glass Journal*, Dec. 25, 1890.

Pride (omn), ca. 1891
4- and 8-inch nappies; four variations shaped and flared differently.
Documented: Factory B Catalogue.

Princess (omn), 1883
Aka Daisy and Button with Fine Cut Panels
Cat. 61
Amber, blue, canary, green berry bowls
Documented: Factory B Catalogue (two- and four-bottle casters)
Introduced in 1883, as reported in *Crockery & Glass Journal*, Jan. 18, 1883, 16.
Image: Butler Brothers (75th Trip 1883): 20.

Puritan (omn), ca. 1887
Cats. 78–79
Amber, blue; crystal with ruby stain
Documented: Factory B Catalogue.
Dated based on illustration in Butler Brothers (Dull Season 1887).

Regal (omn), 1883
Aka Paneled Forget-Me-Not
Cat. 59
Amber, blue, canary, amethyst
Documented: Factory B Catalogue.
Introduced in 1883, as reported in *Crockery & Glass Journal*, Jan. 18, 1883, 16.
Image: Butler Brothers (Cold Weather Edition 1885), 26.

Ruby (omn), 1881
Aka Beaded Band
Cats. 55–56
Documented: Factory B Catalogue.
Introduced in 1881, as reported in *American Pottery and Glassware Reporter*, Feb. 3, 1881.

Shamrock (omn), ca. 1888

Fig. 41
Flanged butter
Amber, blue, canary, amethyst
Documented: Factory B Catalogue.
Dated based on illustration in
F. H. Lovell & Co., *Export Catalogue*
(1888): 15.

Shoes—Chinese Shoe (omn), 1886

Cat. 102
Cane pattern
Amber, blue, canary, amethyst
Attributed to Bryce Brothers by Lee
(*Victorian Glass*, 462), who says it
is illustrated in her Bryce Brothers
catalogue.
Dated based on a report in the *Pottery
& Glassware Reporter*, June 10, 1886.
Lee (*Victorian Glass*, 486) says two
Chinese shoes were joined together
side by side to make a Double
Chinese Shoes novelty.
New image.

Shoes—Chinese Shoe on Toboggan (aka), 1886

Cat. 105, fig. 71
Amber, blue
Attributed to Bryce Brothers by Lee
(*Victorian Glass*, 462), who says it is
illustrated as a novelty in her Bryce
Brothers catalogue.
Lee says the toboggan was also sold
separately.
Image: Spelman Brothers, *Fancy Goods
Graphic* 10, no. 2 (Sept. 1889): 106.

Shoes—Large Slipper (omn), 1886

Cat. 101, fig. 68
Fashion aka Daisy and Button pattern
Amber, blue, canary, amethyst, ruby-
stained, crystal with amber buttons
Documented and dated based on
Patent No. 351,216, issued to H. J.
Smith, Assignor to Bryce Brothers
and George Duncan & Sons, Oct. 19,
1886.
Image: Butler Brothers (Santa Claus
Edition 1887): 38.

Shoes—Sandal (omn), 1886

Aka Daisy and Button Sandal
Cat. 102, fig. 69
Fashion aka Daisy and Button pattern
Amber, blue, canary, amethyst
Attributed to Bryce Brothers by Lee
(*Victorian Glass*, 478).
Attributed and dated based on
illustration in an assortment with
documented Bryce Brothers products
in Spelman Brothers (Fall 1886): 4.
Image: Spelman Brothers.

Shoes—Small Slipper (omn), 1886

Cats. 102–3, figs. 68–69
Fashion aka Daisy and Button pattern
Amber, blue, canary, amethyst, ruby-
stained
Documented and dated based
on Patent No. 351,216, issued
to H. J. Smith, Assignor to Bryce
Brothers and George Duncan & Sons,
Oct. 19, 1886.
Image: Spelman Brothers (Fall
1886): 4.

Shoes—Small Slipper Nappy (omn), 1886

Aka Slipper on a Tray
Cat. 104
Small Slipper attached to a tray in the
Coral pattern, a documented Bryce
Brothers pattern
Amber, blue, canary
Image: Butler Brothers (Santa Claus
Edition 1887): 38.

Standard (omn), ca. 1885

Flanged butter
Documented: Factory B Catalogue.
Dated based on illustration in
Spelman Brothers, *Special Bargain
Catalogue* (ca. 1885): 6.

Star (omn), ca. 1891

Butter
Opaque white
Documented: Factory B Catalogue.

Star of Garter (omn), mid-1880s

Cat. 123, fig. 50
Order of the Garter plate with the
motto "Honi soit qui mal y pense"
(Shame on anyone who thinks evil of
it) in Old Norman French.
Amber, blue, canary, amethyst
Documented: Factory B Catalogue.
Dated based on its production
in color.

Strawberry (aka), 1870

Aka Fairfax Strawberry
Cats. 18–19; figs. 18, 58
Opaque white
Documented and dated based on
Design Patent No. 3,855, issued to
John Bryce, Feb. 22, 1870.
Image: Patent drawing.

Sultan (omn), 1888

Aka Curtain
Cats. 84–85
Amber (mug)
Attributed to Bryce Brothers and
dated based on a report of its
introduction in *Crockery & Glass
Journal*, June 28, 1888.
Image: Butler Brothers (Santa Claus
Edition 1888): 41.

Sunken Icicle (aka), early 1870s
Opaque white
Attributed to Bryce, Walker and dated based on identical element (standard) with Filley and Tulip with Sawtooth, both documented Bryce, Walker patterns of the early 1870s.
New image.

Swell (omn), ca. 1891
Butter
Opaque white
Documented: Factory B Catalogue.

Swiss (omn), ca. 1877
Aka Beads in Relief, Grape with Scroll Medallion
Cats. 40–42
Table set, three graduated mugs
Table set in opaque white; mugs in blue, opaque white, opaque blue
Attributed to Bryce, Walker and dated based on illustration with handwritten notes in F. H. Lovell & Co., *Catalogue of 1877 & 8*, plate 107.
Image: F. H. Lovell. Courtesy of the Sandwich Glass Museum, Sandwich, MA.

Sword Pickle (omn), mid-1880s
Cat. 121
Amber, blue
Documented: Factory B Catalogue.
Dated based on its production in color.

Thistle (aka), 1872
Aka Scotch Thistle
Cats. 22–23, 26; figs. 3, 6, 27, 59
Documented and dated based on Design Patent No. 5,742, issued to John Bryce, Apr. 2, 1872.
Image: Patent drawing.

Troy (omn), ca. 1891
Aka Maltese Cross in Circle
Cats. 93–94, fig. 41
Butter, bread plates
Opaque white
Documented: Factory B Catalogue.

Tulip (omn), ca. 1854
Aka Tulip with Sawtooth
Cats. 1–6; figs. 22–25, 55
Opaque white
Documented: Bryce, Richards page, ca. 1854; Factory B Catalogue.
Possibly made by Bryce, McKee as early as 1850.

Unknown name, ca. 1887
Amber, blue, canary
Attributed to Bryce Brothers based on illustration of a square nappy in the same pattern in an assortment with documented Bryce Brothers products in *Falker & Stern's Trade Journal and Reliable Price List*, no. 2 (1888). Dated based on illustration of the square nappy in R. P. Wallace & Co., *Pioneer Lamp & Glass House* (1887): 50.
New image.

Wall Bracket (omn), 1886
Aka Daisy and Button Shelf
Cat. 118
Amber, blue, canary, crystal with stained dots
Attributed to Bryce Brothers based on illustration in an assortment with documented Bryce Brothers products in Butler Brothers (86th Trip 1886): 35.
Introduced in 1886, as reported in *Pottery & Glassware Reporter*, June 10, 1886.
Image: Butler Brothers.

Wall Pocket (omn), ca. 1887
Aka Wall Basket
Cat. 132.3, figs. 76–77
Toothpick or match holder
Amber, blue, canary, frosted crystal

Attributed to Bryce Brothers and dated based on illustration in an assortment with documented Bryce Brothers products in Butler Brothers (Santa Claus Edition 1887): 38.
Image: Butler Brothers.

Chicago Font (omn) New York Font (omn) St. Louis Font (omn)

World's Fair Lamps, 1890
Cat. 144, fig. 83
Four styles, four sizes, two pedestals; design and omn of fourth font are unknown
Crystal, amber, blue, opaque white or combinations of those colors
Attributed to Bryce Brothers based on identical elements (New York font) with Happy Thought Night Lamp and Pittsburgh pattern (font and stem decoration).
Attributed to Bryce Brothers and dated based on a report of the introduction of World's Fair lamps in *Pottery & Glassware Reporter*, June 5, 1890.
Illustrated in U.S. Glass, *Clinch Collar Lamps Catalogue* (1893).
Images: H. Leonard & Sons, *Illustrated Price List of House Furnishing Goods*, no. 105 (1891): 67, courtesy of The Henry Ford, Dearborn, MI (Chicago font); Butler Brothers (Santa Claus Edition 1890): 27 (New York font); U.S. Glass, *Clinch Collar Lamps Catalogue* (1893) (St. Louis font).

Wreath (omn), ca. 1887
Aka Willow Oak
Cats. 80–81
Amber, blue, canary
Documented: Factory B Catalogue.
Dated based on illustration in Butler Brothers (Santa Claus Edition 1887): 36.

Appendix I

Bryce Family Glassmakers

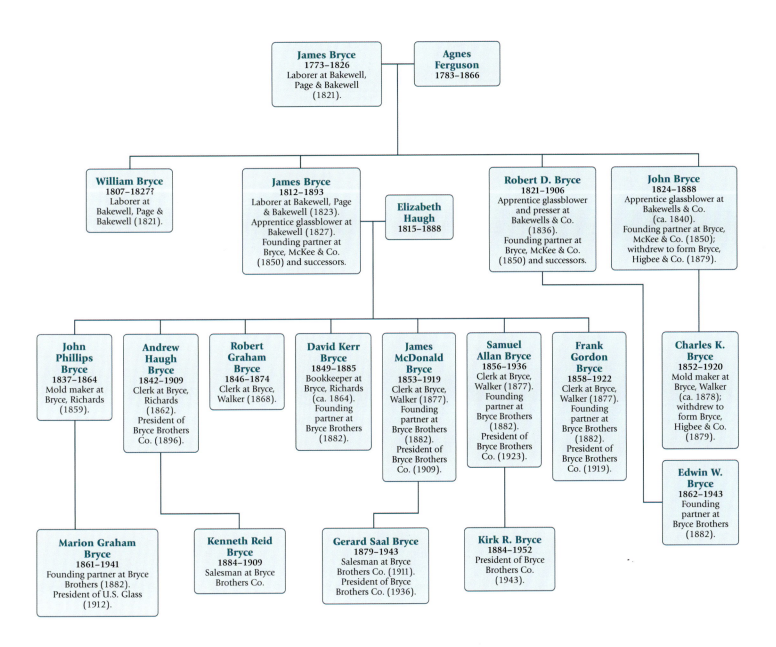

James Bryce
1773–1826
Laborer at Bakewell,
Page & Bakewell
(1821).

Agnes Ferguson
1783–1866

William Bryce
1807–1827?
Laborer at
Bakewell, Page &
Bakewell (1821).

James Bryce
1812–1893
Laborer at Bakewell, Page
& Bakewell (1823).
Apprentice glassblower at
Bakewell (1827).
Founding partner at
Bryce, McKee & Co.
(1850) and successors.

Elizabeth Haugh
1815–1888

Robert D. Bryce
1821–1906
Apprentice glassblower
and presser at
Bakewells & Co.
(1836).
Founding partner at
Bryce, McKee & Co.
(1850) and successors.

John Bryce
1824–1888
Apprentice glassblower at
Bakewells & Co.
(ca. 1840).
Founding partner at Bryce,
McKee & Co. (1850);
withdrew to form Bryce,
Higbee & Co. (1879).

John Phillips Bryce
1837–1864
Mold maker at
Bryce, Richards
(1859).

Andrew Haugh Bryce
1842–1909
Clerk at Bryce,
Richards
(1862).
President of
Bryce Brothers
Co. (1896).

Robert Graham Bryce
1846–1874
Clerk at Bryce,
Walker (1868).

David Kerr Bryce
1849–1885
Bookkeeper at
Bryce, Richards
(ca. 1864).
Founding
partner at
Bryce Brothers
(1882).

James McDonald Bryce
1853–1919
Clerk at Bryce,
Walker (1877).
Founding
partner at
Bryce Brothers
(1882).
President of
Bryce Brothers
Co. (1909).

Samuel Allan Bryce
1856–1936
Clerk at Bryce,
Walker (1877).
Founding
partner at
Bryce Brothers
(1882).
President of
Bryce Brothers
Co. (1923).

Frank Gordon Bryce
1858–1922
Clerk at Bryce,
Walker (1877).
Founding
partner at
Bryce Brothers
(1882).
President of
Bryce Brothers
Co. (1919).

Charles K. Bryce
1852–1920
Mold maker at
Bryce, Walker
(ca. 1878);
withdrew to
form Bryce,
Higbee & Co.
(1879).

Edwin W. Bryce
1862–1943
Founding
partner at
Bryce Brothers
(1882).

Marion Graham Bryce
1861–1941
Founding partner at Bryce
Brothers (1882).
President of U.S. Glass
(1912).

Kenneth Reid Bryce
1884–1909
Salesman at Bryce
Brothers Co.

Gerard Saal Bryce
1879–1943
Salesman at Bryce
Brothers Co. (1911).
President of Bryce
Brothers Co. (1936).

Kirk R. Bryce
1884–1952
President of Bryce
Brothers Co.
(1943).

Fig. 85. Bryce, Walker No. 80
cruet stopper, 1880
(detail, cat. 46.3).

Appendix II

Bryce Patents, 1850 to 1891

Pitcher Cover
Aug. 21, 1860
Patent No. 29,666
Issued to Robert D. Bryce

Grape Band (fig. 56)
Oct. 19, 1869
Design Patent No. 3,716
Issued to John Bryce

Curled Leaf (fig. 57)
Nov. 23, 1869
Design Patent No. 3,759
Issued to John Bryce

Glass Mold Plunger
Apr. 5, 1870
Patent No. 101,485
Issued to John McCord, Assignor to
John Bryce

Strawberry (fig. 58)
Feb. 22, 1870
Design Patent No. 3,855
Issued to John Bryce

Thistle (fig. 59)
Apr. 2, 1872
Design Patent No. 5,742
Issued to John Bryce

**Manufacture of Glass-Lamp Pedestals
(fig. 81)**
Nov. 17, 1874
Patent No. 156,976
Issued to John Bryce

Diamond Sunburst (fig. 60)
Dec. 22, 1874
Design Patent No. 7,948
Issued to John Bryce

Maltese aka Jacob's Ladder (fig. 61)
June 13, 1876
Design Patent No. 9,335
Issued to John Bryce

**Glass Mold and Method of
Removing Articles Therefrom**
Apr. 29, 1879
Patent No. 214,879
Issued to Charles K. Bryce

Ambidextrous Cream Pitcher (fig. 62)
Mar. 15, 1881
Design Patent No. 12,189
Issued to Henry J. Smith, Assignor to
Bryce, Walker & Co.

**Manufacture of Glass Shoes or Slippers
(fig. 67)**
Oct. 19, 1886
Patent No. 351,197
Issued to John E. Miller, Assignor to
George Duncan & Sons and Bryce
Brothers

Glass Slipper (fig. 68)
Oct. 19, 1886
Patent No. 351,216
Issued to H. J. Smith, Assignor to Bryce
Brothers and George Duncan & Sons

Atlas (fig. 64)
Nov. 12, 1889
Design Patent No. 19,427
Issued to Henry J. Smith, Assignor to
Bryce Brothers

**Apparatus for Finishing or Cleaning
Surfaces**
Feb. 24, 1891
Patent No. 446,961
Issued to Andrew Bryce

Bibliography

Bryce company history and products

Bryce, James. Journal. Vol. 1, Aug. 1, 1834–June 3, 1840. Vol. 2, Sept. 7, 1840–May 30, 1876. Original in private collection; copy in the Detre Library & Archives, Senator John Heinz History Center, Pittsburgh, PA.

Bryce, Richards & Co. pattern page, ca. 1854. Rakow Research Library, Corning Museum of Glass, Corning, NY, www.cmog.org.

Gougeon, Brad. "Diamond Quilted, aka Bryce's '1000' (omn) Pattern." *NewsJournal* (Early American Pattern Glass Society) 16, no. 3 (Fall 2009): 6–10.

Gougeon, Brad. "Annie W. Henderson and Loop and Dart . . . a Pattern Glass Mystery." *NewsJournal* (Early American Pattern Glass Society) 20, no. 1 (Spring 2013): 10–11.

Gougeon, Brad. "Bryce's Amethyst. "The Third 'A' in the ABC Era." *NewsJournal* (Early American Pattern Glass Society) 27, no. 3 (Fall 2020): 3–8.

Lethbridge, Sid. "Daisy & Button: Were Bryce Bros. First?" *All About Glass* 9, no. 3 (Oct. 2011): 19–21.

Lethbridge, Sid. "The Bryce Bros. Glass Flotilla of '86." *All About Glass* 12, no. 2 (July 2014): 8–9.

United States Glass Company. "Factory B" (Bryce Brothers) section. Composite catalogue (Jan. 1892). Three extant versions, though they are not identical and none is complete: Carnegie Library of Pittsburgh, PA; Corning Museum of Glass, Corning, NY; Tiffin Glass Collectors Club, Museum, Shoppe and Archives, Tiffin, OH.

Nineteenth-century glass

Bredehoft, Neila. "Nicknames of Glass Companies." *NewsJournal* (Early American Pattern Glass Society) 21, no. 3 (Fall 2014): 10.

Bredehoft, Neila, Tom Bredehoft, and Sid Lethbridge. *United States Glass Company, Volume 1— Tableware Lines 1891–1895.* Weston, WV: Glass Flakes Press, 2020.

Bredehoft, Neila, Tom Bredehoft, Jo Sanford, and Bob Sanford. *Glass Toothpick Holders, Second Edition.* Paducah, KY: Collector Books, 2005.

Ferson, Regis F., and Mary F. Ferson. *Yesterday's Milk Glass Today.* Pittsburgh, PA: R. Ferson, 1981.

Hawkins, Jay W. *Glasshouses & Glass Manufacturers of the Pittsburgh Region, 1795–1910.* New York: iUniverse, 2009.

Innes, Lowell. *Pittsburgh Glass 1797–1891.* Boston: Houghton Mifflin, 1976.

Jenks, Bill, and Jerry Luna. *Early American Pattern Glass 1850–1910.* Radnor, PA: Wallace Homestead, 1990.

Jenks, Bill, Jerry Luna, and Darryl Reilly. *Identifying Pattern Glass Reproductions.* Radnor, PA: Wallace Homestead, 1993.

Kirk, Paul, Jr. *Homestead Glass Works: Bryce, Higbee & Company, 1879–1907.* Atglen, PA: Schiffer Publishing, 2016.

Lechler, Doris Anderson. *Toy Glass.* Marietta, OH: Antique Publications, 1989.

Lee, Ruth Webb. *Victorian Glass: Specialties of the Nineteenth Century.* Rutland, VT: Charles E. Tuttle, 1944.

Lethbridge, Sid. *Campbell, Jones & Co.: The Tableware Products of a 19th Century Pittsburgh Glass Maker.* Brights Grove, ON: Sid Lethbridge, 2015.

Millard, S. T. *Opaque Glass.* Des Moines, IA: Wallace-Homestead, 1975.

Mordock, John B., and Walter L. Adams. *Pattern Glass Mugs.* Marietta, OH: Glass Press dba Antique Publications, 1995.

Pellatt, Apsley. *Curiosities of Glass Making: With Details of the Processes and Productions of Ancient and Modern Ornamental Glass Manufacture.* London: David Bogue, 1849.

Revi, Albert Christian. *American Pressed Glass and Figural Bottles.* New York: Thomas Nelson & Sons, 1964.

Sanford, Jo, and Bob Sanford. *Victorian Glass Novelties.* Atglen, PA: Schiffer Publishing, 2003.

Spillman, Jane Shadel. *White House Glassware: Two Centuries of Presidential Entertaining.* Washington, DC: White House Historical Association, 1989.

Thuro, Catherine M. V. *Oil Lamps, the Kerosene Era in North America.* Radnor, PA: Wallace-Homestead, 1976.

Thuro, Catherine M. V. *Oil Lamps II, Glass Kerosene Lamps.* Toronto, ON: Thorncliffe House; Paducah, KY: Collector Books, 1983.

Welker, John, and Elizabeth Welker. *Pressed Glass in America: Encyclopedia of the First Hundred Years, 1825–1925.* Ivyland, PA: Antique Acres Press, 1985.

Yalom, Libby. *Shoes of Glass, 2.* Marietta, OH: Glass Press dba Antique Publications, 1998.

Trade journals

American Pottery & Glassware Reporter. Various issues, 1879–91.

China, Glass & Lamps. Various issues, 1891–1906.

Crockery & Glass Journal. Various issues, 1875–91.

Pottery & Glassware Reporter. Various issues, 1886–91.

Wholesaler catalogues

American Potter & Illuminator. Various issues, 1886–88.

Butler Brothers. *"Our Drummer."* Various issues, 1883–98.

Falker & Stern's Trade Journal and Reliable Price List, no. 2 (1888).

F. H. Lovell & Co. Various catalogues, 1877/78, 1888.

Missouri Glass Co. *Missouri Glass Company's Commercial Solicitor* 32, no. 377 (May 1887).

G. Sommers & Co. *Our Leader.* Various issues, 1883–91.

Spelman Brothers catalogue. Various issues, 1882–91.

Pittsburgh

Carnegie Library of Pittsburgh. *Pittsburgh in 1816.* Pittsburgh, PA: Carnegie Library, 1916.

Dennis, Stephen Neal. *Keep Tryst: The Walkers of Pittsburgh & the Sewickley Valley.* Rensselaer, NY: Hamilton Printing Co., 2004.

Edwards, Richard. *Industries of Pittsburgh: Trade, Commerce and Manufactures; Historical and Descriptive Review for 1879–1880.* Pittsburgh, PA: Richard Edwards, 1879.

Harper, Frank C. *Pittsburgh of Today, Its Resources and People.* Vol. 4. New York: American Historical Society, 1931.

Lee, Alex Y., and Ward Brothers. *Souvenir of Pittsburgh and Allegheny City.* Columbus, OH: Ward Brothers, 1887.

Lowry, David, James Mills, and E. A. Myers. *Pittsburgh: Its Industry and Commerce, Embracing Statistics of the Coal, Iron, Glass, Steel, Copper, Petroleum, and Other Manufacturing Interests of Pittsburgh.* Pittsburgh, PA: Barr & Myers Publishers, 1870.

Thurston, George H. *Pittsburgh and Allegheny in the Centennial Year.* Pittsburgh, PA: A. A. Anderson & Son, 1876.

City directories

J. F. Diffenbacher's Directory of Pittsburgh and Allegheny Cities for 1890. Pittsburgh, PA: Diffenbacher & Thurston, 1890.

Fahnestock, Samuel. *Fahnestock's Pittsburgh Directory for 1850.* Pittsburgh, PA: Geo. Parkin & Co., 1850.

Riddle, J. M., and M. M. Murray. *The Pittsburgh Directory for 1819.* Pittsburgh, PA: Butler & Lambdin, 1819.

Thurston, George H. *Directory of Pittsburgh 1856–57.* Pittsburgh, PA: George H. Thurston, 1856.

Thurston, George H. *Directory of Pittsburgh and Vicinity for 1857–58.* Pittsburgh, PA: George H. Thurston, 1857.

Thurston, George H. *Directory of Pittsburgh and Vicinity for 1858–59.* Pittsburgh, PA: George H. Thurston, 1858.

Thurston, George H. *Directory of Pittsburgh and Allegheny Cities, 1862–3.* Pittsburgh, PA: George H. Thurston, 1862.

Woodward & Rowlands. *Pittsburgh Directory for 1852.* Pittsburgh, PA: W. S. Haven, 1852.

Other related publications

Boucher, John Newton. *History of Westmoreland County, Pennsylvania.* Vol. 2. New York: Lewis Publishing Company, 1906.

Chambers, Robert, and William Chambers. *The Gazetteer of Scotland Vol. II.* Glasgow: Blackie & Son, 1838.

Current Literature: A Magazine of Record and Review 9, no. 2 (Jan.–April 1892).

Franklin Institute. *Report on the Twenty-Sixth Exhibition of American Manufactures, Held in the City of Philadelphia.* Philadelphia: William S. Young, 1858.

Mellish, John. *Travels in the United States of America in the years 1806 & 1807, and 1809, 1810 & 1811.* Vol. 2. Philadelphia: printed for the author, 1812.

Pennsylvania Bureau of Industrial Statistics. *Annual Report of the Secretary of Internal Affairs of the Commonwealth of Pennsylvania: Industrial Statistics. 1875–6.* Pt. III, vol. 4 (Jan. 1877).

Pennsylvania State Agricultural Society. *Annual Report of the Transactions of the Pennsylvania State Agricultural Society, for the Years 1857–1858.* Harrisburg, PA: A. Boyd Hamilton, State Printer, 1859.

Williams, William W., ed. *Magazine of Western History: Vol. 3, November, 1885–April, 1886.* Cleveland, OH: Magazine of Western History, 1886.

Index

Page numbers in *italics* refer to the illustrations and their captions

A.B.C. plate *72*, 201, *201*, 234, *234*
Acme 220, 234
 cream pitchers *234*
 see also under mugs and cups;
 No. 1205
Acorn mustard 234, *234*
Albany butters *61*, 234, *234*
Albion butters 49, 72, 234, *234*
Amazon *73*, 86, 161, 162, 234
 colored glass 161, 234
 opaque white *52*, 161, *161*,
 234
 covered bowls *234*
 deep dish with lion-head
 handles and finials *52*, 161,
 161
 nappies 161
Ambidextrous 130, 234
 cream pitchers *4*, 49, 79, 130,
 130, 131, 234
 patent showing design *130*,
 234
 table sets 130, 234
American Potter & Illuminator 73,
 132, 152, 186, 190, 202, 234,
 239
*American Pottery & Glassware
 Reporter* 58, 71–72, *73*, 118, 119,
 123, 124, 129, 132, 134, 141,
 142, 150, 158, 159, 160, 165,
 193, 196, 199, 210, 234, 235,
 236, 238, 239, 241, 242, 243,
 244, 245
Argent 142–43, 234
 design elements shared with
 other patterns
 standards 142, *143*
 tableware
 bowls, high-footed *143*
 covered nappies *234*
 plates *142*
 table sets 142
Argyle 144, *145*, 234
 colored glass 58, 144, 234
 tableware
 bread plates 144, *144*
 comports, footed 144
 goblets 144, *144, 234*
Ashburton 13, 39, *40*, 41, 234, *234*
Atlanta (No. 150) 62
Atlas 54, 158, 159, 160, 234
 opaque white glass 160, 234
 patent showing design *160*
 tableware 79

covered bowls *234*
 goblet, engraved *160*
Avon butters 58, 69n.63, 202, 234,
 234
 colored glass 58, 69n.63, 202,
 234

Bakewell, Benjamin 6, 12, 19,
 20–21, 23
Bakewell, Page & Bakewell,
 Pittsburgh 6, 7, 12, 20, *20, 21*,
 21–22, *22*, 24, 27
 destroyed by fire (1845) *28*, 30
 and James Bryce
 as a Castor Pot Servitor 24,
 27
 indentured as apprentice
 glassblower 7, 12, 23–24,
 25, 26, 30n.14
Bakewell, Pears & Co., Pittsburgh
 38, 48
Banner butters *2*, 58, *61*, 190, *192*,
 193, *193*, 235, *235*
 colored glass 193, *194*, 235
Barstibley Farm, Kirkcudbright,
 Scotland 17, *18*
Bartholdi, Frédéric Auguste 194
baskets *see under* novelties
Beaded Band *see* Ruby
Beaded Oval and Scroll 49, 128,
 235, *235*
 design elements shared with
 other patterns 128
 finials 74, 126, 235, 238
 medallions 75, 126, 235, 238
 standards 74, 126, 235, 238
 shapes used in
 bowls, high-footed 126
 butters 128
 interior *128*
 pickle dishes 75, 126
 table sets 128
Beaded Oval Window *see* Argyle
Beads in Relief *see* Swiss
Belt Buckle *see* Jasper
Birch Leaf 49, 99, 235
 design elements shared with
 other patterns
 standards 74, 99, 235
 opaque white glass 48, 99, *99*
 shapes used in
 covered bowls, high-footed
 99, *235*
 table sets 99
Birmingham Flint Glass Works,
 Pittsburgh 28, 46, *47*
blown glass and glass blowing 6,

11, 12, 15, 21, 22–23, 24, 28, 33,
 59, 65
Brashear, John Alfred 48
Brazil 162–63, 236
 colored glass 162, 236
 opaque white 162, *163*, 236
 tableware
 butters, flanged *236*
 cream pitchers *163*
 dishes *162*
 spoon holders *163*
 sugar bowls *163*
 sugar shakers *163*
 syrups *163*
 table sets 162, *163*
Bryce, Agnes Ferguson (mother of
 James) 17, 18, 21, 23, 28
Bryce, Allan (Samuel Allan, son of
 James) 14, 43, 49, 65, *66*
Bryce, Andrew Haugh (son of
 James) 13, 14, 15, 37, 43, 49,
 65, *66*
Bryce Brothers (1882–1891) 14,
 49, 53–63
 becomes part of U.S. Glass
 conglomerate 14–15, 39, 49,
 60, 165 *see also* "Factory B"
 colored glass 14, 55, 56–57,
 69n.63, 144, 146, 150, 151,
 152, 154
 amethyst 14, 56, 57, 58, 106,
 113, 136, 144, 145, 146,
 150
 canary ("vaseline") 14, 56, 58,
 59, 60, 106, 136, 144, 145,
 146, 150, 152, 154
 opaque white *52*, 161, *161*,
 162, *163*, 164, *164*, 179,
 210, 212, 217, 230
 rose stain (Jacqueminot Rose)
 14, 55, 56–57, 58, 136,
 150
 see also under novelties
 employees 53, *54*
 factory on Pittsburgh's South
 Side 53, *54*, 60, *63*
 molds and mold makers 35, *54*,
 62, *63*, 134, 136, 162, 165,
 176, 179, 184
 offices and showroom in
 Pittsburgh 53, 171
 product lines
 lamps 53, 54, 59, 210, *228*,
 228–31, *229, 230, 231*, 238,
 238, 245, *245*
 novelties *see* novelties
 perfumery 54

tableware 53, 55, *58*, 62
 nappies 69n.55, 136
 reorganization 15, 65, 68
Bryce Brothers Company (1893–
 1965) 15, 65–68
 decorative techniques 66, 68
 cutting 15, 66, 68
 engraving 15, 66, 68
 gilding in bands 66
 needle etching 15, 65, 68
 sand blasting 66, 68
 designers *67*, 68
 new factory in Mount Pleasant
 11, 15, 66, *66*, 68
 notable commissions 68
 champagne glass for Space
 Needle Restaurant, Seattle
 World's Fair (1962) *64*, 68
 N.S. *Savannah*, nuclear cargo
 and passenger ship 68
 product lines
 stemware 15, *64*, 65, 68
 tableware 15, 65, 68
 sold to Lenox, Inc. (1965)
 11–12, 68
 types of glassware
 hand-blown glass 15, 65, 66,
 68
 lead crystal glass 15, 66, 68
Bryce, Charles (nephew of James)
 47
Bryce, David Kerr (son of James)
 13, 14, 37, 43, 49
Bryce, Donald (James McDonald,
 son of James) 14, 15, 43, 49, 65,
 66, 68
Bryce, Edwin Wilson (nephew of
 James) 14, 49
Bryce, Elizabeth Haugh (wife of
 James) 27, *29*
 portrait by Leisser *29*
Bryce, Frank Gordon (son of
 James) 14, 43, 49, 65, *66*
Bryce glass
 authenticating and attributing
 71–75, 77, 93, 105, 115, 233,
 235–45
 catalogues 38–39, *40*, 71
 wholesalers 7, 49, 56, 72–73,
 74, 77, 136, 146, 151, 152,
 156, 171, 208, 212, 214, 233
 see also named wholesalers
 see also under "Factory B"; U.S.
 Glass
 patents 134, *134*, 160, 176, *176*,
 224, 234, 239, 244 *see also
 under* Bryce, Walker

trade journals 7, 48, 49, 54, 59, 71–72, 77, 118, *122*, 141, 150, 171, 172, 176, 195, 233
 see named trade journals
 see also Bryce Brothers; Bryce, McKee; Bryce, Richards; Bryce, Walker
Bryce, Higbee & Co. (John and Charles Bryce) 35, 47, 221n.3
Bryce, James
 biographical details 11, 12
 birth and early life 17
 death 15, 68
 emigration to Pittsburgh from Scotland 12, 17–19
 houses 19, 28, 38, 45
 journal 6, 7, 12, *12*
 marriage and children 13, 14, 15, 27–28, *29*, 247
 parents and siblings 6–7, 12, 13, 17–18, 23, 247
 employment
 with Bakewell 6, 7, 12, 21, 22–24, *25*
 agreement to serve as a Castor Pot Servitor 24, 27
 decanter (possibly Masterpiece) 26
 indentured as an apprentice glassblower 7, 12, 23–24, *25*, *26*, 30n.14
 works as a finisher 27
 Mulvany & Ledlie 28, 46
 glass companies *see* named Bryce glass companies
 portrait by Leisser *29*
Bryce, James, Sr. (father of James) 6–7, 12, 17, 18, 19, 20, 21, 23
Bryce, John (brother of James) 23, 47, *47*
 Bryce, Higbee & Company 35, 47
 partner in Bryce glass companies 12, 33, 37, 43
 patents
 geometric patterns 13, 47, 49, 102, *102*, 106, *106*, 237, 239
 for lamp pedestals 224, *224*
 naturalistic patterns 13, 47, 49, 88, *88*, 90, *90*, 96, 97, 100, *100*, 227, 236, 238, 244, 245
 pattern designer for Bryce glass 13, 47, *48*, 49, 79, 88, 90, 96, 100, 102, 106
Bryce, John Phillips (son of James) 13, 27, 37
Bryce, Marion Graham (grandson of James) 14, 49, *66*
Bryce, Mary (daughter of James) 28
Bryce, Mary (sister of James) 17, 18, 23, 30n.15
Bryce, McKee & Company (1850–54) 33–35
 change of name 13, 34, 37, 69n.8
 factory on Pittsburgh's South Side 12, 33

founding 6, 11, 12, 30, 33
lamps 13, 34, 224
offices and showroom in Pittsburgh 33–34
partners 33, 69n.8
patterns 35, 39, 41, 80, 86, 234, 237, 238, 245
pressed glassware 7, 13, 35
Bryce, Richards & Company (1854–1865) 13, 37–41
 catalogue page 38–39, *40*, 71, 77, 80, 86
 change of name 13, 38, 43
 factory on Pittsburgh's South Side 37
 molds and mold makers 13, 35, *35*
 offices and showroom in Pittsburgh 37
 partners 37, 38, 69n.10
 patterns 13, 35, 38, 39, 40, 71, 77, 80, 86, 234, 237, 238, 245
 pressed glassware 7, 35, 37–38
Bryce, Robert Graham (son of James) 43
Bryce, Robert D. (brother of James) 12, 23, 28, 33, 37, 43, 46, 49, 239
Bryce, Walker & Company (1865–1882) 13, 27, 38, 43–51
 change of name 13, 14, 38, 49
 colored glass
 opaque blue 116, *116*, 214
 opaque white (pearl or opal ware) 47, 48, *48*, 96, 97, 98, *98*, 99, *99*, 116, *117*, 214, *225*, *226*, 227
 factory on Pittsburgh's South Side 44–45, *46*, *47*, 50–51
 finials *10*, 13, *16*, *32*, *36*, *42*, 47, 69n.41, *70*, 72, 74
 letterhead *45*
 molds and mold makers 47, 96, 100, *100*, 123, 130
 offices and showrooms in Pittsburgh 44–45, *45*, 46
 partners 43, 49, 69n.7
 patents 47, 49, 79, 130, *130*, *234*
 geometric patterns 13, 47, 49, 102, *102*, 106, *106*, 237, 239
 naturalistic patterns 13, 47, 49, 88, *88*, 90, *90*, 96, 97, 100, *100*, 236, 238, 244, 245
 patterns 13, 48, 50–51, 79, 88, 90, 92, 93, 96, 98, 99, 100, 102, 105, 106, 113, 115, 116, 118, 119, 123, 124, 126, 127, 128, 129, 130, 132, 237, 239
 design elements shared with other patterns 74–75, 92, 93, 99, 239, 243, 245
 in "Factory B" catalogue 72, 98, 105, 106, 113, 118, 119, 123, 124, 126, 129, 132
 product lines 45
 lamps 13, 45, 47, 48
 mugs 214

perfumery 45, 47
tableware 45, 47
telescope disks 48
tobacco fly traps 48–49
reputation 43–44, 47
trade cards 46, 47
Bryce, William (brother of James) 12, 17, 18, 20, 23
buckets *see under* novelties
Buckle and Star *see* Orient
Butler Brothers
 catalogues *74*, *75*, 119, 135, 136, 140, 144, 146, 151, 152, 154, 156, 162, 174, 178, 179, 182, 186, 194, 195, 196, 201, 203, 208–9, *210*, 212, 214, 217, 220, 228, 230, 233, 234, 235, 236, 237, 238, 239, 240, 242, 243, 244, 245
 "Our Drummer" 72–3, *74*, 233

Cambridge Glass, Cambridge, Ohio 210
Cameo *61*, 236, *236*
Campbell, John, Duke of Argyll, Marquis of Lorne (husband of Princess Louise) 145, 200
Campbell, Jones & Co., Pittsburgh 62
Cane *see under* novelties, patterns
Carnegie Library, Pittsburgh 60, 61–62, 80
Cathedral *see* Orion
Centennial Exhibition (1876), Philadelphia 47, 194
Chain with Star *see* No. 79
Charm butters 236, *236*
Chauncey I. Filley catalogues 98, 99, *234*
Chicago World's Fair (1893) 228
Chickie *see* bird baskets *under* novelties, toothpicks
colored pressed glass 14, 55, 55–59
 canary glass 55, 59, *59*, 60
Colossus 49, 127, 236
 design elements shared with other patterns
 finials 74, 126, 236, 238
 medallions 75, 126, 236, 238
 standards 74, 126, 236, 238
 shapes used in
 bowls, high-footed 126
 interior *127*
 pickle dishes 75, 126
 pitchers *237*
Coral 54, 158, 159, 160, 236
 colored glass 159, 236
 novelties 159, 179, *180*, 221n.19, 244, *244*
 tableware 159
 covered bowls 236
 covered nappies *159*
 pickle dishes *159*
 trays 159
Corning Museum of Glass, Corning, New York 38–39, *49*, 61, 62, 231n.7

Crockery & Glass Journal 27, 38, 54, 55, 59, 72, 118, 123, 132, 133, 134, 156, 158, 162, 165, 172, 190, 212, 214, 234, 236, 239, 241, 243, 244
Cross Hatching *see* Daisy toy mugs *under* mugs and cups
Crystal Ball *see* Atlas
Curled Leaf 13, 47, 49, 79, 90–91, 236
 covered bowls
 lids 90, *90*, 236
 low-footed *91*
 patent showing design *90*, 236
Curtain *see* Sultan
cut glass 11, 24, 38, 134, 136, 165

Daisy and Button *see* Fashion
Daisy and Button with Fine Cut Panels *see* Princess
Degenhart Crystal Art Glass Company, Cambridge, Ohio 214
Derby 49, 72, 132, 214, 236
 colored glass 58, 132, 236
 shapes used in
 bread plates with open handles 132, *132*
 covered bowls, high-footed *236*
Diamond 39, *40*, 86–87, 237
 colored glass 56, *125*, 237
 design elements shared with other patterns
 standards 74
 shapes used in
 bowls 74, *237*
 bowls, footed *31*, 86, *87*
 interior *87*
 nappies 56
Diamond Quilted *see* No. 1000
Diamond Sunburst 13, 47, 49, 50–51, 79, 102–4, 237
 design elements shared with other patterns
 finials 102, 115, 238
 medallions 75, 126
 standards 243
 finials, crown-shaped 13, *42*, 47, 69n.41, 72, 102, *103*, 104
 opaque white glass 48, *48*, 102, *112*, 237
 patent showing design *102*
 shapes used in
 lamps 102, 224, *225*, 227
 tableware 102
 covered bowls *104*
 covered bowls, high-footed *42*, *44*, *103*
 pickle dishes 75
 pitchers *237*
 plates *102*
 syrups 48, 102, *112*
Dot *see* Beaded Oval and Scroll
Double Vine *see* No. 85
Duke Nappy *see under* novelties, fish

George Duncan & Sons, Pittsburgh 176, *176*, 178, 244
Duquesne 154–55, 169n.44, 237
 colored glass 154
 tableware
 bread plates *154*
 butters *237*
 jellies *155*
 table sets 154

Earl Ind. Boat *see under* novelties, boats
Earl Pickle *see under* novelties, fish
East Birmingham *see* Pittsburgh's South Side
Eastlake, Charles 221n.83
Eastlake mug set *see* mugs and cups
Edward III, king of England 200
Excelsior 13, 30, 39, *40*, 41, 237
 covered bowls 237

"Factory B" (Bryce Brothers as part of U.S. Glass)
 catalogue 15, *35*, 41, 60–62, *61*, 69n.73, 71, 75n.2, *80*, 150, 151, 152, 154, 158, 159, 162, 169n.1, *172*, 233, 234–45
 novelties *72*, 172, *172*, 174, 184, 191, 193, 196, 198, 199, 200, 202, 217, 218, *218*, 220, 238
 patterns 39, 49, 75, 77, 80, 86, 98, 106, 118, 123, 124, 126, 132, 133, 136, 140, 142, 146, *163*, 165, 186, 212
 shapes 129, 134, 136, *138*, 140, 144, 145, 160, 161, 164 *see also* novelties *above see also under* Bryce, Walker
Fairfax Strawberry *see* Strawberry
Falker & Stern: *Trade Journal and Reliable Price List* 73, 206, 212, 220, 234, 236, 239, 241, 245
Fashion 136–39, 237
 colored glass 58, 136, 142, 184, 186, 235, 237, 242
 novelties
 baskets 136, *137*, 242, *242*
 boats
 Genesta Boat 56, 186, *188*, *189*, 235, *235*
 Puritan Boat 7, 56, 76–77, 184, 186, *187*, *188*, *189*, 235, *235*
 commemorative glassware 190, *190*, 191, *191*, 192, 193, *193*
 fish
 Fashion Nappy 56, *59*, 184, *185*, 238, *238*
 slippers 136, 176, *177*, 178, *178*, *180*, 181, 244, *244*
 toothpick holders 136, *137*, 212, *213*
 Wall Bracket 195, *195*, 245, *245*
 tableware
 butters *61*, 136, *136*, 139

cream pitchers 136, *137*, *138*, 237, *237*
custard cups 136, *137*, 237, *237*
jellies 136, *137*
nappies 56, *59*, 184, *185*, 238, *238*
pickle dishes 186
pitchers 237
sugar bowls 136
tumblers *57*, *138*
Filley 49, 98, 237
 design elements shared with other patterns
 standards 74, 99, 235, 245
 opaque white glass 48, 98
 shapes used in
 covered bowls, high-footed 99
 egg cups 98
 goblets 237
Fine Cut (No. 720) 62
Fine Cut with Panels (No. 260) 62
Fish cream with tilting glass cover 199, *199*, 238, *238*
Fishscale *see* Coral
Flat Oval *see* Monarch
Flat Panel (No. 15003, Pleating) 62
flint glass 6, 7, 12, 13, 21, *26*, 34, 37–38, 45
Floral Diamond Band *see* No. 900
Fly 171, 196–97
 colored glass 196, 221n.55, 238
 butters *2*, 58, 196, *197*, 208, 238, *238*
 dishes 196, *196*
 pickle dishes 196, *196*, 238, *238*
Franklin Institute of Philadelphia's Exhibition of American Manufactures (1858) 38

Geddes 49, 115, 238
 design elements shared with other patterns 115, 119
 finials 102, 238
 medallions 75, 115, 119, 238
 finials, crown-shaped 102, 115
 shapes used in
 lamps 227, *227*, 228, *228*, 231n.5, 238, *238*
 pickle dishes 75, 115
 pitchers *115*
Genesta *see under* novelties, boats
Genesta (yacht) 186
Glass Basket with Handle *see* compotes *under* novelties, baskets
glass blowing *see* blown glass
glass pressing *see* pressed glass
glass production 6–7, 11, 12, 15, 20, *20*, 22, 30n.20, 38, 44, 60 *see also* blown glass; colored glass; cut glass; flint glass; pressed glass
Grape Band 13, 47, 49, 79, 88–89, 238
 design elements shared with other patterns

egg-and-dart border 74, 93
 standards 74, 93, 243
opaque white glass 48, *48*, 88, *88*, *112*, 169n.9, *226*, 227
patent showing design 88, 238, *238*
shapes used in
 lamps *226*, 227
 tableware
 bowls 74
 pickle dishes 88
 bottom *88*
 pitchers 88, *89*, 169n.9
 syrups 48, 88, *112*
Grape with Scroll Medallion *see* Swiss
Greenfield Swirl *see* No. 159

Hand and Bar *see* No. 90
Hand with Torch *see* Liberty Torch
Harp 13, 39, *40*, 41, 238
 butters 39, *40*, 238
Heisey, Augustus H. (U.S. Glass) 60
Henderson, Annie W. 79, 92, 239
G. M. Hopkins Co.: *Pittsburgh Map* 45, 46, *46*
Huber 13, 39, *40*, 41, 238, *238*
Huxtable, Garth 68

Imperial *see* Maltese
Inominata *see* No. 95

Jackson, Andrew (U.S. President) 24
Jacob's Ladder *see* Maltese
Jasper 126, 238
 colored glass 126, 238
 design elements shared with other patterns 49, 127, 128
 finials 74, 126, 235, 236, 238
 medallions 75, 126, 235, 236, 238
 standards 74, 126, 235, 236, 238
 shapes used in
 bowls, high-footed 126, *238*
 pickle dishes 75, 126, *126*
Jefferson, Thomas (U.S. President) 20–21
Jersey table sets 238, *238*
Jones, Cavitt & Co., Pittsburgh 62
Jones, John Paul 30n.2
Just Out table salts 206, *206*, 239, *239*

Kirkcudbright, Scotland 17, *18*, 30n.2
Kitchen Jar Set 239, *239*

Lacy Spiral *see* Colossus
Lafayette, Gilbert du Motier, Marquis de 24
Lager Beer Mug 239, *239*
lamps 13, 34, 41, 45, 47, 48, 53, 54, 210, 223–31
 colored glass 59, 228, 230, 245
 opaque white 227, 228, 245

parts
 fonts *226*, 227, *227*, 228, *229*, 230, 231n.4, 231n.5, 245, *245*
 pedestals *225*, 227, *227*, 231n.4
 patent showing design *224*
patterns
 Diamond Sunburst 102, *225*, 227
 Filley 98
 Geddes 115, 227, *227*, 228, *228*, 231n.5, 238
 Grape Band *226*, 227
 Palmette 93, *226*, 227
 Tulip *224*
 Tulip with Sawtooth *223*
types
 Chicago lamps 230, *230*, 245
 hand lamps 210, 228, *228*
 Happy Thought lamps 210, 230, *231*, 238, *238*, 245
 New York lamps 228, *229*, 245, *245*
 night lamps 230, *231*
 Pittsburgh lamps 228, 245
 St. Louis lamps 228, *229*, 245
 World's Fair lamps 59, 228, *229*, 230, 245, *245*
Late Buckle *see* Jasper
lead, in glassmaking 7, 11, 12, 23, 38
Leaf flanged butters 58, *61*, 69n.63, 202, *202*, 239, *239*
 colored glass 58, 69n.63, 202, 239
Leaf Berry Set 62
Lee, Alex Y.: *Souvenir of Pittsburgh and Allegheny City* (with Ward Brothers) 62
Lee, Ruth Webb 178, 179, 181, 182, 208, 212, 221n.19, 221n.21, 233, 236, 237, 239, 244
Leighton, William, Sr. 38
Leisser, Martin B.: portraits of James Bryce and Elizabeth Haugh Bryce 29
Lenox, Inc. 11–12, 68
H. Leonard & Sons: *Illustrated Price List of House Furnishing Goods* 229, 230, 245
Leverne *see* No. 80
Liberty Torch *see under* novelties, toothpicks
Loop and Dart 49, 79, 92, 239
 sugar bowls 92, *92*, 239, *239*
Lorne butters 58, 69n.63, 145, *145*, 202, 239, *239*
 colored glass 58, 69n.63, 145, 202, 239
Louise, Princess (daughter of Queen Victoria) 145, 200
F. H. Lovell & Co. catalogues 73–74, 113, 115, 116, 178, 179, 194, 210, 221n.12, 223, *227*, 235, 238, 239, 242, 244, 245
Lyre *see* Harp

Magic 54, 158, 159, 160, 239
 colored glass 158, 239
 covered nappies *239*
 pickle dishes *158*
 spoon holders 158, 239
Maltese 13, 47, 49, 79, 106–12, 239
 colored glass 58, 106, *125*, 239
 opaque white 48, *48*, 106, *112*, 239
 design elements shared with other patterns
 Hand and Bar stoppers *106*, 124, *125*
 medallions 75, *126*
 finials with Maltese Cross *10*, *13*, *44*, *47*, *104*, 106
 patent showing design *106*
 tableware
 bowl, dolphin stem 75, *111*, 203
 bowls, high-footed interior *13*, *108*
 celeries *109*
 covered bowls *44*, *104*, 106
 covered bowls, high-footed *107*
 interior *108*
 cruets 106, *106*, *125*
 pickle dishes and pickle casters 75, *110*
 syrups *48*, *112*, 239
Maltese Cross in Circle *see* Troy
Maverick, Peter 22
McKee & Brother(s), Pittsburgh (previously F. & J. McKee) 35, 41, 47, 48
Melish, John: *Travels in the United States of America* ... *20*
milk glass *see* opaque white glass
Miller, John E. 176, *176*
Missouri Glass Company's Commercial Solicitor 136, 210, 239
Mitered Diamonds (No. 126) 62
Monarch 72, 141, 239
 berry bowls 141, *141*, 239
 colored glass 58, 141, 239
Monongahela House, Pittsburgh *55*
 glass exhibition 54
Monongahela River, Pittsburgh 12, *20*, *21*, *28*, 29, 30, *34*, 44, 46, 169n.44
 steamboats *34*
Monroe, James (U.S. President) 24
Morgan silver dollar (George T. Morgan) 190, 191
Mosser Glass, Cambridge, Ohio 217
mugs and cups 214–20, 233, 240–41
 colored glass 214, 217, 220, 240, 241, 242
 Daisy toy mug 171, *172*, 182, *211*, 212, 236, 240, *240*
 with perfume bottle 171, 212

graduated mugs 116, *172*, 214, *215*, *216*, 217, 218, 240
 beaded handles *216*, 217, *218*, 240
 No. 1300 Gliding Swan *216*, 217, 221n.92, 240
 No. 1301 Pointing Dog *216*, 217, *240*
 No. 1302 Bird on a Branch *216*, 217, *240*
 No. 1303 Dog Chasing Deer *216*, 217, *240*
 Eastlake handles 214, *215*, 240, *240*
 Boy with Begging Dog 214, *215*, 240
 Deer and Cow 214, *215*, 240
 Heron and Peacock 214, *215*, 240
 flat handles *172*, *216*, 217, *217*, *240*
 No. 1200 Pugs and Chicks *172*, *216*, 217, *240*
 No. 1201 Feeding Deer and Dog *172*, *216*, 217, *240*
 No. 1202 Grape Bunch *172*, *216*, 217, *240*
 No. 1203 Robin in a Tree *172*, *216*, 217, *240*
 Strawberry and Pear 217, *217*, 241
 Happy Thought mug 210, *211*, 230, *231*, 238, *241*
 as toothpick holders 210, *211*
 No. 4 Birds and Insects *172*, 218, *241*
 No. 175 Toy Cup and Saucer *172*, 219, *219*, 221n.94, 242, *242*
 No. 1205 paneled hobnail 220, *220*, 241, *241*
 see also Acme
Mulvany & Ledlie, Pittsburgh 28, 46

National bread plate *72*, *170*, 190, 190–91, *191*, 193, 194, 214, 241, *241*
New York 49, 105, 241
 design elements shared with other patterns
 standards 74, 105, 241
 tableware
 bowls 74
 bowls, high-footed *105*
 pitchers *241*
 see also lamps
No. 79 49, 118, 241, *241*
 butters *118*
 design elements shared with other patterns
 standards 74, 126
No. 80 49, 115, 119–22, 241, *241*
 design elements shared with other patterns 115, 119
 medallions 75, 115, 119, 238
 feet 119, *122*

finials *36*
 tableware
 bowls 119
 butters *36*, *121*, 241
 cake stands 119
 covered bowls, high-footed 119, *122*
 cruets *121*, 246
 pickle dishes 75, 115, 119, *120*
 pitchers 119, *121*
 plates 119
 salvers 119, *232*
 wine glasses *119*
No. 85 49, 72,123, 241
 bread plates *78*, *123*, 241
 pickle dishes 123
No. 87 241
 cruets 241
 goblets 241, *241*
No. 88 241
 pitchers *241*
No. 90 49, 124–25, 241
 colored glass 124
 cruets with stoppers 124, *125*, 241
 finials, with Hand and Bar *70*, 124, *124*
 sugar bowl *70*, 124, 241
No. 95 49, 124, 242
 design elements shared with other patterns 129
 shapes used in
 cream pitchers *242*
 syrups 129
No. 103 242
 colored glass 242
 shapes used in
 altar sets 242
 cruets with stoppers *125*
No. 118 242
 altar set, tray and catsup 242
No. 159 242
 colored glass 58, 242
 goblets *242*
No. 160 62
No. 900 146, 242
 comports *242*
 syrups 242, *242*
No. 1000 146–49, 242
 colored glass 58, 146, 242
 tableware
 celeries *148*
 comports *58*, *149*
 goblets *147*
 mugs *147*
 pitchers *147*
 sugar bowls 148, *149*
 syrups *242*
 table sets *148*
 water trays *146*
Nos. 1112–15 242
 colored glass 242
 lemonade glasses *242*
novelties 171–221
 colored glass 58, 195, 198, 201, 202, 203, 206, 207, 239, 243, 244, 245

patterns
 Cane *178*, 179, 181, *181*, *183*, 207, *207*, 210, *210*, 237, *237*, 238, *238*, 244, *244*
 Coral 159, 179, *180*, 221n.19, 244, *244*
 diamond block 182, *183*, *211*, 212
 Fashion *see under* Fashion
 Orion 56, *56*, *57*, 138, 150, 184, *184*, *185*, 186, *189*, 235, *235*, 237, *237*, 238, *238*
 Puritan 207, *207*, 243, *243*
reproductions 77, 181, 182, 186, 201, 210, 212, 214, 217
types
 baskets 136, *137*, 209, 210, *210*, 211, 212, 235, *235*, 242, *242*
 colored glass 235
 butters *61*, 235
 compotes 235, *235*
 see also toothpick and match holders; Basket
 boats 171, 186–89, 233
 colored glass 186
 Canoe Celery 150, 184, 186, *189*, 235, *235*
 Earl Ind. Boat 56, *57*, 138, 150, 186, *189*, 235, *235*
 Genesta Boat 56, 186, *188*, *189*, 235, *235*
 Whisk Broom Holder 186, *188*
 Puritan Boat *7*, 56, 76–77, 184, 186, *187*, *188*, *189*, 235, *235*
 buckets 172–75, *173*, *175*, 221n.3
 colored glass 174, 236
 handles 174, 221n.7
 products
 butters 174, *175*
 cream pitchers *58*, *149*, 174, *175*
 jellies 14, *14*, *172*, 174, 221n.4
 with tin lids *172*, *173*, 236
 "Old Oaken Buckets" *58*, *172*, *172*, *173*, 207, 236, *236*
 pitchers 172, 174, *175*, 236
 spoon holders *175*
 sugar bowls 174, *175*
 table sets *172*, 174, *175*
 toy buckets 14, *172*, *172*, *173*, 174, 210, *211*, 236
 toy tea sets *172*, *175*
 commemorative and patriotic glassware 14, 171, 190–94, 235
 colored glass 191, 193, 194, 239, 241

see Banner Butter, National
bread plate
see Liberty Torch under
novelties, toothpicks
fish 14, 59, 171, 233
colored glass 14, 58, 184,
237–38
Duke Nappy 150, 184, 184,
237, 237
Earl Pickle 56, 150, 184,
184, 185, 238, 238
Fashion Nappy 56, 59, 136,
185, 238, 238
savings banks 171
shoes 176–83
colored glass 178, 179, 181,
182, 221n.19, 235, 236,
244
boots 56, 79, 171, 176, 178,
181–82, 183, 212, 233,
235, 235–36, 236
as advertisements 178,
182, 183
with perfume bottle 171,
182
with roller skates 176,
182, 183, 236, 236
Chinese shoes 171, 176,
178, 179, 244, 244
Chinese Shoe on
Toboggan 176, 179,
181, 181, 244
with perfume bottle
171, 181, 244, 244
patents 176, 176, 178,
181–82, 182
as perfume bottle holders
171, 181, 181–82, 182,
244, 244
Sandals 176, 178, 178, 179,
181, 244, 244
slippers 79, 136, 159, 176,
177, 178, 178, 179, 179,
244
as advertisements 179,
180
Small Slipper Nappy 176,
179, 180, 221n.19, 244,
244
tableware
bread plates 170, 190,
190–91, 191
butters 61, 174, 175, 192,
193, 193, 196, 196, 197,
202, 202
cream pitchers 174, 175,
199, 199
nappies 56, 59, 176, 179,
180, 184, 184, 185
pickle dishes 56, 184, 184, 18
plates 200, 200, 201, 201
table salts 206, 206
toothpick and match holders
55, 57, 58, 136, 137, 171,
178, 182, 208–13
colored glass 209, 212, 236,
237, 238, 245

combined with lamps 210,
230, 231
types
Basket 209, 210, 210, 211,
235, 235
Bird Basket 209, 210, 210,
211, 212, 235, 235
Coal Bucket 182, 211,
212, 236, 236
Coal Hod 212, 212, 236,
236
Dog Kennel 208–9, 209,
237, 237
Dolphin Match Holder
212, 212, 237, 237
Fashion toothpick 136,
137, 212, 213
Fan 209, 210, 210, 211,
237, 237
Gypsy Kettle 209, 210,
210, 211, 238, 238
Liberty Torch 171, 190,
194, 194, 209, 210,
222, 239, 239
with perfume bottle
171, 194, 194
Match Safe 212, 212, 239,
239
Monkey 210, 211, 239,
239
Toy Buckets see under
novelties, buckets
Wall Pocket 171, 209,
210, 210, 211, 245, 245
with perfume bottle
171, 210, 210

O'Hara & Craig Glass Works,
Pittsburgh 20
O'Hara Glass Company, Pittsburgh
124
opal ware see opaque white glass
opaque white glass (pearl or opal
ware) 47–48, 48
Openwork Dish with Dolphin
Standard 203, 203, 205, 242, 242
Orient 49, 113–14, 242
colored glass 58, 113, 242
design elements shared with
other patterns
medallions 75, 126
standards 74, 126
finials with Maltese Cross 106,
113, 114
tableware
butters 10, 114
interior 114
covered bowls 242
pickle dishes 75
syrups 113, 113
Orion 150, 235, 237, 243
colored glass 56, 58, 86, 184,
235, 237, 243
novelties 56
boats
Canoe Celery 150, 184,
186, 189, 235, 235

Earl Ind. Boat 56, 57, 138,
150, 186, 189, 235, 235
fish
Earl Pickle 56, 150, 184,
184, 185, 238, 238
Duke Nappy 150, 184, 184,
237, 237
tableware
bowls 150, 184
bowls, high-footed 58, 149,
150
cream pitchers 243
goblets 58, 149
nappies 56, 136, 179
Oval Medallion see Argyle

Palmette 49, 92, 93–95, 243
design elements shared with
other patterns 239
egg-and-dart border 74, 93,
94, 101
finials 92, 92, 239
medallions 126
standards 74, 93, 105, 241,
243
opaque white glass 48, 93, 226,
227, 243
shapes used in
lamps 226, 227
tableware
bowls 74, 105
bowls, high-footed 93, 94
butters
lids 93, 243
five-bottle caster set 95
sugar bowls 92, 92
syrups 93
Paneled Cable see Acme
Paneled Daisy see Brazil
Paneled Forget-Me-Not see Regal
P.D. and Pilot caster sets 243, 243
Peas and Pods (No. 5602) wine
glasses 57, 138
pearl ware see opaque white glass
Pennsylvania State Agricultural
Society 37–38
Perfumery Stand 207, 207, 243, 243
Persian nappies 243, 243
Pert 140, 214, 243
colored glass 140, 243
tableware
butters 243
cream pitchers 140
mugs 140, 243
mustard pots, footed 140, 243
table sets 140, 243
Pilot caster sets see P.D. and Pilot
caster sets
Pitkin and Brooks: Glassware
Catalogue 238
Pittsburgh 21, 28, 34
Bryce glass offices and
showrooms see under named
Bryce glass companies
glass exhibitions 37–38, 54, 55
glassmaking 6–7, 11, 12, 13,
14, 20, 20–23, 27, 35, 44,

60 see also Bakewell, Page &
Bakewell; named Bryce glass
companies
history 11, 12, 19, 24, 28, 53
Great Fire (1845) 12, 28,
28–30
maps 20, 45, 46, 63
Pittsburgh's South Side (prev.
East Birmingham) 33
Bryce glass factories 12, 33,
34, 37, 38, 45, 46, 47
map 45, 46
Pittsburgh (pattern) 60, 165–68,
243
covered bowls, high-footed 168,
243
lamps 228, 245
salvers 165, 166
vase, double 165, 165, 167
The Pittsburgh Directory for 1819 19
Pittsburgh in 1816 (illustration of a
Conestoga wagon) 19
Pittsburgh, Pennsylvania, vol. 2,
South Side and Allegheny: fire
insurance map 63
Pleat and Panel see Derby
Pottery & Glassware Reporter see
American Pottery & Glassware
Reporter
pressed glass 11, 13, 27, 136
molds and mold makers 33, 35,
35, 79
see also colored pressed glass;
named Bryce glass companies
Pride nappies 243, 243
Princess 133, 134–35, 136, 145,
243, 243
colored glass 56, 86, 134, 243
tableware
goblets 135
nappies 56, 86
pitchers 135
two-bottle casters 79, 124,
134, 243
handle with hand and ring
124, 134, 241
Prism and Diamond Points see No.
103
Prisms and Globules see Pittsburgh
(pattern)
Puritan (pattern) 151, 243
colored glass 56, 151
perfumery stands 207, 207
tableware
celeries 151
cream pitchers 151
nappies 151
spoon holders 151
tumblers 243
Puritan Boats see under novelties,
boats
Puritan (yacht) 186

Regal 133, 145, 243
colored glass 58, 133, 243
cream pitchers 140, 243
pitchers 133

Ribbed Forget-Me-Not *see* Pert
Ribbon Candy (No. 15010, Double Loop) 62
Richards & Hartley, Pittsburgh 35, 38
Rochester Tumbler Co., Beaver County, Pennsylvania 53
Roman Rosette (No. 15030) 62
Rope Band *see* Argent
Rose in Snow (No. 125) 62
Rosette *see* Magic
Ruby 49, 129, 243
 design elements shared with other patterns 129
 pickle dishes 129, *129*
 syrups 129, *129*, 243
 table sets 129
Russia table sets 49, 72

Sawtooth *see* Diamond
Sawtooth Band *see* Amazon
Scotch Thistle *see* Thistle
Seattle World's Fair (1962) *64*, 68
shoes *see under* novelties
Shamrock butters 58, *61*, 244, *244*
 colored glass 58, 244
Silhouette series (Zeisel) 67
Smith-Brudewold Co., Hammondville, Pennsylvania 65
Smith, Henry J. 49, 79, 130, 134, 160, 176, 234, 244
soda lime, in glassmaking 11, 38
G. Sommers & Co. catalogues 73, 134, 178, 210, 214, 230, 236, 239
Spelman Brothers catalogues 56, 73, 86, 106, 128, 134, 136, 145, 169n.38, 178, *179*, *181*, *182*, 186, 194, *194*, 207, *207*, 210, *210*, 212, 214, 218, 234, 235, 237, 239, 240, 242, 243, 244
Spread Eagle Tavern, Pittsburgh 19, *19*
Standard flanged butters 244, *244*
Star butters 244, *244*
 opaque white glass 244
Star Band *see* Geddes
Star in Honeycomb *see* No. 80
Star of Garter plate *72*, 145, 200, *200*, 244, *244*
Statue of Liberty 14, 190, 194
Strawberry 13, 47, 49, 79, 96–97, 244
 design elements shared with other patterns

egg-and-dart border 74, 93, 169n.11
 standards 74, 93, 243
finials, strawberry-shaped 13, *32*, 47, 96, 97
 opaque white glass *32*, 48, 96, 97
patent showing design 97, 244
tableware
 bowls 74
 covered bowls 96
 covered bowls, high-footed 169n.11
 egg cups 96
 goblets 96
 pickle dishes 96
 pitchers 96
 sugar bowls 32
 syrups 96
 table sets 96, *97*
Sultan 156–57, 244
 colored glass 156, 244
 covered bowl, high-footed *157*
 mugs *156*
 pitcher *244*
Sunken Icicle 49, 245
 bowls, high-footed 69n.42, *245*
 design elements shared with other patterns
 standards 69n.42, 74, 245
 opaque white glass 48, 245
Swell butters 245, *245*
Swiss 49, 116–17, 245
 colored glass
 opaque blue 116, *116*, 245
 opaque white 48, 116, *117*, 245
 tableware
 butter lids *116*
 mugs 116, *116*, 245
 sugar bowls *117*, 245
 table sets 116, 245
Sword pickle 198, *198*, 245, *245*

Tappan, Herman 79, 182, 221n.26, 235, 236
Teasel *see* No. 87
Texas Bull's Eye *see* Filley
Thistle 13, 47, 49, 79, 100–101, 245
 design elements shared with other patterns
 egg-and-dart border 74, 93, *94*, *101*
 medallions 75, 126
 standards 74, 93

finials, thistle-shaped 13, *16*, *44*, 47, 100, *101*, *104*
patent showing design 100, 245
tableware
 bowls 74, *245*
 bowls, high-footed *101*
 interior *13*, *100*
 covered bowls *44*, *104*
 covered bowls, high-footed *16*, *44*
 goblets *100*
 pickle dishes 75
Thurston, George 47
Tiffin Glass Collectors Club, Museum, Shoppe and Archives, Tiffin, Ohio 60, 61, 62, 69n.73
toothpicks 14, 54, 208
 see also under novelties
Troy 164, 245
 bread plates 164, *164*, 245
 butters *61*, *164*, 245, *245*
 opaque white glass *164*, *164*, 245
Tulip 13, 39, 40, 80–85
 jars 80, *82*
 opaque white 48, 80, *82*, 169n.6, 245
 shapes used in
 lamps 224
 tableware
 butters 39, *40*, *41*, 80, *83*, 169n.6
 base *39*
 celeries 80, *80*, 245
Tulip with Sawtooth 13, 39, *40*, 74, 80, 86
 design elements shared with other patterns
 standards 74, 99, 235, 245
 shapes used in
 jars *82*
 lamps *223*
 tableware
 butters 39, *40*, *41*, 80, *83*
 base *39*
 celeries 80, *80*, 245
 covered bowls, high-footed *85*, 99
 decanters *81*
 plates *84*

uranium, in glassmaking *59*, 59–60
U.S. Glass Company 14–15, 38, 60, 62, 65, 71, 80, 138, 145, 179
 Bryce Brothers in conglomerate *see under* Bryce Brothers

catalogues 240, 241, 242
 Catalogue of Pressed Tumblers and Beer Mugs 210, 220, 241
 Clinch Collar Lamps Catalogue 228, 230, 231n.7, 245
 Factory B catalogue *see under* "Factory B"
 Packers' and Confectioners' Catalogue 212, 221n.92

Victor (No. 128) 62
View of the Country round Pittsburgh (from *Travels in the United States of America* by Melish) 20

Wall Bracket 195, *195*, 245, *245*
Wall, William Coventry
 Pittsburgh after the Fire from Birmingham 28
 View of the City of Pittsburgh in 1817 ... (after sketch by Mrs E. C. Gibson) 21
R. P. Wallace & Co.: *Pioneer Lamp & Glass House* 73, 236, 242, 245
Walker, William 43, 49, 69n.20
Ward Brothers: *Souvenir of Pittsburgh and Allegheny City* (with Lee) 62
Waverly (No. 140) 62
Welker, John and Elizabeth: *Pressed Glass in America* 30n.20, 58–59
Wheat and Barley *see* Duquesne
Williams, Anna Willess 190
Willow Oak *see* Wreath
Woodworth, Samuel: *The Old Oaken Bucket* (poem) 172
World's Columbian Exposition (1893) 228
Wreath 152–53, 245
 colored glass 152, 245
 tableware
 bread plates 245
 butters 152, *152*
 celeries *153*
 covered bowls, high-footed *153*
 pitchers 152, *153*
 water sets 152
L. G. Wright 181, 186

Zeisel, Eva *67*, 68
Zig Zag (or No. 126, Mitered Diamonds) 62
 cordials 35